The Connecticut River

Garnet Books

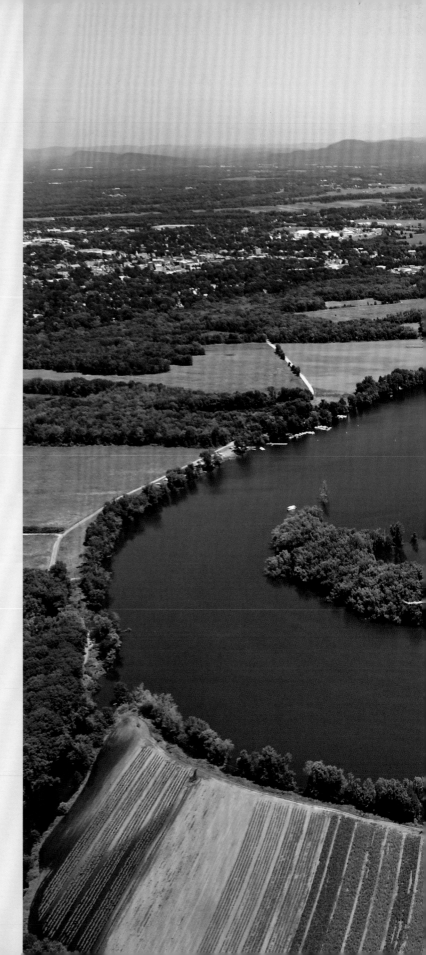

The Connecticut River

A PHOTOGRAPHIC JOURNEY THROUGH THE HEART OF NEW ENGLAND

Al Braden

Afterword by CHELSEA REIFF GWYTHER,

Executive Director, Connecticut River Watershed Council

WESLEYAN UNIVERSITY PRESS Middletown, Connecticut

Published by

Wesleyan University Press, Middletown, CT 06459

www.wesleyan.edu/wespress

Text and photos © 2009 by Al Braden

Afterword © Chelsea Reiff Gwyther

Printed in China

5 4 3 2 1

Library of Congress Cataloging-in-Publication Data

Braden, Al.

The Connecticut River : a photographic journey through
the heart of New England / Al Braden ; afterword by
Chelsea Reiff Gwyther.

 p. cm.

Includes bibliographical references.

ISBN 978-0-8195-6895-3 (cloth : alk. paper)

1. Connecticut River Valley—Pictorial works.

2. Connecticut River—Pictorial

works. I. Title.

F12.C7B73 2009

974'.0440222—dc22

2009018241

This book has been printed on paper certified by the
Forest Stewardship Council.

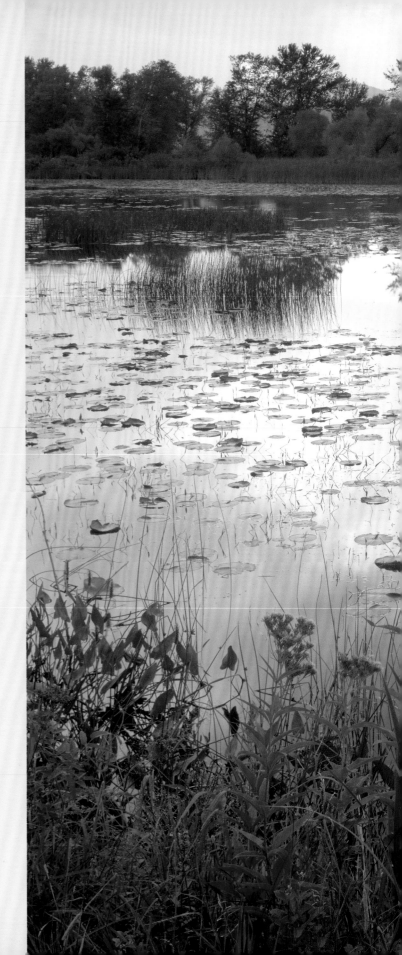

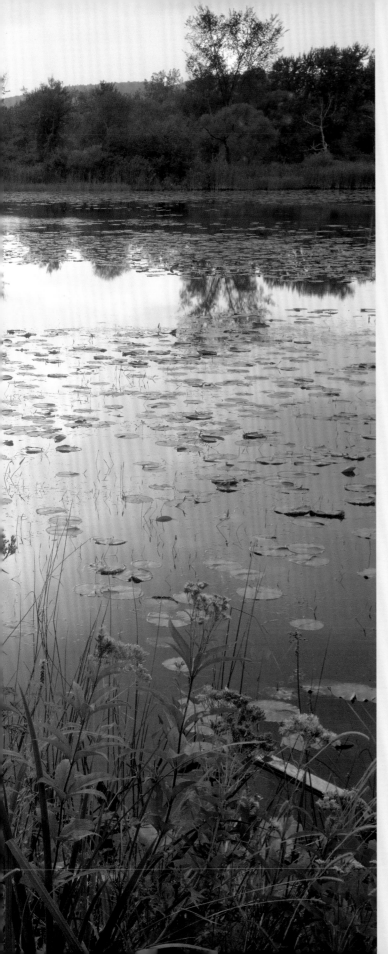

Contents

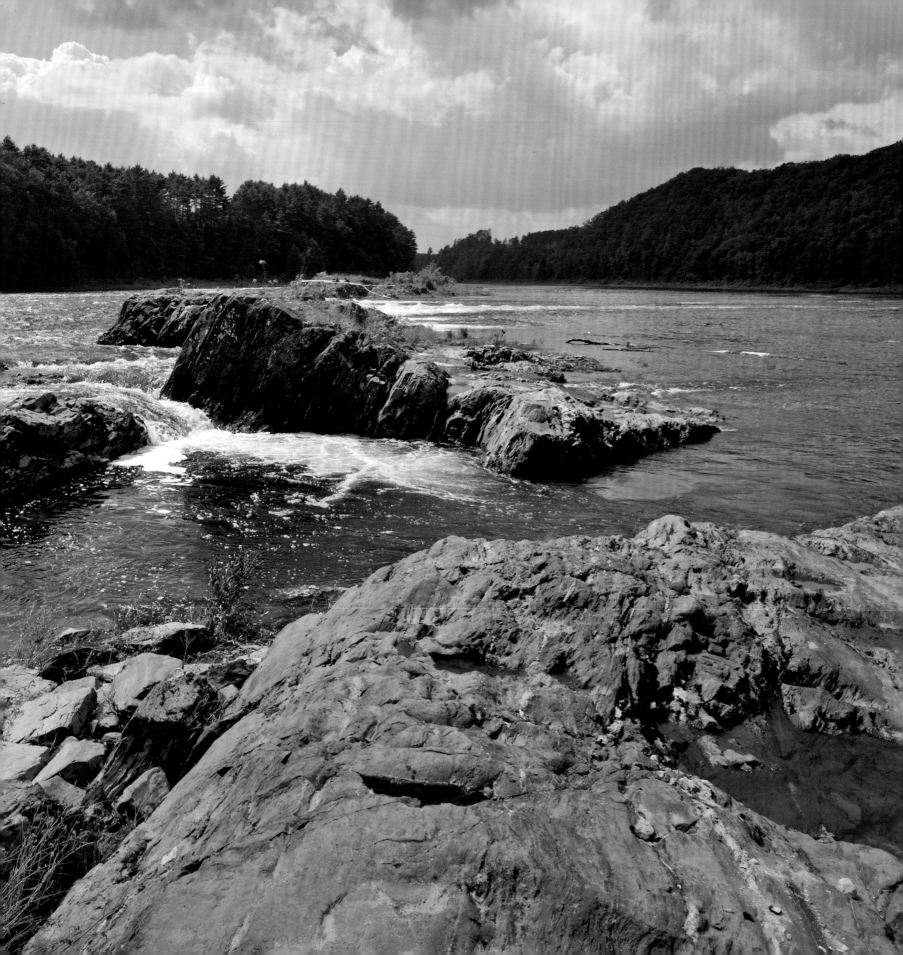

Introduction Cannon Fire and All That Stuff

A bright summer day.

I was cruising down the Connecticut River toward Charlestown, New Hampshire, in my sixteen-foot bow rider. I passed farm fields, sandy banks and a few small islands; almost no sign of civilization.

I was just enjoying the day's quiet isolation. A beautiful day with few boats or canoes on the water. How exquisite to be out enjoying *this* day.

"The river is underused," I thought.

I almost stopped the boat. "Underused! #$*&#&&*#!! Who are YOU to think such a thing? Would you be happier with an extra hundred boats per mile?"

"Well, no, it's just fine like this, thank you."

And so with that bit of back-and-forth, I began to think more about our relationship with the Connecticut River. How do we relate to this beautiful river? How have we used it? How was it in the past? How has it sustained us? How has it contributed to our history? Have we abused it? What are we doing to conserve it?

Rounding the bend at the Charlestown Bridge, I heard cannon fire, interrupted by rifle volleys. I slowed my boat down to hear what was going on. Cannon fire was unexpected on this summer river trip.

Though I had set out with boat and camera to capture the beauty and landscape of the Connecticut River, history and humanity were never far away. Approaching by water, it was hard to see over the banks to the reconstructed Fort at No. 4, with its surrounding fields, where the battle reenactment was taking place. This fort at Charlestown, New Hampshire, got its name from having been built to defend the fourth of twenty-six "plantations" established by the Massachusetts General Court in 1735 for colonization of the upper Connecticut River Valley.

I nudged the boat onto a sandy shore, tied on to a branch and carefully climbed up the bank, wanting to see the battle, not become a part of it.

Throughout the Connecticut Valley, we are always just a step away from history. One step from something that happened way back in the 1700s that affects our communities today.

Watching the battle reenactment, I thought how far away from Deerfield's fort I was, by foot or canoe. While an easy hour away on Interstate 91 today, in 1744, the distance would have been a difficult forty-five miles through wilderness. The river was then the surest route. Even then, you might have struggled against a heavy current, or risked being stranded in low water. At that time, the river was not the tame, interconnected series of reservoirs behind cement dams that we know today. It was wild and rocky. For those traveling by boat, the treacherous Bellows Falls and Turners Falls would have to be portaged.

The French troops in the reenactment would have had an even more difficult journey, traversing rugged Vermont after canoeing down the shores of Lake Champlain from Quebec.

Back then, there was no noise pollution, light pollution, acid rain, parking lot runoff or radioactive rods stored by the river's shore. If you were out in the woods, you were out there on your own. Self-reliance was the norm. Night was dark, food was scarce. You had to know what was edible in the forest and how to find it.

I set out to explore this river, its past . . . present . . . and future. I wanted to understand it . . . photograph it . . . and do what I could to help comprehend our important role in protecting it.

After ten years' traveling, boating, hiking, cruising and flying, I have a series of images that touch on our relationship with this river and its watershed. But it is only my introduction. There is an unlimited amount yet to explore.

I had set out to photograph the landscape; yet again history confronted me most days on the water. As I traveled the river from its quiet beginning at the Fourth Connecticut Lake to the wide, shallow mouth at Saybrook Jetty Light, I was struck by so many intertwined themes. The history of colonization is intermixed with agriculture. Then a dam and hydroelectric plant appear, some industrial buildings, a preserved forest . . . then a town. Rail and highway bridges abound along the river. Then a cove, another town. Some things are current, some abandoned, some historic.

I had tried to separate all these subjects into groups. Ultimately, all the themes are so inextricably woven together that I made a simple choice: to present my images in the geographic order in which I encountered them. To set the scene, let me offer a brief summary of the topics I found along the way.

GEOGRAPHIC REGIONS
Broadly speaking, the river's 410-mile path takes it through four different natural regions.

GREAT NORTH WOODS
Fir and spruce cover the mountainous headwaters in northern New Hampshire. Moose range freely in the Lakes Region. The area is known for lumber and pulp production and four-season recreation. Hunting and fishing camps are spread throughout.

The river runs down from its headwaters, picking up important tributaries, flowing by the Northeast Kingdom in Vermont and then passing through the major reservoirs at Moore and Comerford Dams.

UPPER VALLEY
As the Passumpsic tributary flows in from St. Johnsbury near Barnet, Vermont, the river begins to open up into the rich and fertile valley that characterizes the New Hampshire–Vermont border. Forests abound, dairy and produce farms fill the valleys.

Mountain ridges run north-south, directing the Connecticut River on a southerly course.

PIONEER VALLEY AND TOBACCO VALLEY
Below Vernon Dam in Vermont, the river breaks through a ridge at French King Gorge, and it takes a westerly turn to Barton Cove and Turners Falls before hitting the Pocumtuck Range and heading south again. Here it begins to open up into the rich farmland of the Pioneer Valley in central Massachusetts and continues south until reaching the Holyoke Ridge and winding its way between Mount Holyoke and Mount Tom.

Once again, it opens into a broad plain from Holyoke into Connecticut's Tobacco Valley. The next major obstacle is the ridge at Rocky Hill, which once formed the southern end of Glacial Lake Hitchcock. Breaking through at Rocky Hill, it flows south to Middletown where it takes a strong southeasterly turn through Bolton Ridge.

TIDEWATERS
The East Haddam Swing Bridge seems to me to symbolize the river's change to the Tidewaters. Unique in all of New England, the wetlands of the lower Connecticut River are designated by the United Nations Ramsar Convention as being of international importance:

The site includes open water; fresh, salt and brackish tidal wetlands; floodplains, river islands, beaches, and dunes. The system serves as essential habitat for numerous regionally, nationally, and globally rare or otherwise significant species and forms an extensive biological corridor that links marine and estuarine waters of the Atlantic Ocean.

These many estuaries, coves and ponds of the tidal lower river continue to exist as natural habitats because the shallow, sandy mouth of the river prevented the establishment of a major shipping port with the attendant pressure to fill in wetlands for shipping and industrial uses as has occurred at many other river ports.

In addition to waterfowl, these habitats also provide feeding grounds for many other birds including herons, egrets, cormorants and a now-thriving osprey population. During the winter, bald eagles fish the river's mouth as the ospreys move south.

EXPLORATION AND COLONIZATION

Native American people are believed to have populated the Connecticut River Valley for as long as 12,000 years. Originally hunters, they began farming such crops as squash, beans and corn long before contact with Europeans. The Native American population in the Connecticut River Valley may have reached approximately one hundred thousand, principally with the Abenaki in the north and the Pequot in Connecticut.

From the first recorded European visit by Dutch explorer Adrian Block in 1614 through the American Revolution, a relentless wave of exploration and colonization pushed the native inhabitants out of the valley. That colonization, combined with diseases brought from Europe, decimated the native population, leaving little written record.

The Dutch first settled the river valley. River transportation made the valley more accessible and the floodplain bottomlands were the most fertile and easiest to clear and till. Adrian Block reached Enfield Rapids in 1614.

By 1634, English settlers founded Wethersfield, followed by Saybrook the next year. Both Hartford and Springfield were settled in 1636. By 1654, English settlements dominated, and the Dutch were pushed out of the valley. By 1675, native populations were virtually eliminated in the southern area of the river.

English colonists moved quickly northward with settlements in Deerfield (1669), Fort Dummer, near Brattleboro (1725), Bellows Falls (1735) and Fort at No. 4 (1740). The Fort at No. 4 was abandoned in late 1746 and resettled again in the spring of 1747. It remained under frequent attack until 1753, when it was chartered as Charlestown, New Hampshire. During the 1760s, settlement spread on both sides of the river. Dartmouth College was chartered in 1769 at Hanover, New Hampshire, originally to teach and train native populations for the ministry. By the late 1700s, the majority of the towns we know today along the river were settled.

TRANSPORTATION

Steamboat service from New York to Hartford began in 1822, continuing till 1931. The river valley became the path of railroad and road transportation as it offered the best grade and route. Most stretches of the river have a nearby railroad bed on one side or the other. Bridges for rail—often now abandoned—and highways are common features of the river landscape.

The first bridge over the Connecticut was built in 1785 by Enoch Hale near the site of the present Vilas Bridge in Bellows Falls, Vermont. By 1796, three additional bridges were built: at Springfield, Massachusetts; from Cornish, New Hampshire, to Windsor, Vermont; and from Hanover, New Hampshire, to Norwich, Vermont.

By the early 1800s, most of the original wooden bridges had decayed and been replaced by covered bridges, keeping the timbers and deck dry. A typical toll, for example at Bellows Falls, was Foot Passengers, 3₵; Horse and Rider, 6₵; One horse, Chaise or Sulkey, 12 1/2₵. Farm animals were 1/2₵ each. The current bridge from Windsor to Cornish was completed in 1866 at a cost of $9,000 and remains in use. At 460 feet, it is the longest covered bridge in the United States.

Transportation changed quickly from water to rail, and by the 1850s rail was king. Between 1847 and 1852, rail lines were laid from Boston to Montreal, running through Fitchburg, Massachusetts, Keene, New Hampshire, and Bellows Falls, Rutland and Burlington, Vermont. In Connecticut, the New York, New Haven and Hartford Railroad line began service in the river valley in 1871. The Northern Railroad, meanwhile, reached from Boston to Lebanon, New Hampshire, and Montpelier and Burlington, Vermont. A north-south route went from Greenfield, Massachusetts, upstream to St. Johnsbury, Vermont. Portions of this route are still used by the Connecticut Valley Railroad for the popular steam train route that runs north from Essex. These rail lines dominated transportation until the major highway systems came on the scene in the mid-1900s.

AGRICULTURE AND TIMBER

Agriculture along the river began as subsistence farming. River transportation made it possible to ship grains and wood products. Gristmills and lumber mills sprang up on the tributary streams where water drops were often of a greater height than on the main stem of the Connecticut River. Rail's arrival in the mid-1850s turned many farmers to raising dairy cattle—fresh milk products could then reach the city markets before spoiling. In addition, woolen mills throughout New England opened a large demand for sheep farming. Most of central New England land was cleared and used for farming.

A growing demand for wood products and pulp pushed timber harvesting farther north. Major log drives took place on the river from the early 1860s until 1915. The log drives posed threats to bridges, dams and canals. Competing rights to the river resulted in conflicts between log drivers and the bridge and dam operators. Legislation permitted the drives as long as the logs were under the "immediate care and controul of some person or persons." This control was often tenuous at best. After all, there was no stopping the log drives once they were released into the river. An agreement between competing interests had to be reached for the dams' gates to be opened.

INDUSTRY

In early 1845, an upstart gun shop in Windsor, Vermont, won a federal contract for 10,000 rifles at $10.90 each, with the work to be completed within three years. The Robbins and Lawrence Armory completed the job in eighteen months. In meeting the contract's requirements, the company built a plant from scratch and perfected the use of interchangeable parts on a scale that had never been attempted. The firm also improved the precision of each part to such a point that a rifle could be built from a mass-produced collection of parts rather than having each part hand fitted.

Robbins and Lawrence exhibited both their rifles and new process at the 1851 Crystal Palace Exposition in London, England, and became an instant success. The British Enfield Armory ordered 25,000 rifles and 138 precision machine tools.

Robbins and Lawrence then built a plant in Hartford, Connecticut, with plans to make 325,000 rifles. An initial order of 25,000 was produced, but the follow-up order for 300,000 never materialized, forcing bankruptcy. Through many changes of name and ownership, the business eventually moved to Springfield, Vermont, leading to the develop-

ment of the machine tool industry in the area that became known as Precision Valley.

Today, the Robbins and Lawrence Armory houses the American Precision Museum, tracing the entire development of the machine tool industry in New England and the development of the system of interchangeable parts.

The rifle's development is a major story throughout the Connecticut River Valley. Springfield, Massachusetts, became the site of the U.S. Armory, controlling the development of the Springfield Rifle and many other weapons systems until its closing in the 1960s. The facility is now being redeveloped as a community college and business center. The U.S. National Park Service preserves part of the original armory and parade grounds as a museum.

Downstream, in Hartford, where Robbins and Lawrence went bankrupt, Samuel Colt made a name for himself with the Colt 45. The Colt plant, now a National Historic Landmark, also is being redeveloped and is a prominent feature on the Hartford skyline, with its blue onion-shaped dome given by a Russian czar in appreciation for Colt weapons.

These three cities—Windsor, Hartford, and Springfield—along the Connecticut River all produced weapons and became central players in developing precision industrial machinery now used worldwide.

In addition, significant mill centers sprung up using waterpower from the Connecticut and its tributaries. Bellows Falls and Turners Falls were once centers of paper production. Holyoke was planned as an industrial city with a series of canals fed from the river. Initially, woolen mills were the primary projects, but paper soon followed as the area's major product and Holyoke became known as the Paper City of the World. Many mills are still standing, some remaining in use for production or distribution.

ELECTRIC POWER

With industry's growth and the increased population, hydroelectric power came to prominence and the Connecticut River was a natural source of energy.

Vernon Station, near Brattleboro, went on line in 1909 with eight two-megawatt turbines. Two more were added in 1910, and two larger units in 1921, bringing the total capacity to twenty-seven megawatts. Several of these generators are still operating, a testament to both skill in construction and maintenance. Four replacement generators were added in 2008, bringing capacity to thirty-four megawatts. Vernon Station was the first plant to sell electricity across state lines, feeding towns in southwestern New Hampshire, as well as Fitchburg and Gardner, Massachusetts.

Bellows Falls Station was developed for hydroelectric power in 1928 with three generators capable of producing forty-nine megawatts. Comerford Station, near Monroe, New Hampshire, one of the largest construction projects of its time, was switched on from the White House by President Hoover in 1930. Housing four generators, it was capable of generating 164 megawatts. The last and largest dam on the Connecticut was Moore Station, near Littleton, which went on line in 1957 with a capacity of 200 megawatts.

While milestones in their time, all of the hydroelectric plants in the New Hampshire–Vermont section of the river together do not equal the capacity of Vermont Yankee nuclear plant's 650 megawatts, which went on line in 1972. Vermont Yankee has recently extended its license and been permitted to increase its thermal discharge.

There is no completely pollution-free or hazard-free source of energy. Whenever power is produced, the environment will be affected in some way. Choices must be made, and those choices are critical to providing energy and to protecting the delicate balance of the environment. Hydroelectric power and nuclear power are only two among many

energy choices. Their differing impacts on the Connecticut River are very significant.

Hydroelectric power is renewable and does not in itself produce pollution. However, it does change the character of the river. We don't remember the free-flowing days. Habitats, particularly fisheries, have been radically changed. Elimination of the salmon runs is only the most visible example of how the river has been affected by dams.

Flood control is a side benefit that comes with hydroelectric power dams. And the dams enhance many forms of river recreation, particularly boating and some forms of fishing. Yet, the opportunity for white-water sports has been reduced. There are trade-offs.

Environmental concerns are gaining a greater voice in the relicensing of existing dams and in efforts to remove dams no longer needed. Relicensing agreements generally require higher minimum flows, which will benefit the fish populations.

Nuclear power does not produce greenhouse gases like coal- and oil-fired plants. It does, however, produce thermal pollution as a result of the river water being used for plant cooling. The possibility of radioactive release from plant failure is a well-known risk. And the storage of spent fuel near the river is a danger that may be eventually relieved if a federal high-level radioactive waste storage facility elsewhere becomes operational.

We continue to need a viable national energy plan that recognizes the realities of diminishing fossil fuels, the urgent need to reduce CO_2 emissions, the aging of current nuclear plants and our increasing demand for energy.

RIVER RESTORATION

By-products from industrial manufacturing and agricultural sources, both in animal waste and fertilizer runoffs, mixed with the wastewater from a growing population in the area's cities and towns, once created a potent blend of pollution.

Much of the Connecticut River became unsafe for swimming. Many areas also were unsafe for fishing and boating. In cities, such as Springfield and Hartford, interstate highways were built right on the river's banks, cutting off or minimizing public access to the river. The river itself was neglected and abandoned. The once beautiful river became a raging sewer—running for hundreds of miles.

In the 1950s and 1960s public interest in the earth's stewardship began to build, leading to the creation of many organizations to support environmental issues. By the early 1970s the Federal Clean Air and Water Act mandated action to reduce water pollution and provided 85 percent federal funding for cleanup projects along the river. High on the list were wastewater treatment plants to halt the discharge of sewage into the river.

As the river has once again become suitable for recreation in many areas, cities up and down the river are benefiting. They are finding that a clean riverfront is a major business and tourist attraction.

The Hartford Riverfront Recapture is one of the largest projects, creating parks and boat landings on both sides of the river, an amphitheater and a walkway across the river connecting to downtown. Cruise boats add to the river access.

Old bridges and rail lines are being converted to bike paths and walkways, such as the Connecticut River Greenway State Park in Northampton, Massachusetts. And Springfield is building new public parks on the riverbank downtown.

Up and down the Upper Valley area, towns are planning Connecticut River Way Point visitor centers. They will highlight local history in the context of the river. Vermont's exhibits will be at Brattleboro, Bellows Falls, Windsor, White River Junction, Fairlee, Wells River and St. Johnsbury. New Hampshire's Way Point towns include Claremont, Woodsville, Lancaster and Colebrook.

In 1998, Vice President Al Gore announced the designa-

tion of the Connecticut River as an American Heritage River, providing more funds for local initiatives aimed at cleaning up the river and increasing the opportunities for recreation.

SILVIO O. CONTE NATIONAL FISH AND WILDLIFE REFUGE

Recognizing the critical importance of the Connecticut River Watershed, a new approach to wildlife management was initiated in 1997 with the creation of the Silvio O. Conte National Fish and Wildlife Refuge. The name honors long-time U.S. congressman Silvio O. Conte, who served western Massachusetts from 1959 to 1991 and championed many environmental causes.

The watershed is simply too large, diverse, populated and fragmented to be walled off as a national park. And, for so many ecological, economic and recreational reasons, it is also too important to be left alone.

So the best solution is a kind of embedded "national park," where all the many interested parties can work together to manage and protect the many aspects of the watershed, including fish and wildlife, native plants, habitat, control of invasive species, recreation and the conservation of public and private lands throughout the entire 7.2-million-acre Connecticut River watershed.

The refuge works in partnership with many individuals and organizations to develop and implement long-term plans for the watershed.

And the refuge operates three visitor centers highlighting river and habitat issues: The Great Falls Discovery Center at Turners Falls, Massachusetts; exhibits at the Montshire Museum of Science in Norwich, Vermont; and a visitor center at Colebrook, New Hampshire.

ACKNOWLEDGMENTS

Along my way, the Connecticut River Watershed Council provided invaluable help, ideas, and publications. In particular, the council's book, *The Complete Boating Guide to the Connecticut River,* has been my constant companion. It covers every turn and point of interest along the river. In addition to landmarks and water conditions, the guide offers detailed information on points of historic and environmental interest.

Many authors have provided me with insight and inspiration, but perhaps the best example is Michael Tougias' book *River Days, Exploring the Connecticut River from Source to Sea.* This narrative of his canoe trip on the navigable stretches of the river includes a wealth of historical information. While enjoying this tale of his journey, I came to a photo of the Cornish-Windsor Bridge with sunlight on the north side and Mt. Ascutney in the background. That led to an early morning trip in June when the sun rose at its earliest. It also opened up my awareness of other bridges, including the historic Schell Bridge in Northfield, which were lit by the early summer morning light.

I found that two significant bridges had been built and donated by individuals: the Schell Bridge in Northfield and the Vilas Bridge in Bellows Falls. The latter had been built by a gentleman from Alstead and donated to the towns of Rockingham, Vermont, and Walpole, New Hampshire. The 1931 dedication plaque includes a section of the poem *The Bridge Builder* by Will Allen Dromgoole:

There followeth after me to-day
A youth whose feet must pass this way
This stream that has been such a joy to me
To the fair-haired youth might a pitfall be

He, too, must cross in twilight dim
Good friend, I am building this bridge for him.

I thank Charles Nathaniel Vilas for the wisdom and generosity of his beautiful double-arch bridge at Bellows Falls.

Likewise, many people have helped me along the way as I worked on this book. I enjoyed exploring the river and North Country with my family. Early on, my oldest son, Mark, led the way through rain, mud and moose tracks on our first visit to the Fourth Connecticut Lake. Kathryn, my daughter, helped me find the vantage points over Bellows Falls on the side of Fall Mountain. And my son Dan worked to critique the early drafts and has been a great camping companion, hiker and moose finder on many North Country trips.

Martha Bauman, my Keene neighbor, helped edit the text and made suggestions. Pam Wagner, in Austin, has been a great help in reviewing the book and in helping me work with the English language.

I have enjoyed working with Chelsea Gwyther and the Connecticut River Watershed Council for many years on this and other projects. I especially thank Chelsea for her afterword to this book that so clearly identifies the issues we face in conserving the river.

Judy Preston of the Tidewater Institute in Old Saybrook was helpful in guiding me to significant locations in the lower river area and in identifying important topics and species. Pilot John Hall, of Chester Charter, gets a big credit for the aerial images. He was able to put me in the right positions for all my planned shots and many more.

I can't thank Leslie Starr at Wesleyan University Press enough for her insight, suggestions and collaboration in shaping this book in such a constructive manner. And my sweetheart, Sandra Braden, has been so supportive in discussions and proofreading and living with my sometimes singular focus.

Thanks so much to all for all the help along the way. Any remaining errors and omissions belong to me.

CONCLUSION

I have enjoyed the journey of discovery, which led to this book—a brief view of so many different aspects of the river.

There are countless ways to enjoy the Connecticut River and preserve it for future generations. Each and every reader will have a different path, a different experience and perhaps a varied perspective.

Cheers and good weather to you along the way!

Al Braden

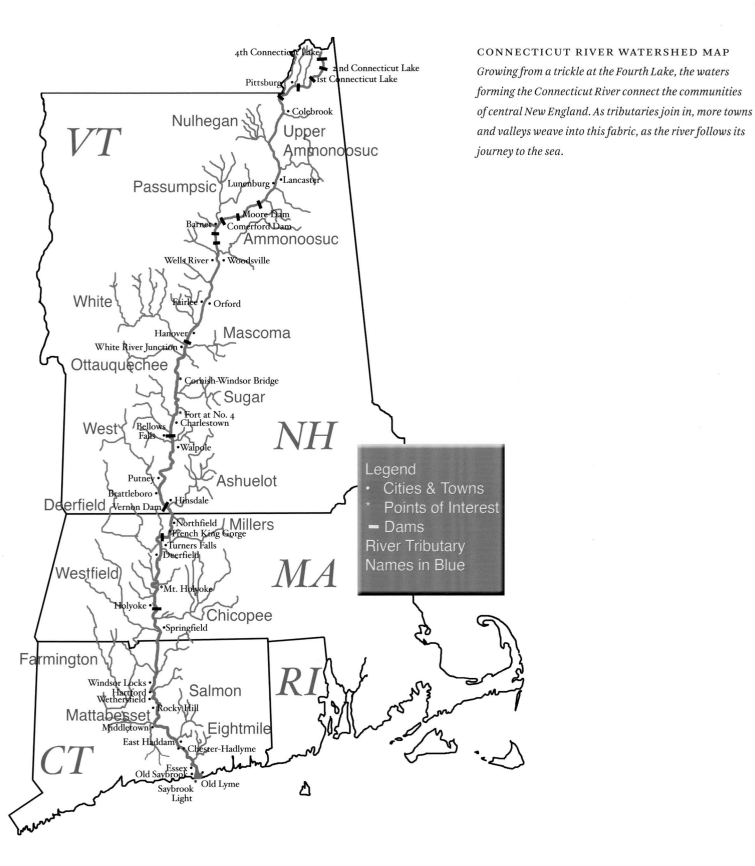

CONNECTICUT RIVER WATERSHED MAP

Growing from a trickle at the Fourth Lake, the waters forming the Connecticut River connect the communities of central New England. As tributaries join in, more towns and valleys weave into this fabric, as the river follows its journey to the sea.

4th Connecticut Lake

2nd Connecticut Lake

1st Connecticut Lake

Pittsburg

• Colebrook

VT

Nulhegan

Upper Ammonoosuc

Passumpsic

Lunenburg • • Lancaster

Moore Dam

Barnet • Comerford Dam

Ammonoosuc

Wells River • • Woodsville

White

Fairlee • • Orford

Hanover •

Mascoma

White River Junction •

Ottauquechee

NH

* Cornish-Windsor Bridge

Sugar

* Fort at No. 4

West

• Charlestown

Bellows Falls

• Walpole

Putney •

Ashuelot

Brattleboro •

Deerfield

Vernon Dam • Hinsdale

• Northfield

Millers

• French King Gorge

• Turners Falls

• Deerfield

Westfield

Legend
• Cities & Towns
* Points of Interest
▬ Dams
River Tributary
Names in Blue

MA

* Mt. Holyoke

Holyoke •

Chicopee

• Springfield

Farmington

RI

Windsor Locks •

Salmon

Hartford •

Wethersfield •

Mattabesset

• Rocky Hill

Middletown •

Eightmile

East Haddam •

• Chester-Hadlyme

CT

Essex •

Old Saybrook •

* Old Lyme

Saybrook Light

The Photographic Journey

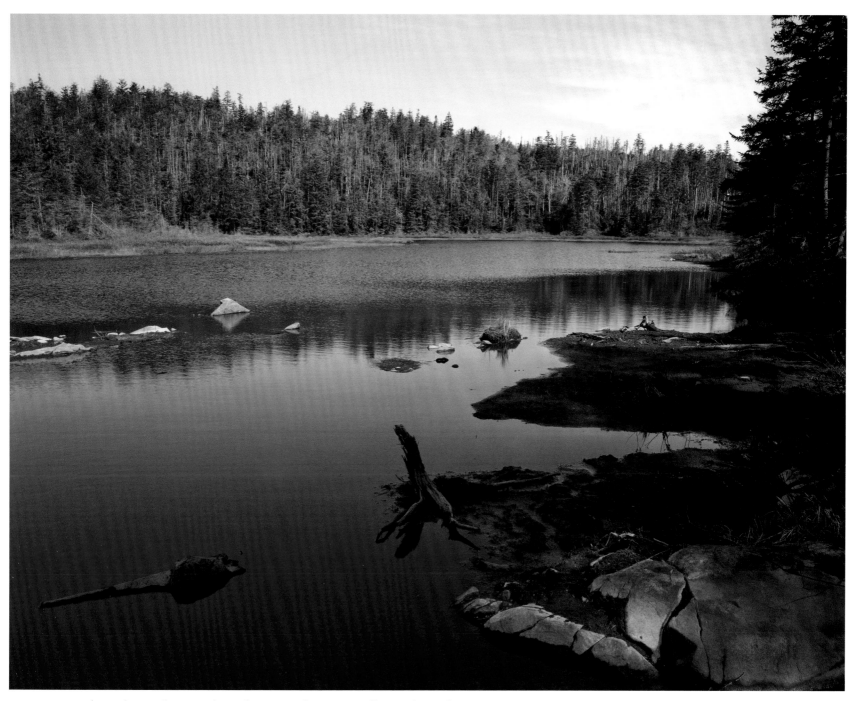

Morning at the Fourth Connecticut Lake. Start at the U.S.-Canadian Border Station
on Route 3 in Pittsburg, New Hampshire, and hike forty-five minutes uphill to the west.
Follow the trail markers along the border with Quebec.

Narrow enough to step across, the Connecticut River starts as a small stream, quickly vanishing into the underbrush on its way downhill to the Third Connecticut Lake. In its first mile, the river drops roughly 400 feet.

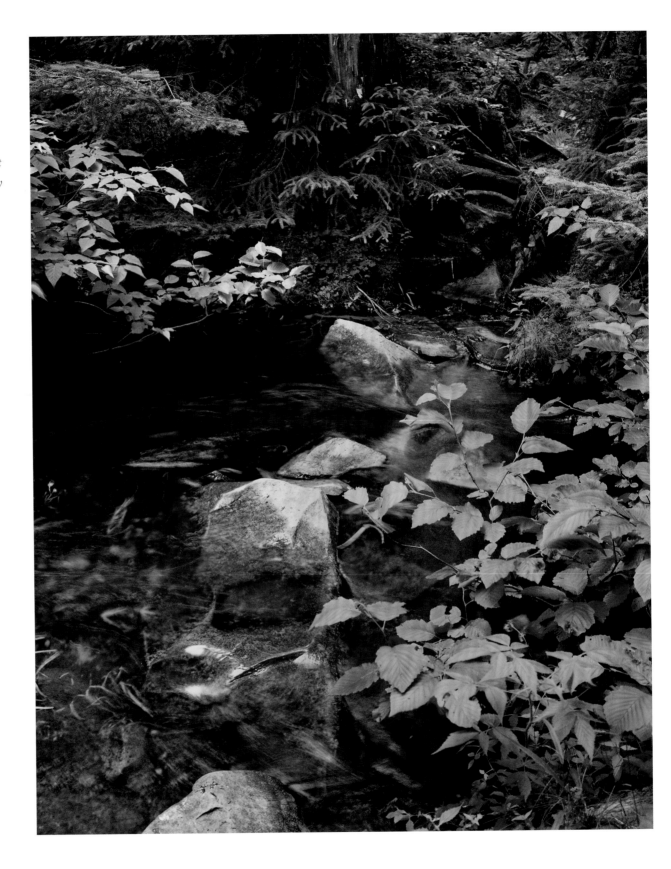

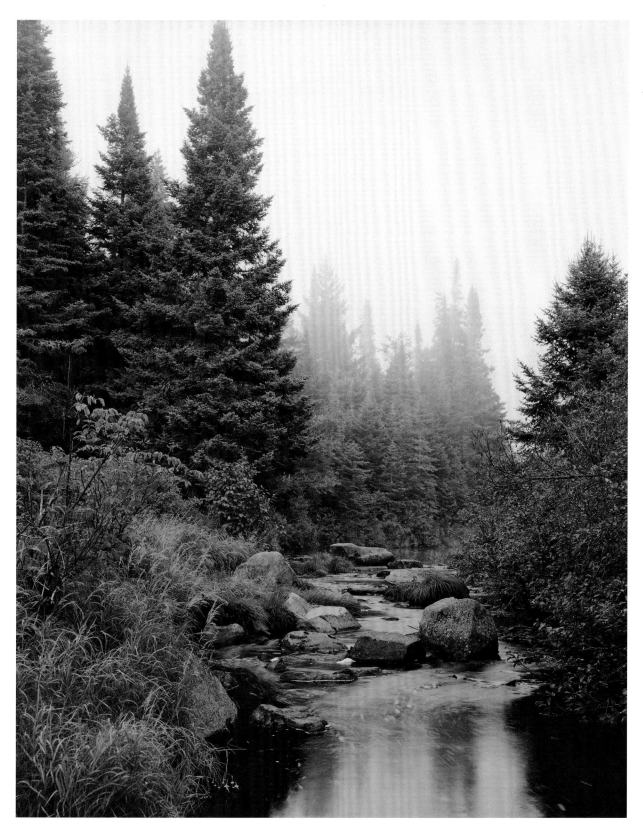

Winding from Moose Bog to the Second Connecticut Lake, the river grows to a dozen feet in width as it passes Deer Mountain Campground in northern New Hampshire.

We didn't find moose this morning, but Moose Bog is always a prime spot for these impressive inhabitants of the Great North Woods.

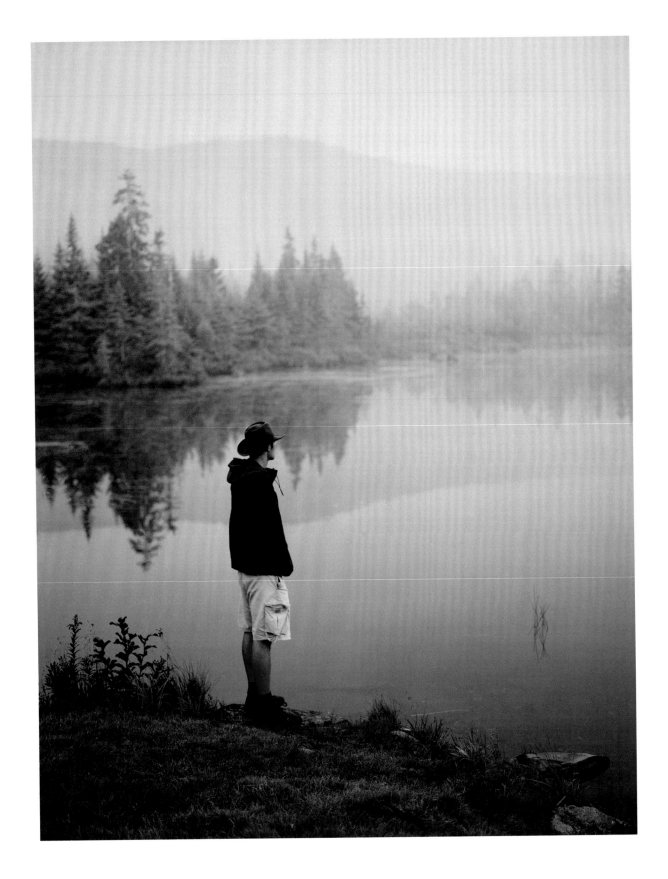

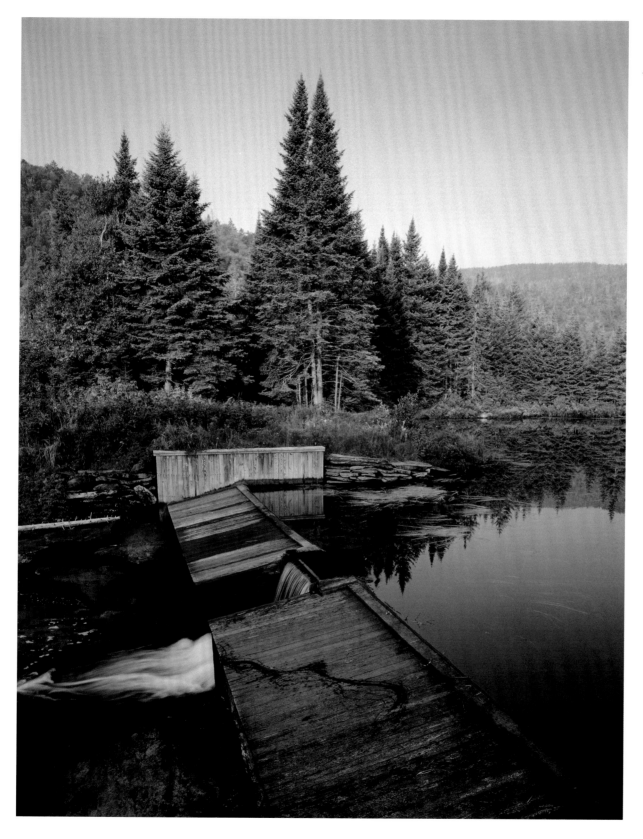

Moose Falls Dam creates about twenty-five acres of prime brook trout habitat as well as a home for moose, fox and a variety of northern birds.

In the early morning mist, Scott Stream approaches the northern end of the Second Connecticut Lake. Upstream, Scott Bog is a one-hundred-acre fly-fishing pond for brookies as well as prime moose country.

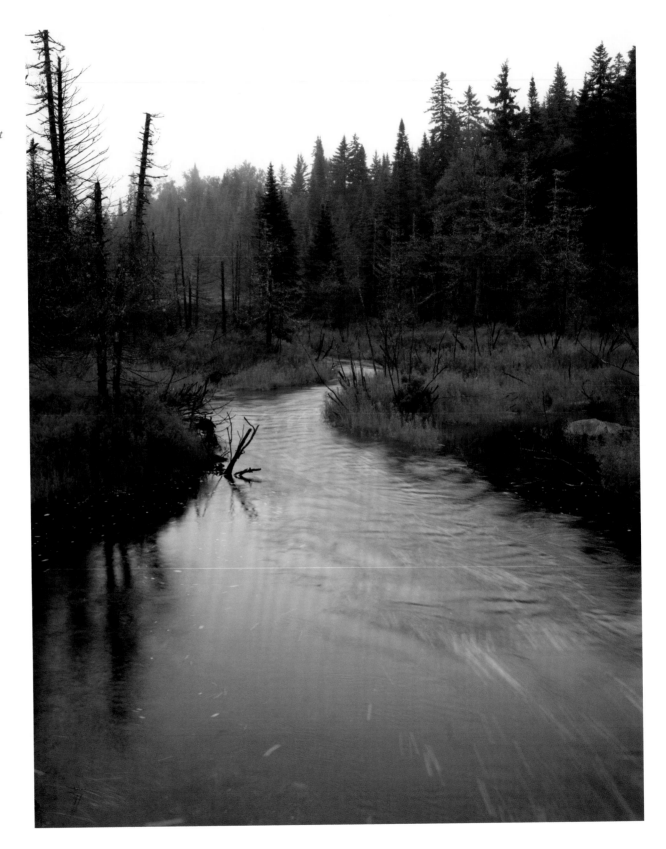

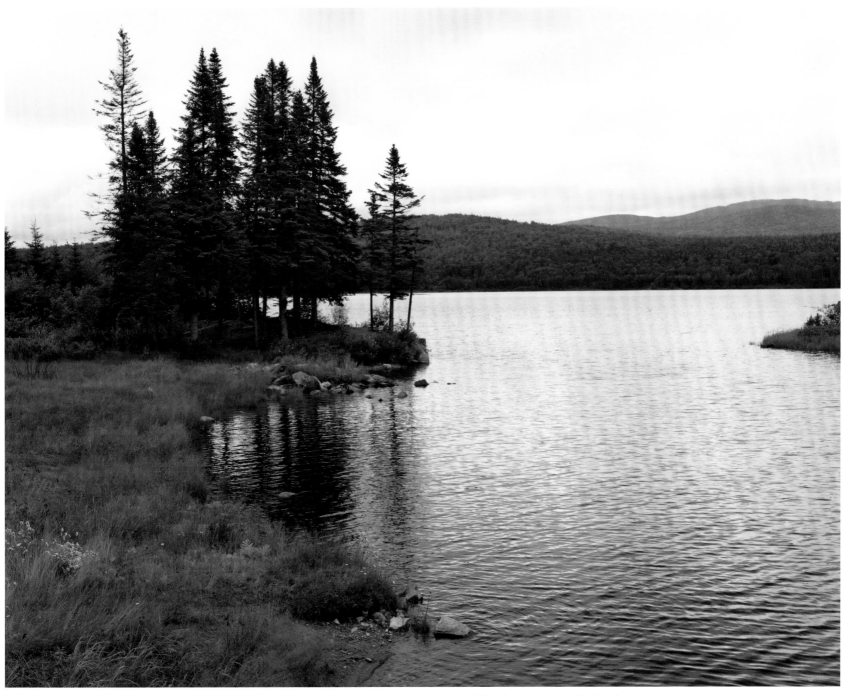

The dams at Connecticut Lakes and Lake Francis in Pittsburg, New Hampshire, control flow for power dams farther downstream.
The Second Connecticut Lake is beautiful natural country, well north of power lines and cell towers. Over sixty feet deep, it is home
for lakers and landlocked salmon. They can occasionally be taken with deep gear in the summer, but the prime season is just after
ice-out or through the ice from January through March.

The dam at the First Connecticut Lake forms New Hampshire's fifth largest lake at 2,800 acres. It reaches depths of 160 feet. Here lake trout and landlocked salmon stay down deep in the summer. Winter's ice fishing season and early spring ice-out are the times to fish. With its deep discharge point, the outflow of the lake remains cool all summer, supporting an excellent fly-fishing trout stream below. With a landmark 2003 agreement, 171,000 acres surrounding the lake are now preserved as the Connecticut Lakes Headwaters Working Forest.

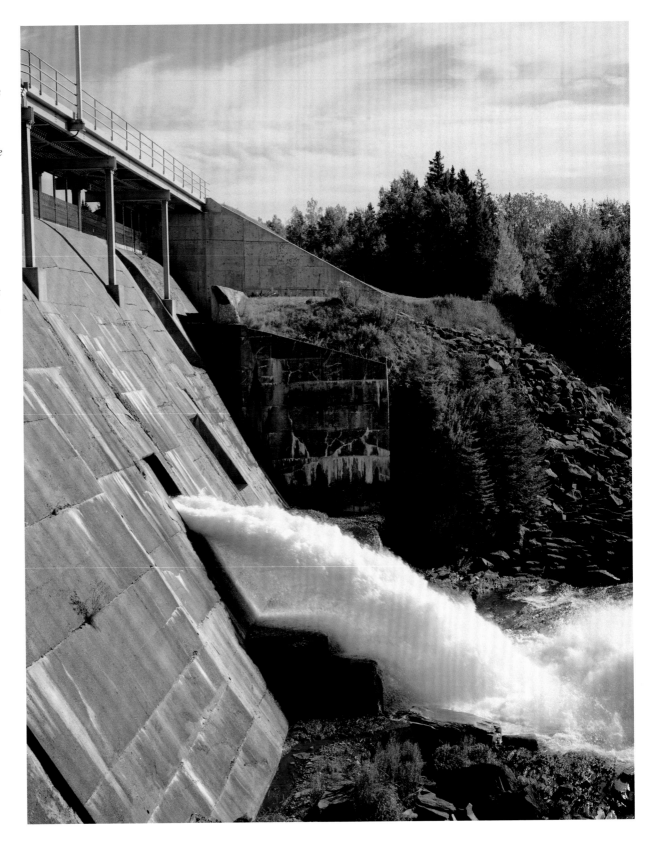

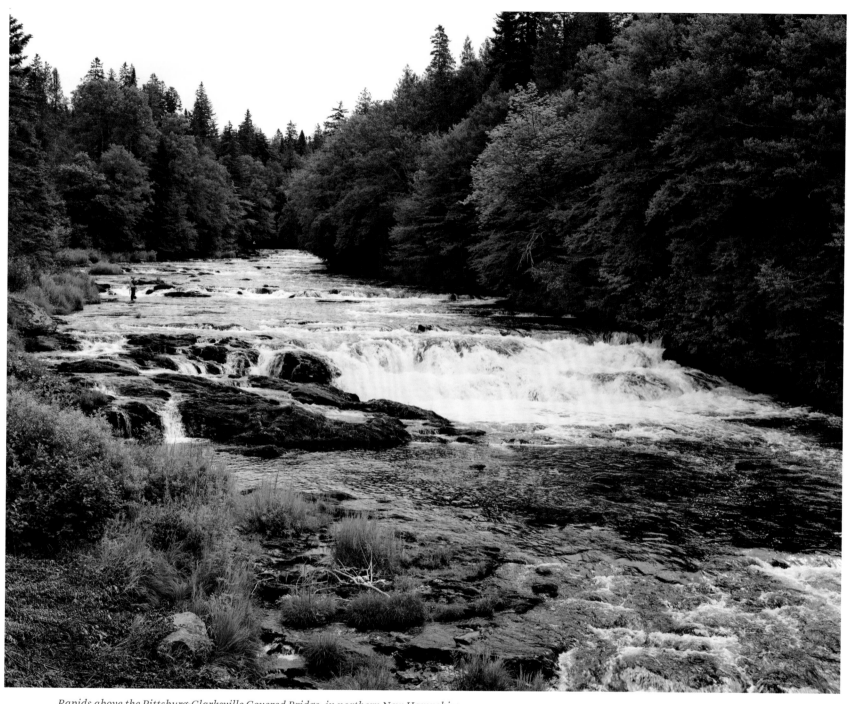

Rapids above the Pittsburg-Clarksville Covered Bridge, in northern New Hampshire, offer prime trout habitat in a free-flowing section of the river.

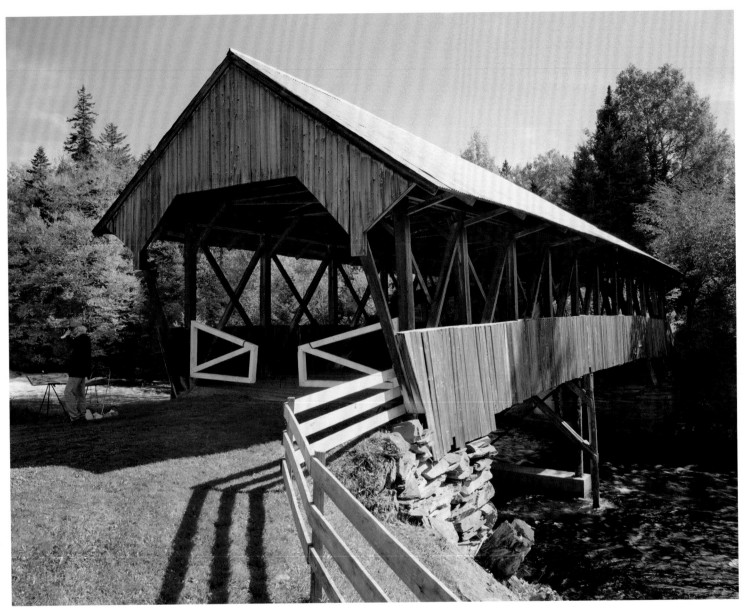

Always a popular spot, the Pittsburg-Clarksville Bridge (also known as the Bacon Road Bridge) is the northernmost covered bridge on the Connecticut River. It is 88.5 feet long with a span of 70 feet. Its date of construction is uncertain, but in 1878 Pittsburg requested partial payment for its cost from Clarksville and was turned down. The two New Hampshire towns now contribute jointly to its upkeep.

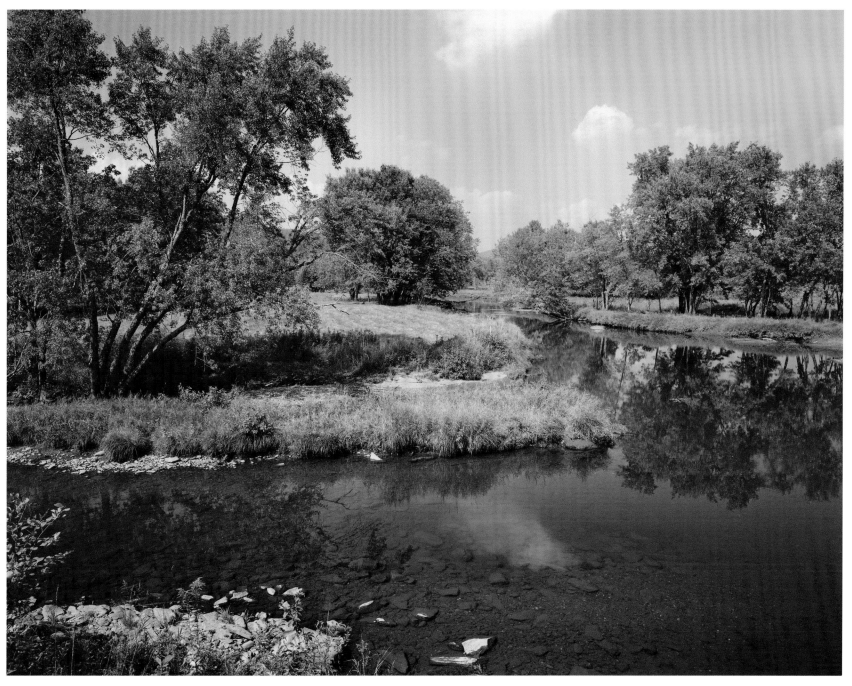

Indian Stream is the westernmost of the three northern tributaries of the Connecticut River and gained notoriety in 1832 when the local inhabitants declared themselves an independent republic, complete with their own militia. They joined New Hampshire in 1840, settling disputes about which tributary streams constituted the border with Canada. Indian Stream is home to brook trout; near the confluence with the Connecticut, browns and rainbows are also found.

The Connecticut River gains size and speed after picking up Perry Stream and Indian Stream on its way to Beecher Falls, Vermont.

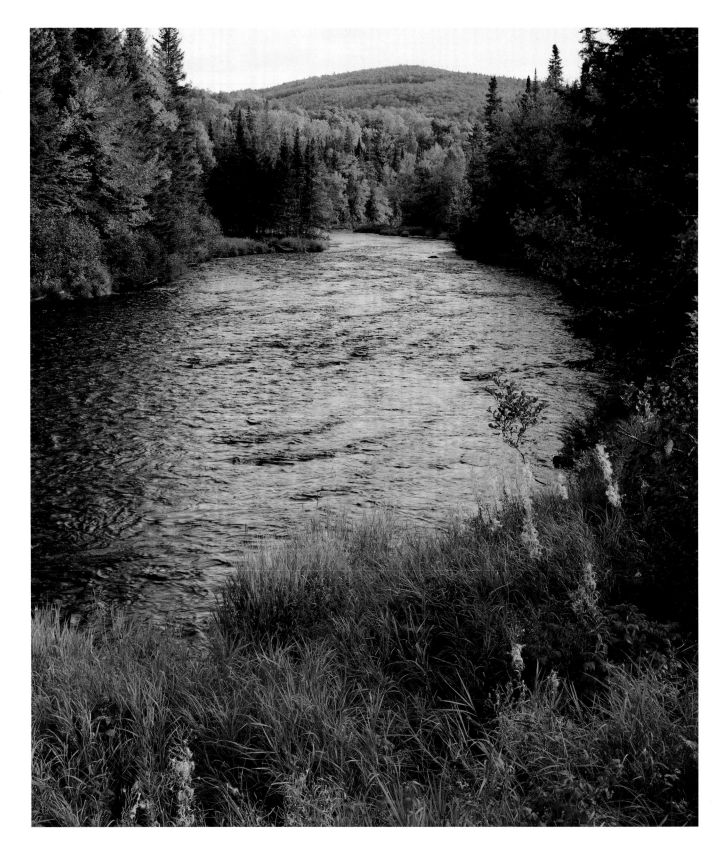

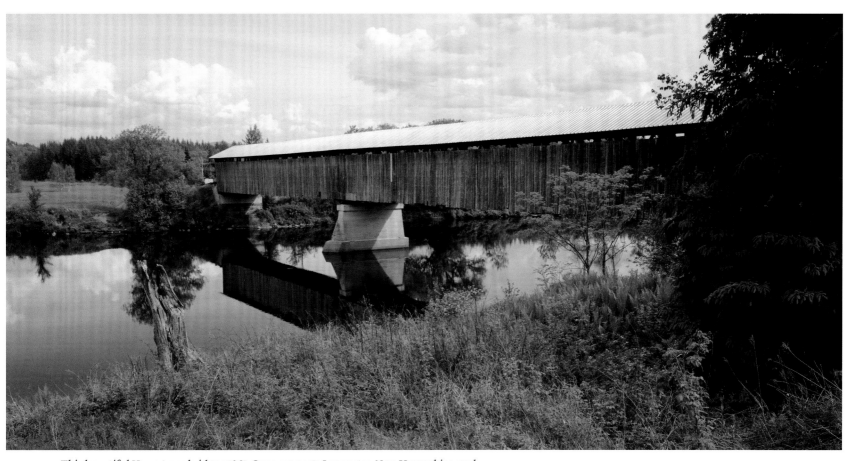

This beautiful Howe truss bridge at Mt. Orne connects Lancaster, New Hampshire, and Lunenburg, Vermont. Constructed in 1911 at a cost of $6,678, it replaced an earlier bridge that had been destroyed by a logjam in 1908. It is 260 feet long with clear spans of 127 and 126 feet. It was revitalized and rededicated in 1983 and continues in active use.

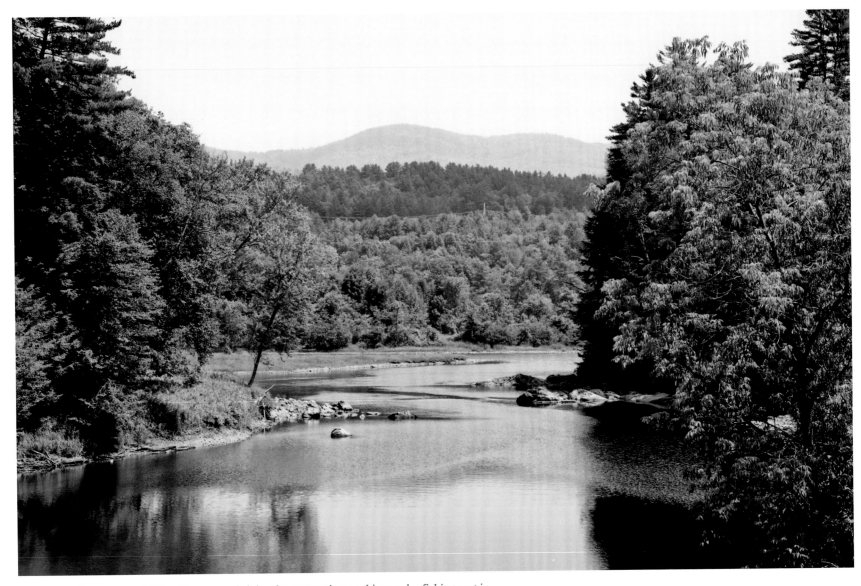

The Passumpsic River (foreground) joins the Connecticut at this popular fishing spot in Barnet, Vermont, marking the southern end of the Connecticut River's travel through the Great North Woods and the transition to the fertile Upper Valley. Until reaching the Massachusetts border, the river forms the boundary between New Hampshire and Vermont. As established by King George II in 1764, New Hampshire's territory extends to the western shore.

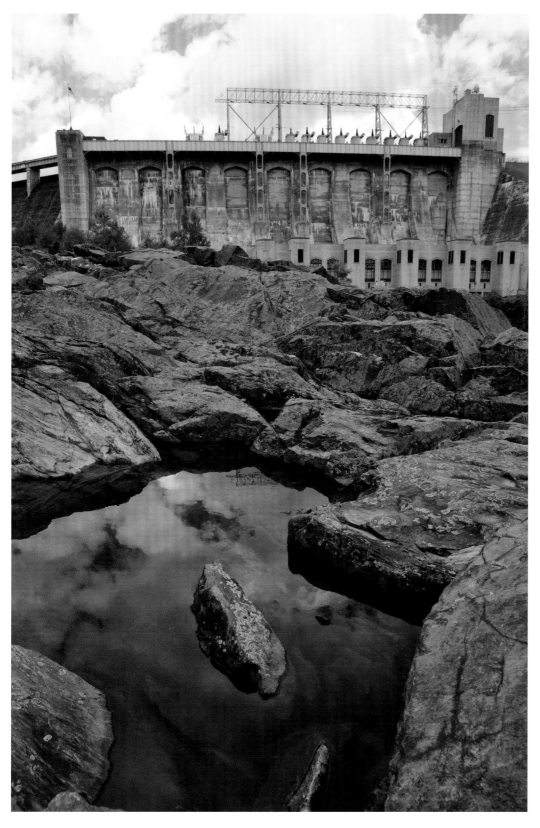

Comerford Dam, with a generating capacity of 164 megawatts, was switched on line in 1930 by Herbert Hoover, as the first in a chain of three dams on the Fifteen Mile Falls.

The dam provides flood control and hydroelectric power generation. Its reservoir stretches upstream over seven miles and covers nearly 1,100 acres.

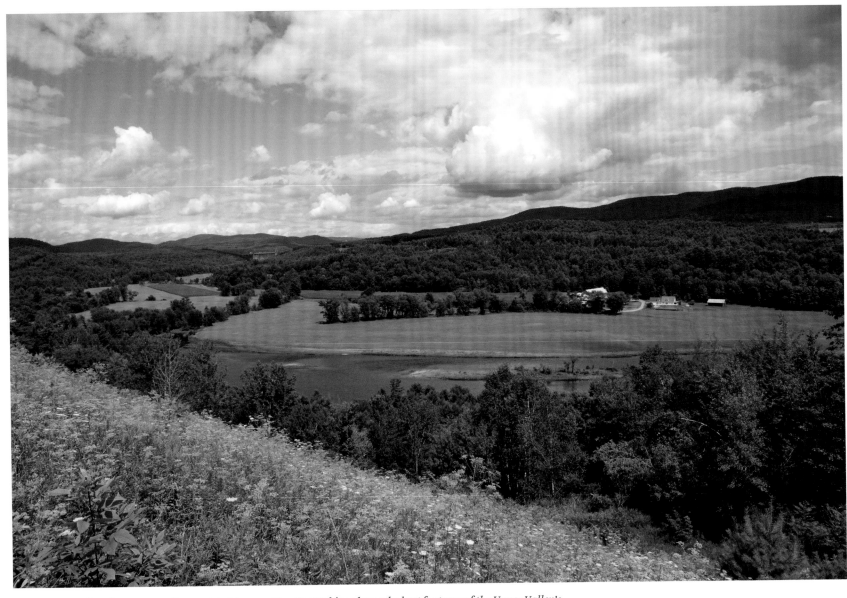

Looking from Barnet, Vermont, to Monroe, New Hampshire, shows the best features of the Upper Valley's fertile farmlands. Family dairy farms, passed down for generations, are common. Corn and hay are primary field crops. The Passumpsic River has just joined the Connecticut River a few hundred yards upstream. This land was near the upper end of Glacial Lake Hitchcock, which extended to St. Johnsbury, Vermont.

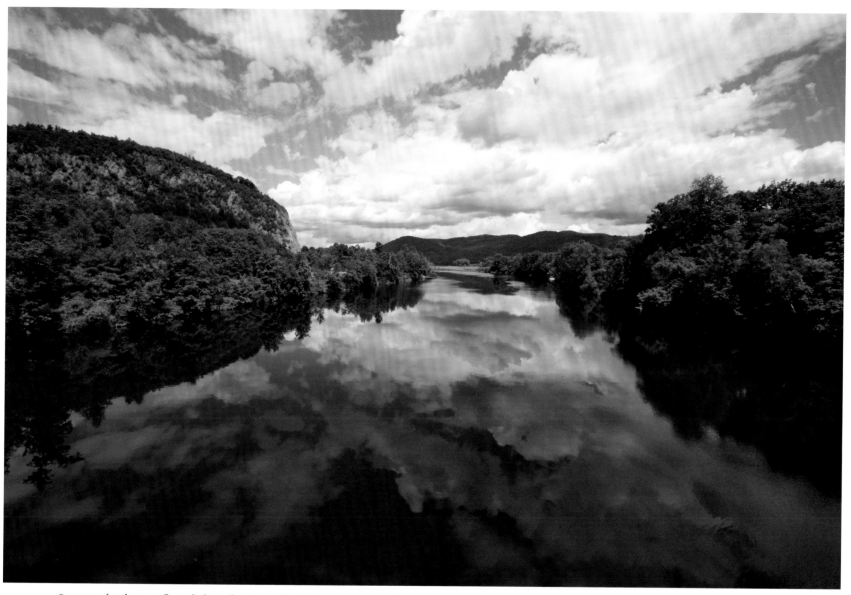

Summer clouds are reflected along the Connecticut River between Fairlee, Vermont, and Orford, New Hampshire. Peregrine falcons nest in the Palisades at Fairlee, on the left. At this site in 1793 Captain Samuel Morley of Orford first demonstrated the use of steam-powered navigation on the Connecticut River. Through a friend, the idea was shown to Robert Fulton who built on it and received much of the credit and success. Orford features a ridge of seven historic estate homes, including Morley's.

*A summer day is the
perfect time for a swim
in the Connecticut River
at Dartmouth College in
Hanover, New Hampshire.
The college was founded in
the far northern wilderness in
1769 with a royal charter from
King George III. It has been
associated with the river ever
since Dartmouth student John
Ledyard fashioned a log canoe
in 1772, dropped out of school
and became a noted world
explorer.*

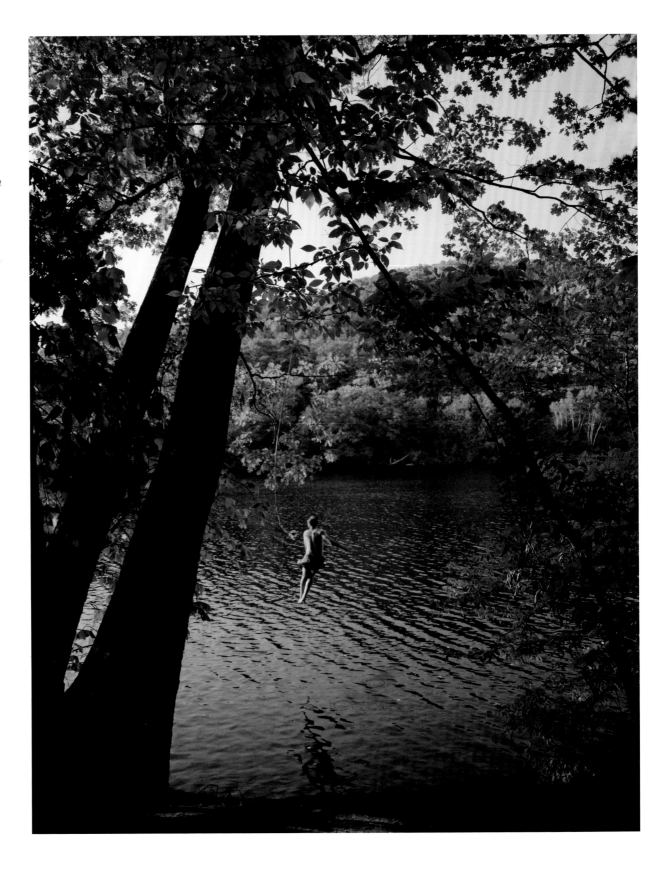

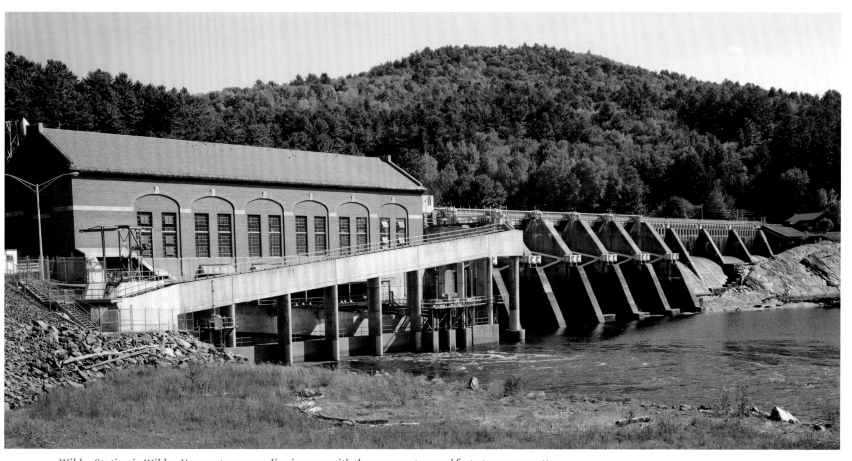

Wilder Station in Wilder, Vermont, came on line in 1950 with three generators and forty-two megawatts of capacity. Its control room also remotely controls the turbines at Bellows Falls and Vernon, Vermont.

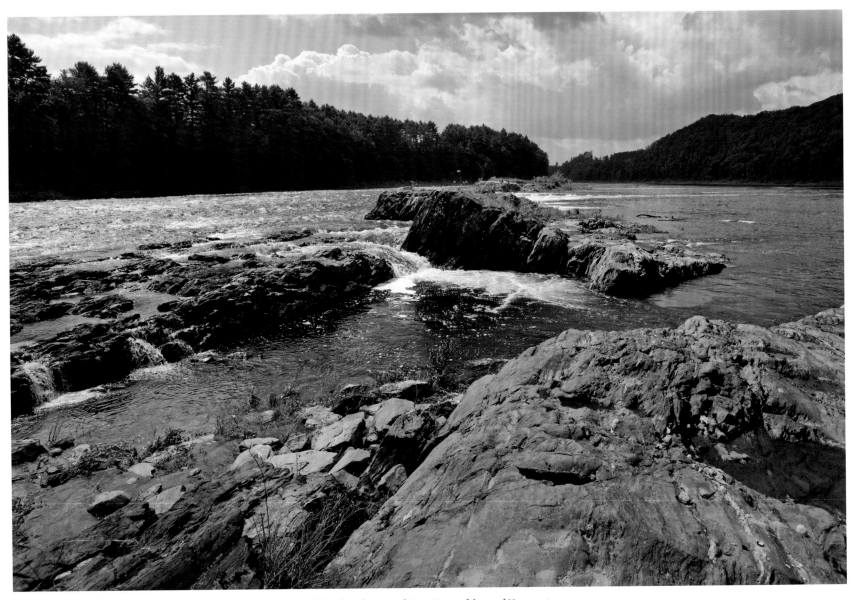

Sumner Falls is on the only remaining wild stretch of the river in central New Hampshire and Vermont. Near Hartland, Vermont, it was once considered for hydroelectric development, but that is now unlikely as the economic and environmental considerations have changed. It is a popular spot for kayaking, and Dartmouth students call it their "home rapids."

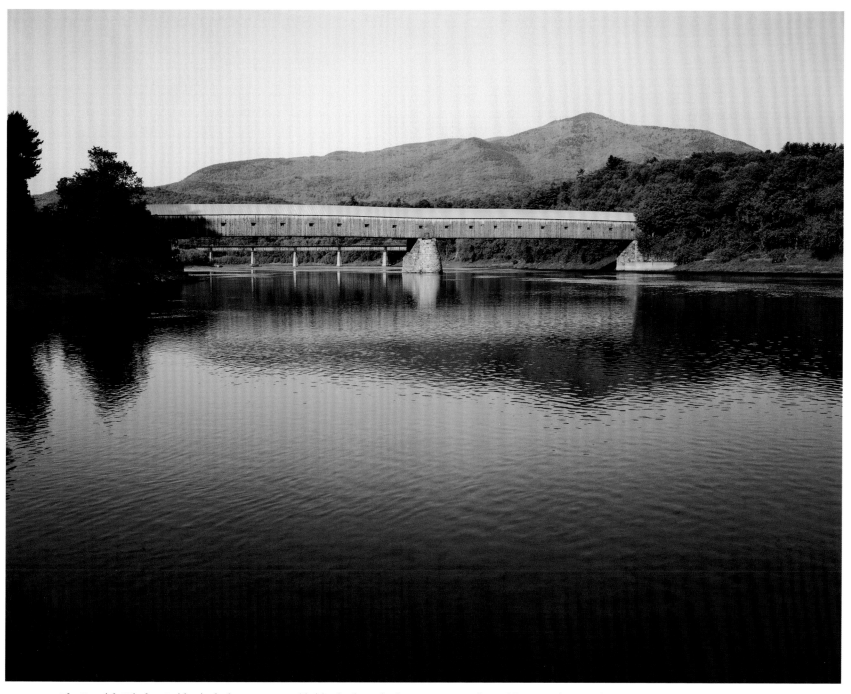

The Cornish-Windsor Bridge is the longest covered bridge in the United States at 449.5 feet, with spans of 204 and 203 feet. Built in 1866 for $9,000, this Town lattice truss design has stood the test of time. After reconstruction in 1989, the bridge has been in daily use for vehicles up to ten tons. Looking south toward Mt. Ascutney, Vermont, it is lit by the morning sun in early June.

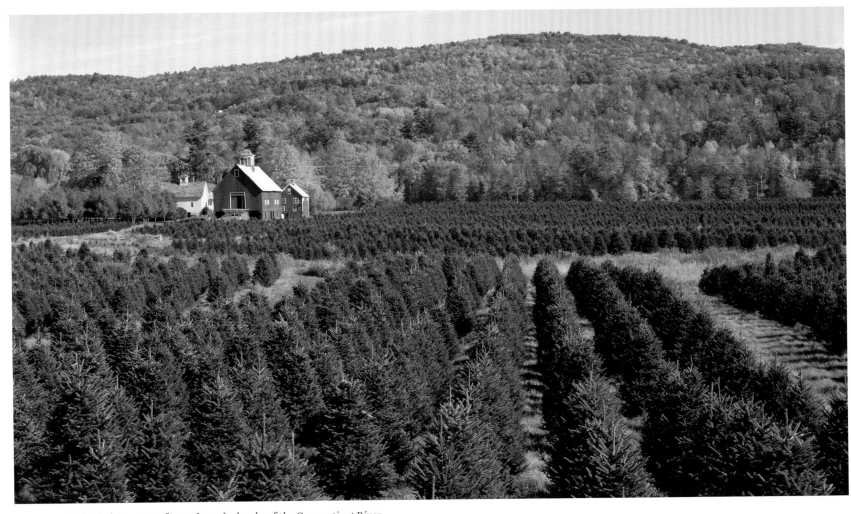

This Christmas tree farm along the banks of the Connecticut River near Ascutney, Vermont, offers an ideal fall setting.

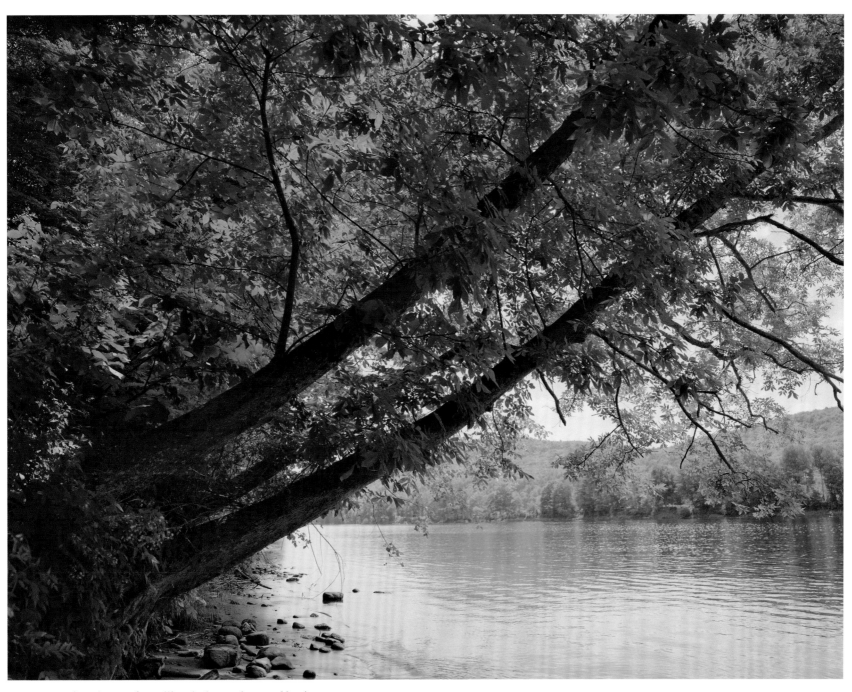

A favorite spot for pulling the boat ashore and having lunch under the shade during the summer, this is a bank of the Connecticut River near Charlestown, New Hampshire.

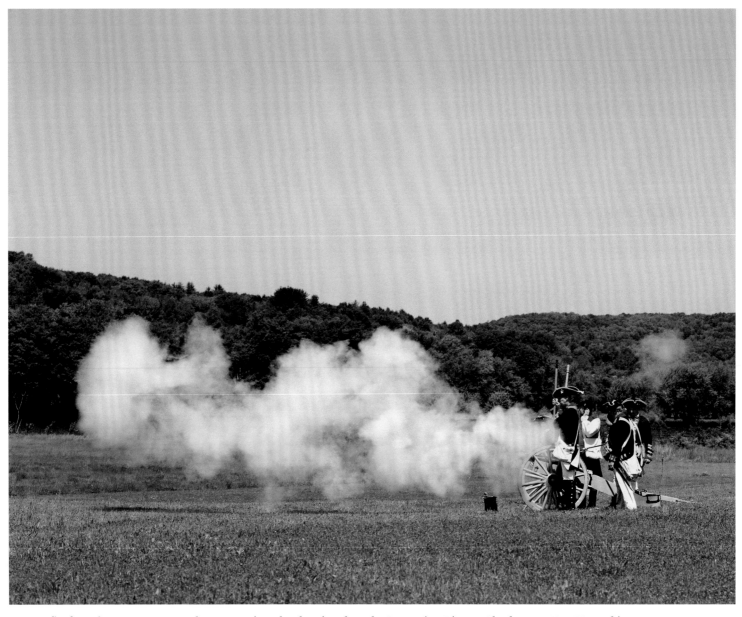

Cannon fire from the Fort at No. 4 caught my attention when boating along the Connecticut River at Charlestown, New Hampshire.

(opposite)
Fort at No. 4, at Charlestown, New Hampshire, recreates the life of an eighteenth-century English settlement along the banks of the Connecticut River. Originally settled in 1740, the fort was the northernmost English outpost during the French and Indian War. The nearest settlements were Fort Dummer, near Brattleboro, Vermont, and Deerfield, Massachusetts.

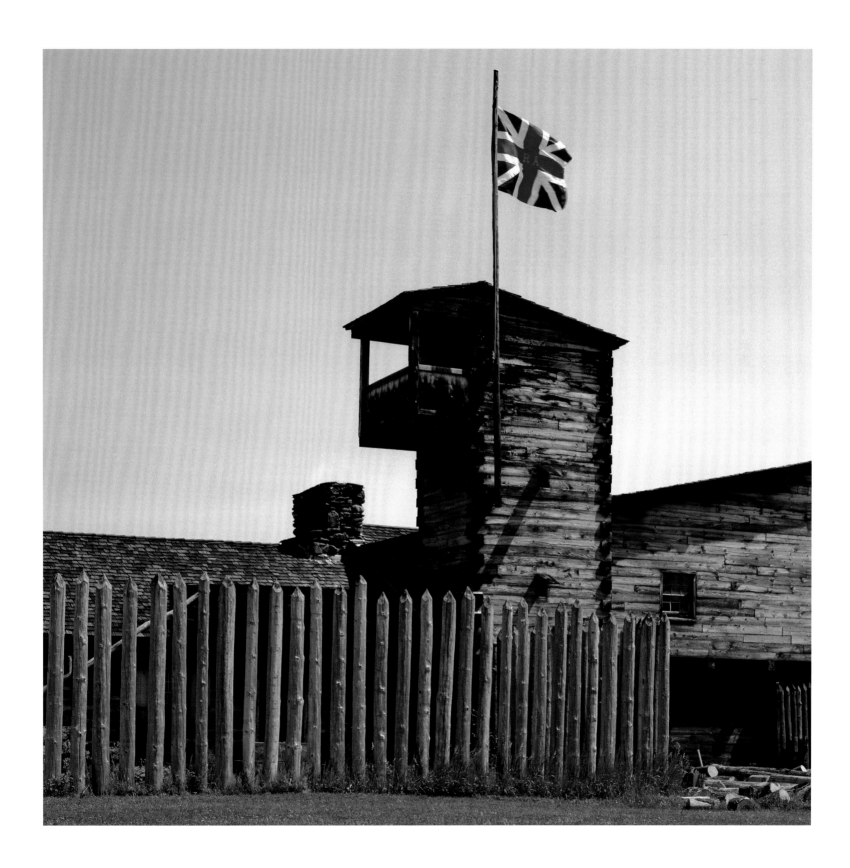

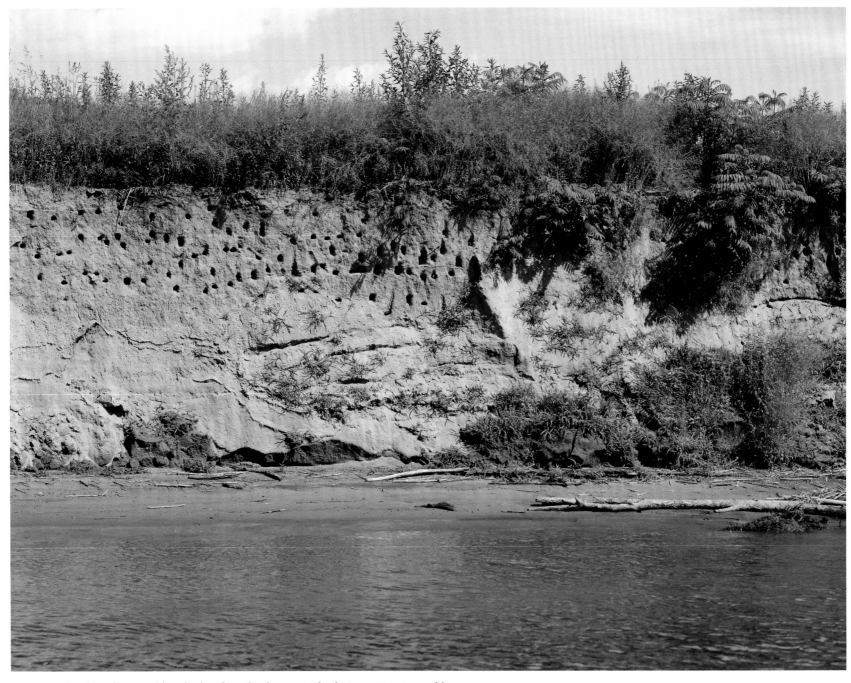

Bank swallows nest in colonies along the river near Charlestown, New Hampshire.

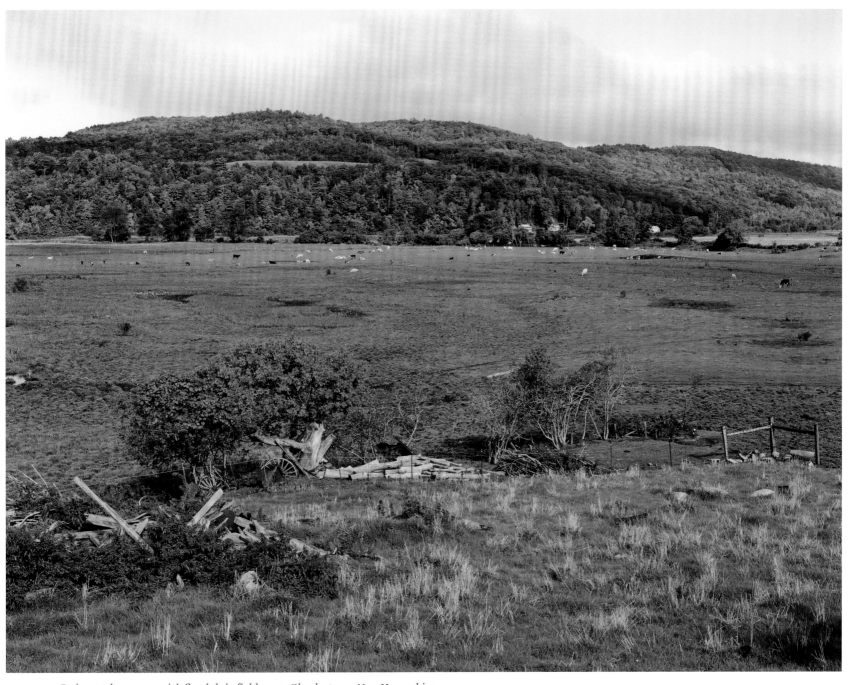

Dairy cattle graze on rich floodplain fields near Charlestown, New Hampshire.

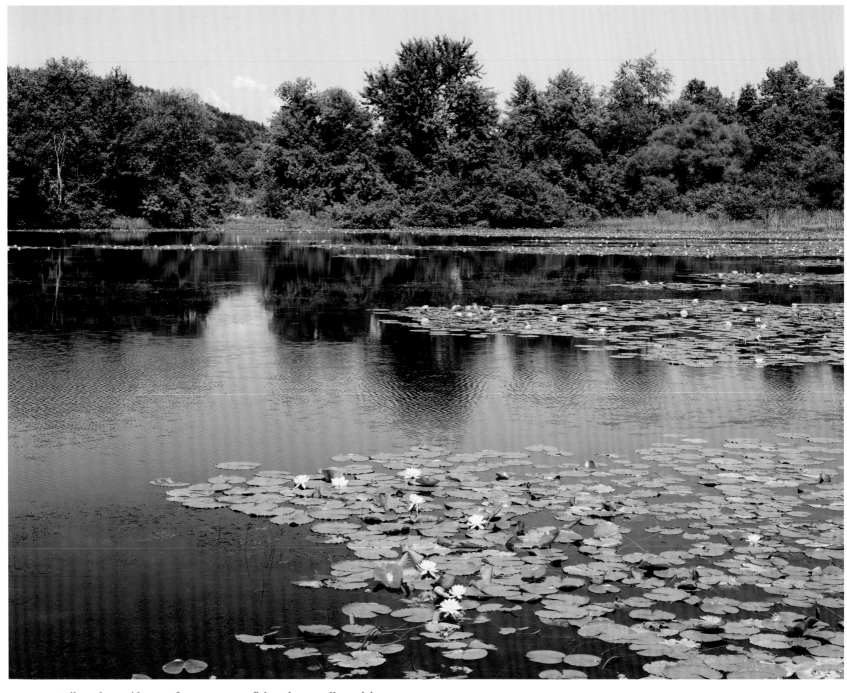

Lily pads provide cover for warm-water fish such as smallmouth bass and perch near North Walpole, New Hampshire.

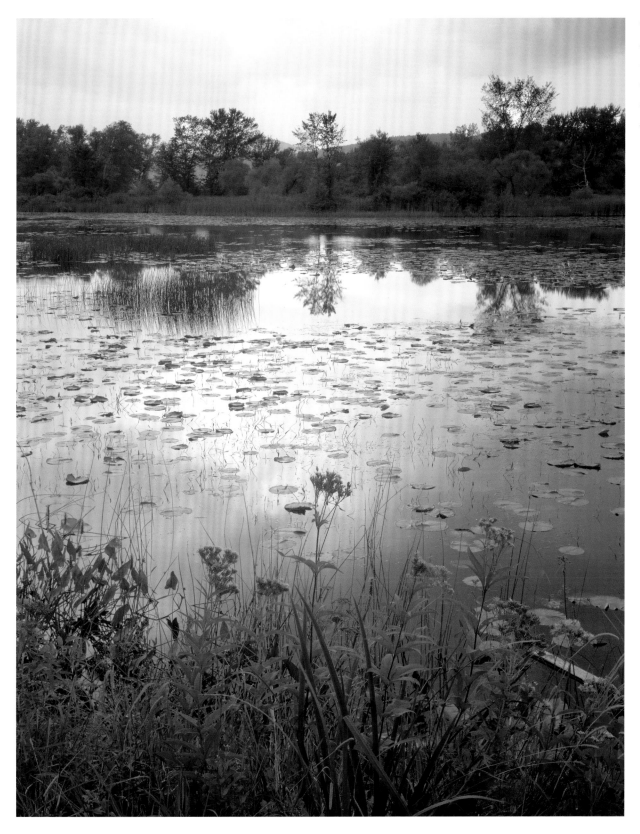

Queen of the Meadow flowers in late August along a quiet back cove near North Walpole, New Hampshire.

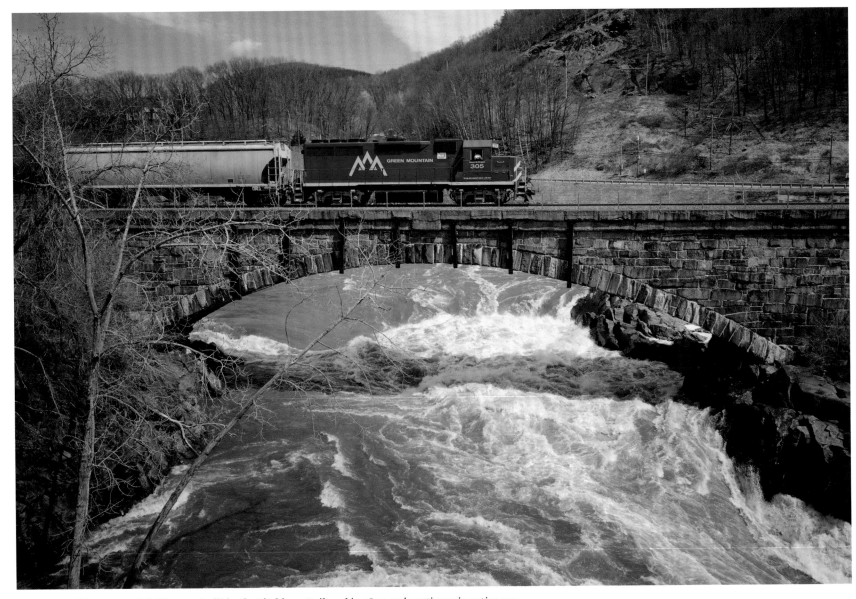

This stone arch bridge was built by the Fitchburg Railroad in 1899 and continues in active use, crossing the rocky natural channel at Bellows Falls, Vermont. The town remains an active rail hub in central New England. The bridge can be seen at the lower right in the view of Bellows Falls on the following page.

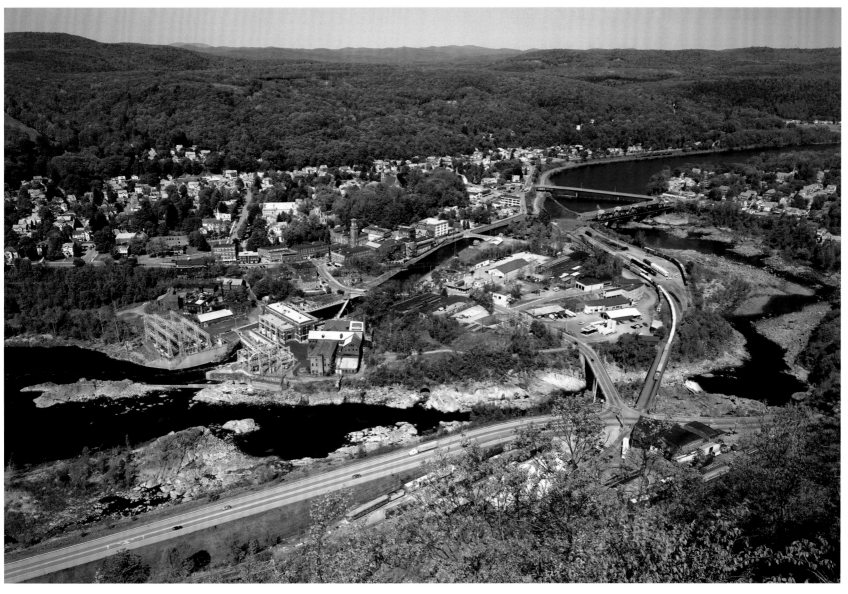

The rocky channel at Bellows Falls, Vermont (bottom right of photo), *was a real barrier to navigation. It was bypassed by the Bellows Falls Canal* (center of photo) *in 1802, through eight locks that raised boats a total of fifty-four feet. As railroads came to dominate transportation by 1849, the canal was used to power machinery, especially paper mills on the Bellows Falls "Island." Now the canal feeds water to the hydroelectric generators at Bellows Falls Station* (left), *before it is released back to the river.*

Bellows Falls Dam backs up the river nearly to Ascutney, Vermont, a distance of almost twenty miles. A popular area for boating and warm-water fishing, public boat launches are located at Rockingham and Springfield on the Vermont side and Charlestown and Claremont in New Hampshire. Water from the dam is diverted into the power canal for hydroelectric power generation.

Bellows Falls Station went on line in 1928 with three generators producing a combined forty-nine megawatts of electric power. The station is used primarily for peak demand times, because it can be started up in a matter of minutes.

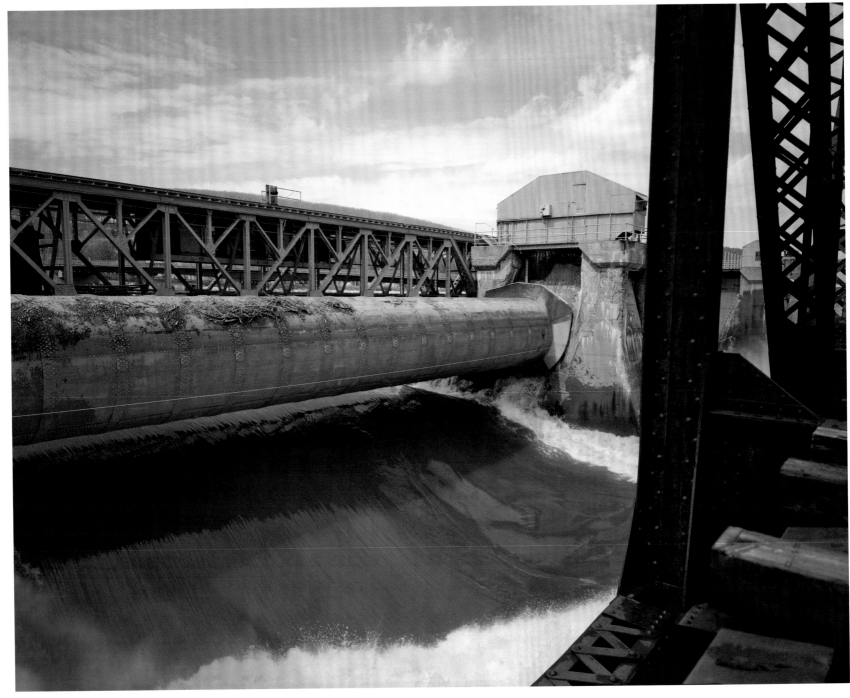

Flow from the Bellows Falls Dam is controlled by a pair of unique roller gates, each measuring 13 feet in diameter and 115 feet in length. Here, a powerful chain drive lifts one of the roller gates to allow water to flow through the dam during periods of high water.

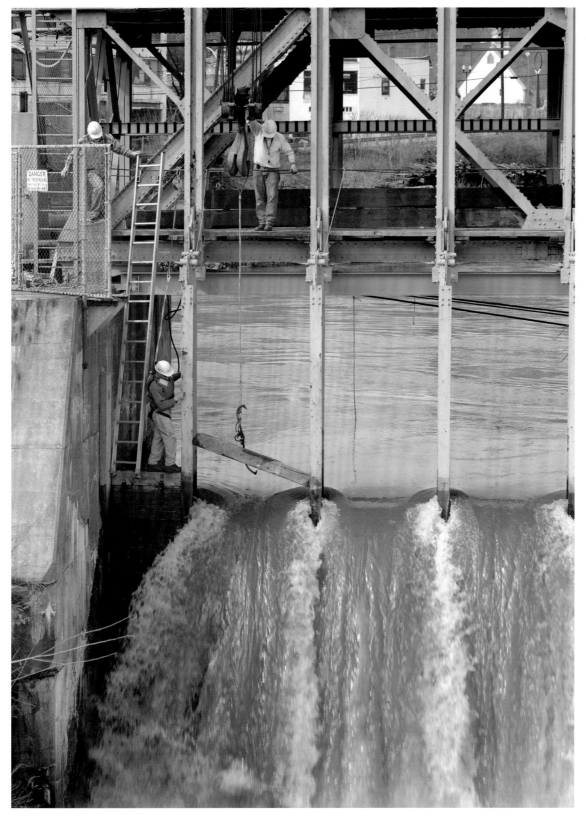

During the spring freshet, workers remove the flash boards from Bellows Falls Dam, allowing the high water to flow directly into the natural channel.

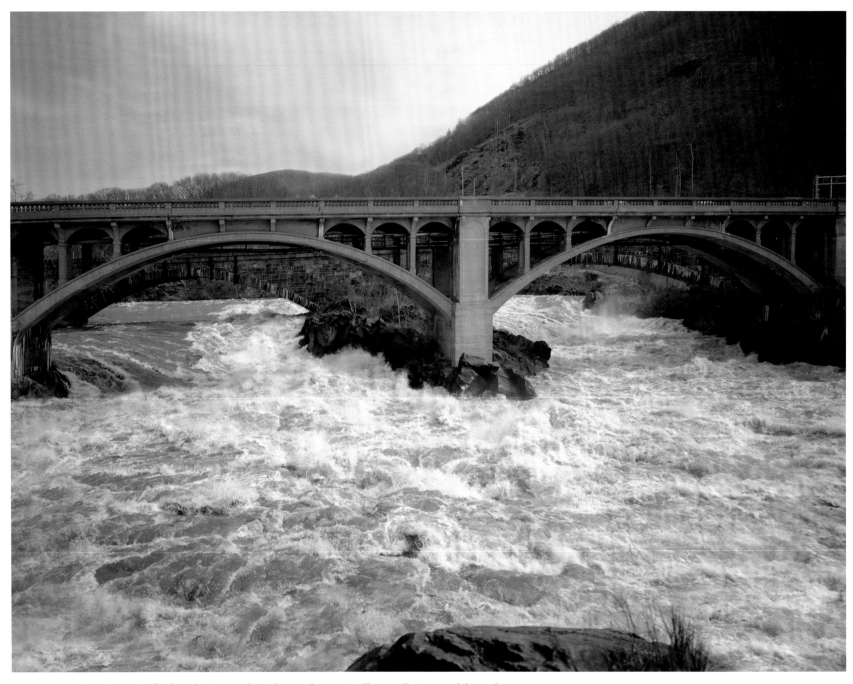

During the spring freshet, the Connecticut River rushes past Bellows Falls Dam and down the natural channel, giving a sense of what it might have been like in colonial times. The rock island in the center supports both the Vilas Bridge and the Fitchburg Railroad Bridge in the background. The first bridge anywhere on the Connecticut River was built at this site by Enoch Hale in 1785.

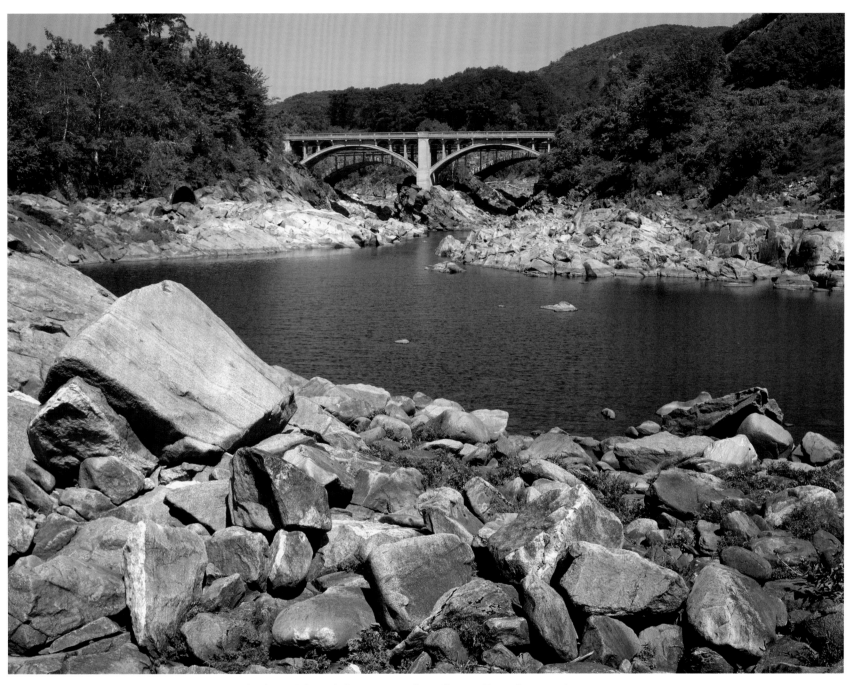

During normal flows, most of the river is diverted through the power canal to Bellows Falls Station, exposing the rocky edges and drops in the natural channel. The Vilas Bridge was donated to the towns of Rockingham, Vermont, and Walpole, New Hampshire, by Charles Nathaniel Vilas in 1931.

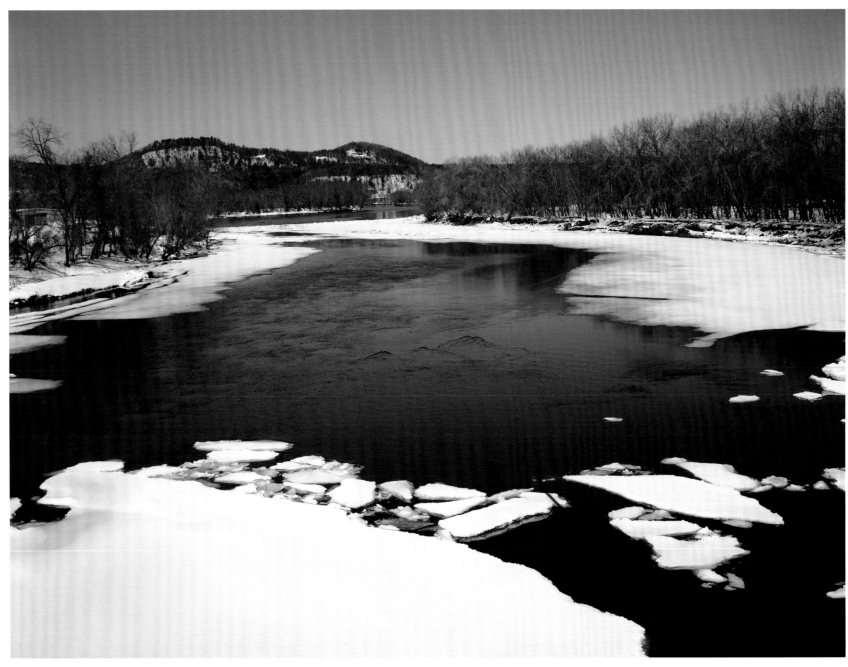

Spring ice-out soon brings the opportunity for fishing at
Westminster, Vermont, and Walpole, New Hampshire.

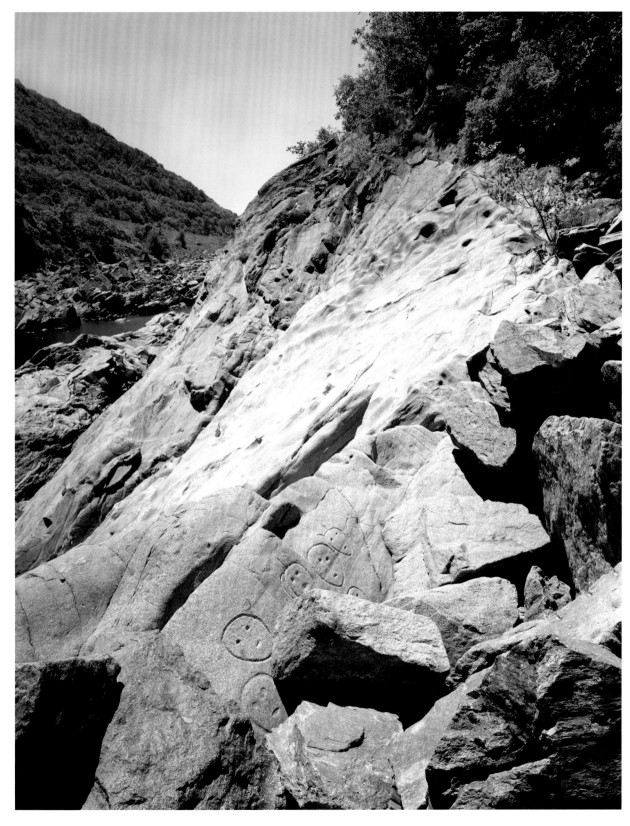

Petroglyphs found along the Connecticut River at Bellows Falls, Vermont, point to the presence of Native Americans in the river valley for thousands of years. The origin of these images is not known, but age estimates range from three hundred to several thousand years.

Abenaki tribes were known to fish in the area and perhaps made them. In the 1930s the recarving of many of the images was sponsored by the Daughters of the American Revolution in an attempt to make them more visible. Luckily, close inspection at the site reveals many petroglyphs that exist in their original condition.

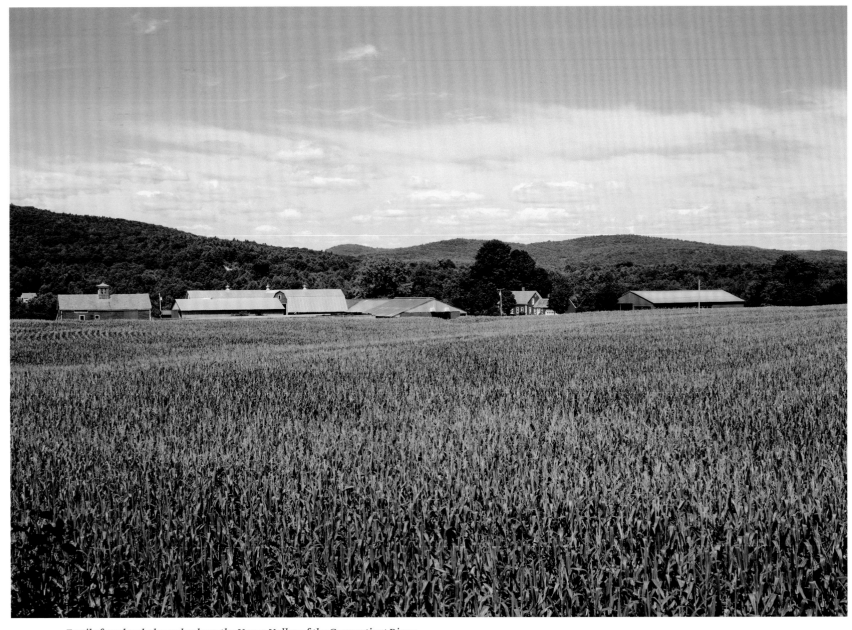

Fertile farmland abounds along the Upper Valley of the Connecticut River;
cornfields are shown here between Westminster and Putney, Vermont.

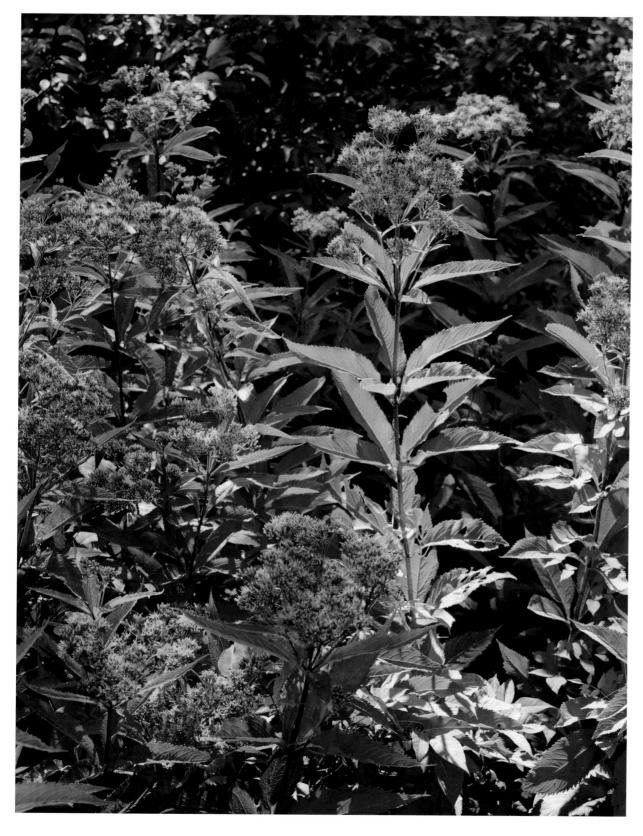

Queen of the Meadow produces a regal array of color from late August and into September. These five-foot plants were found in the low meadows along the river near Walpole, New Hampshire.

The plant's root has been used in a variety of herbal medicines for treatments of maladies including infections, rheumatism, asthma, whooping cough and gout.

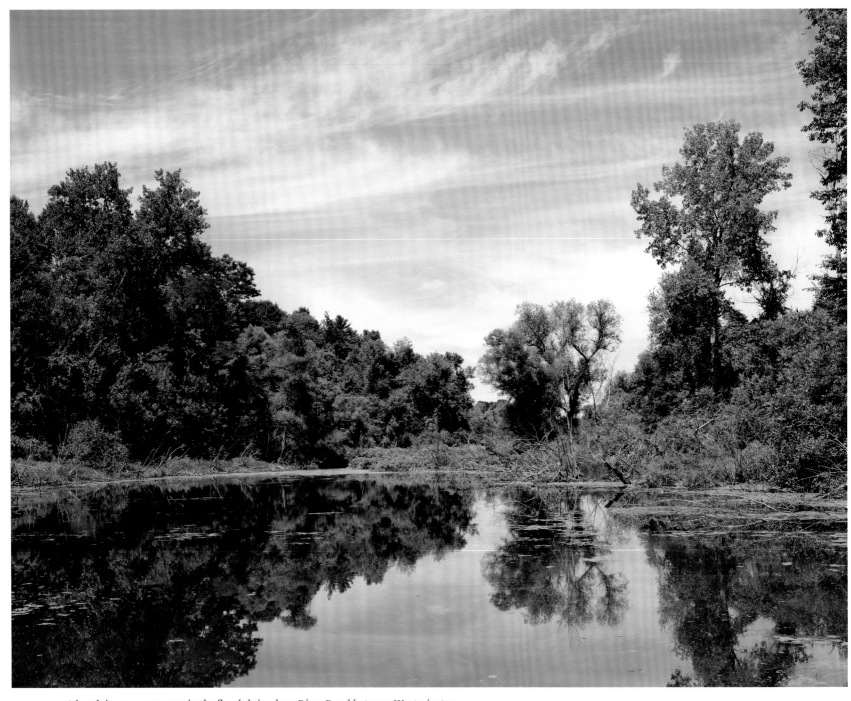

A low-lying swampy area in the floodplain along River Road between Westminster and Putney, Vermont.

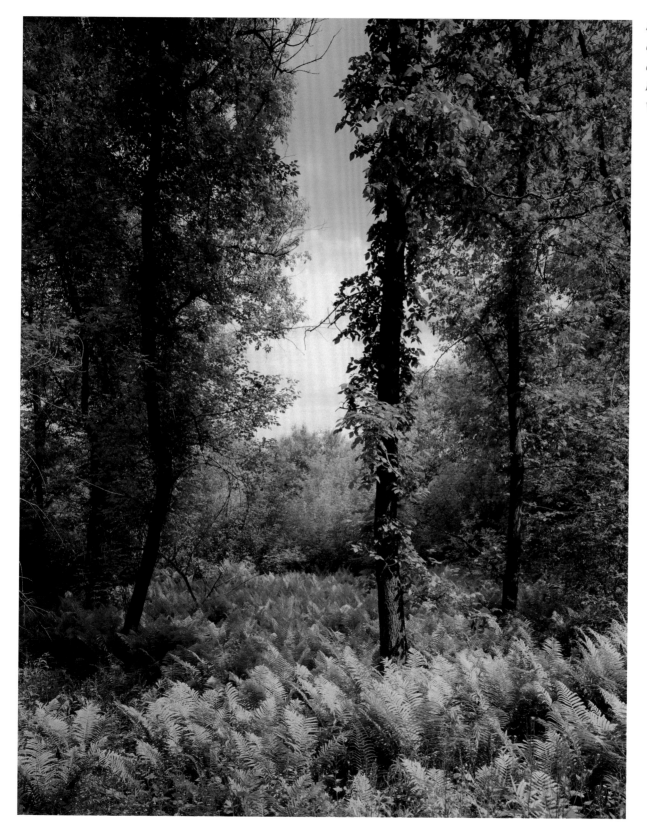

Springtime brings an explosion of ferns along the Connecticut River near Putney, Vermont.

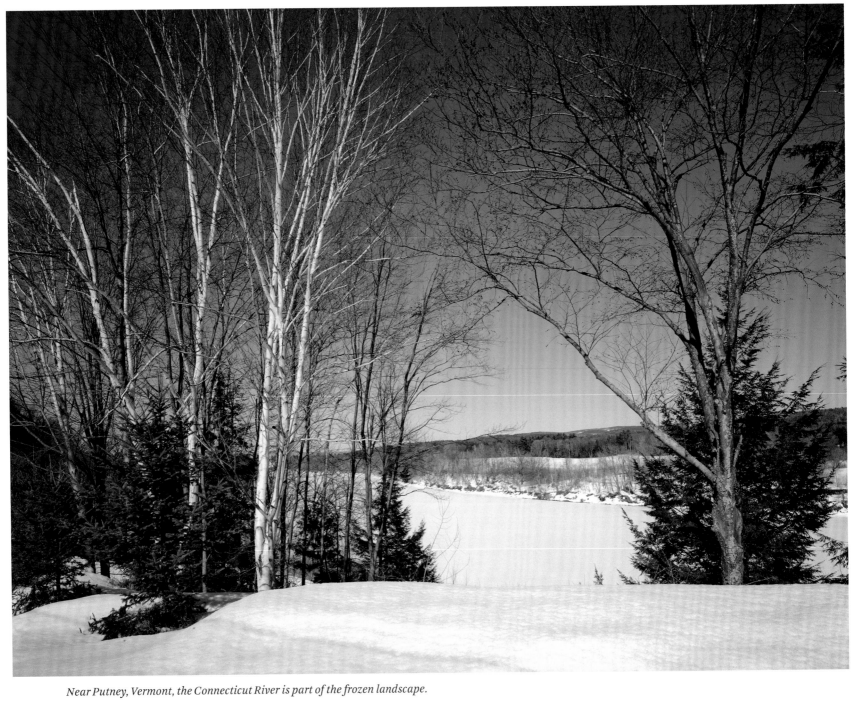

Near Putney, Vermont, the Connecticut River is part of the frozen landscape.

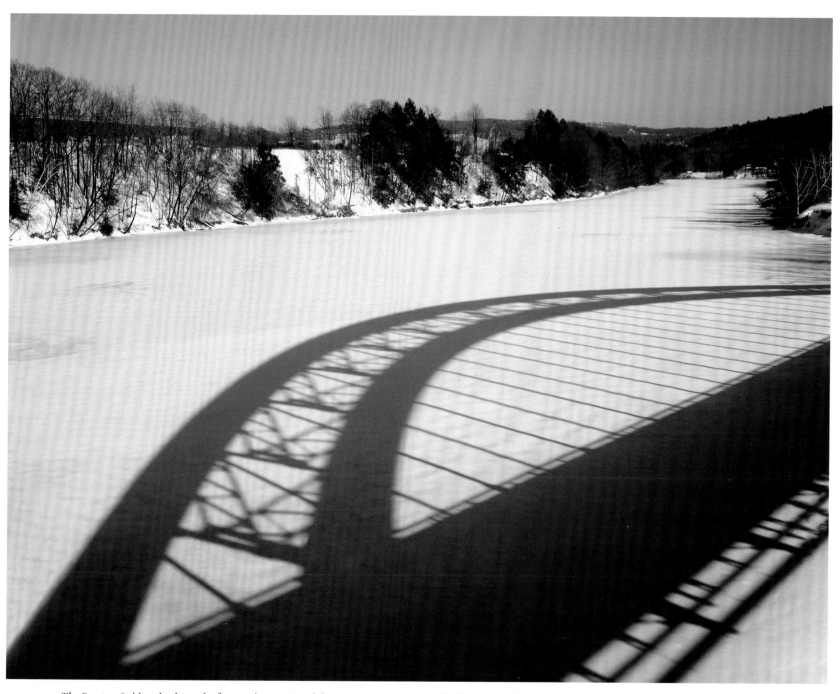

The Route 9 Bridge shadows the frozen river at Brattleboro, Vermont. A new and wider bridge of matching design was constructed a few feet upstream in 2003, allowing this original 1936 bridge to be converted to a walking path. In those winters with lots of cold and little snow, the river's surface can be smooth enough for ice skating—miles of ice skating.

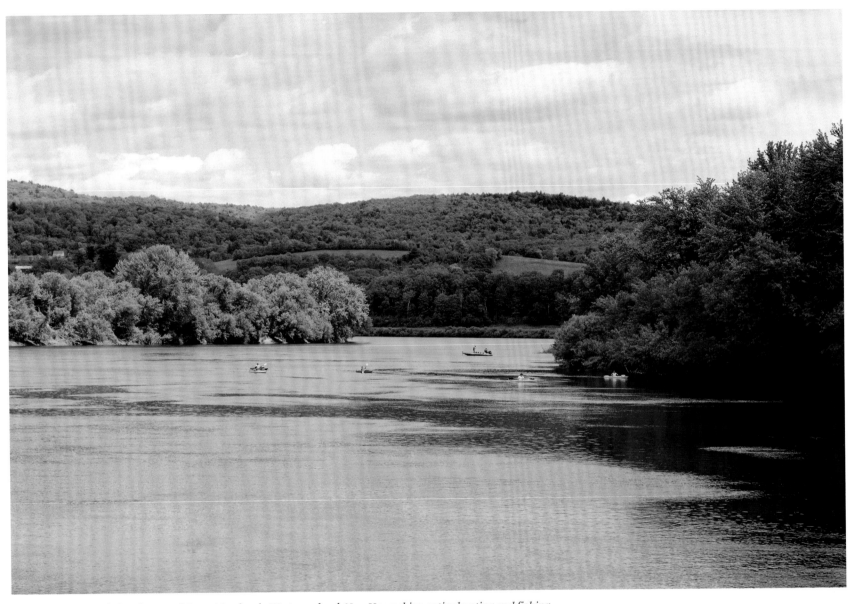

The gentle bends around Great Meadow in Westmoreland, New Hampshire, entice boating and fishing.

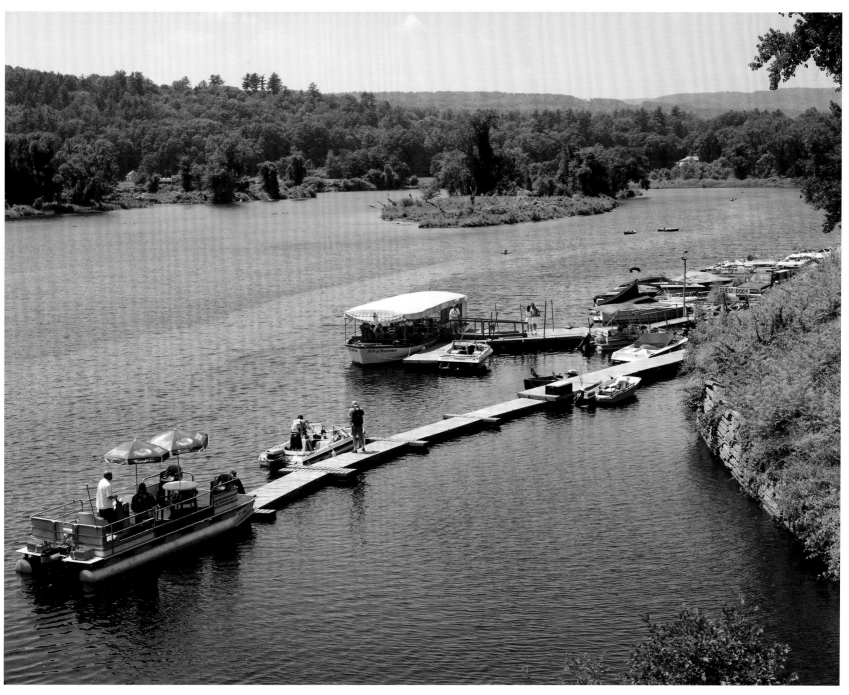

The West River flows into the Connecticut just past this natural harbor to the north of Brattleboro, Vermont. The restaurants on shore are a hit with boaters.

This steel railroad bridge south of Brattleboro, Vermont, is representative of the many rail lines crossing the Connecticut River and running along its shores.

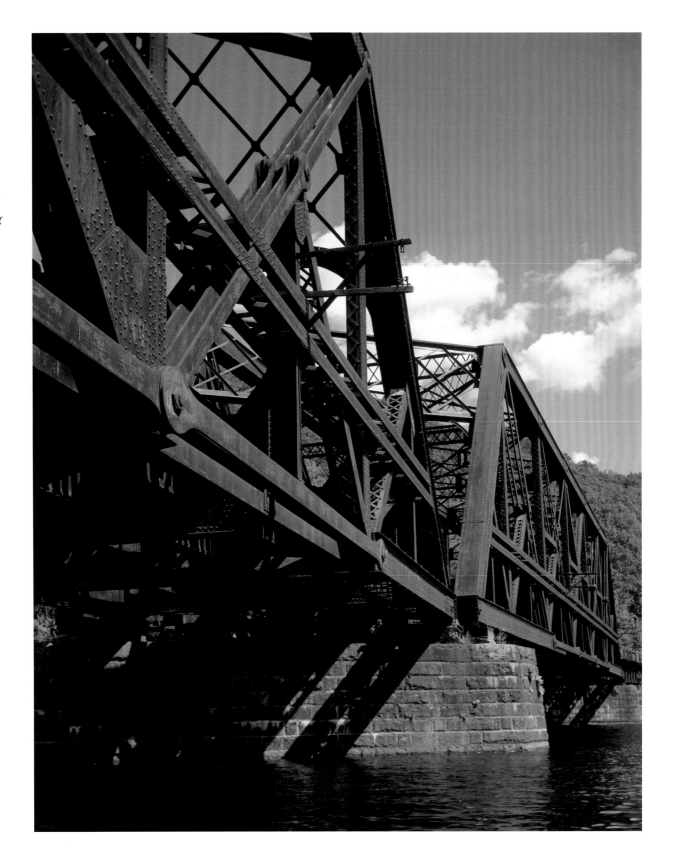

This abandoned railroad bridge is on a rail bed that follows the river's eastern bank near Hinsdale Bluffs in New Hampshire.

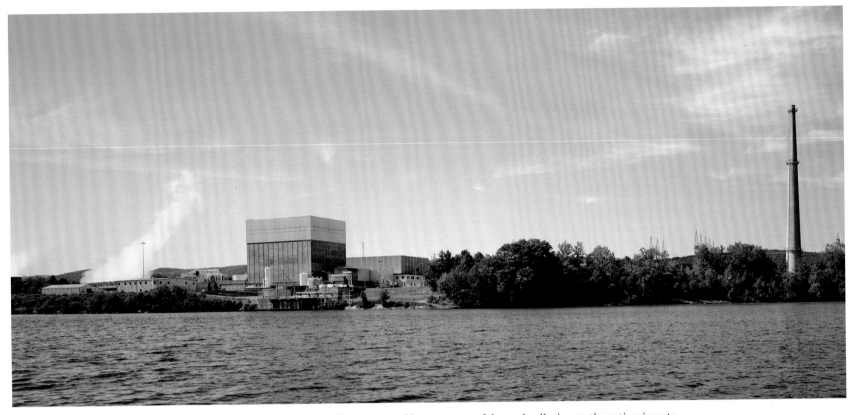

Vermont Yankee Nuclear Power Plant, in Vernon, is one of the most significant sources of thermal pollution on the entire river. As much as half a billion gallons of plant cooling water per day is discharged at temperatures as high as 105 degrees. The American shad population in that section of the river has declined 99 percent since the early 1990s, and the temperature increases have been noted as far south as Holyoke, Massachusetts.

(opposite)

Fall storms are on the move in early November, transforming the landscape. This hill on Route 146 in Vernon, Vermont, looks north toward mountains in southern New Hampshire.

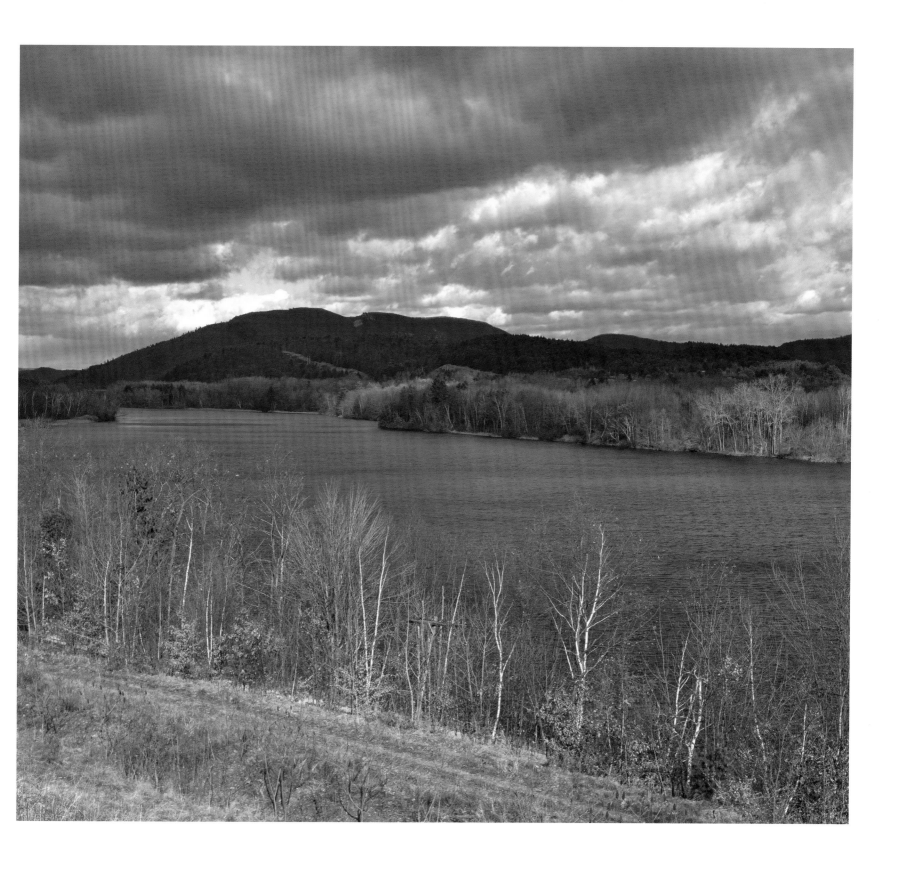

Installed in 1909, these generators at Vernon Station are the oldest on the river, with a combined capacity of twenty-two megawatts as shown in this 2001 photograph.

In 2008, new generators replaced four of the units in the foreground, bringing the total capacity to thirty-four megawatts.

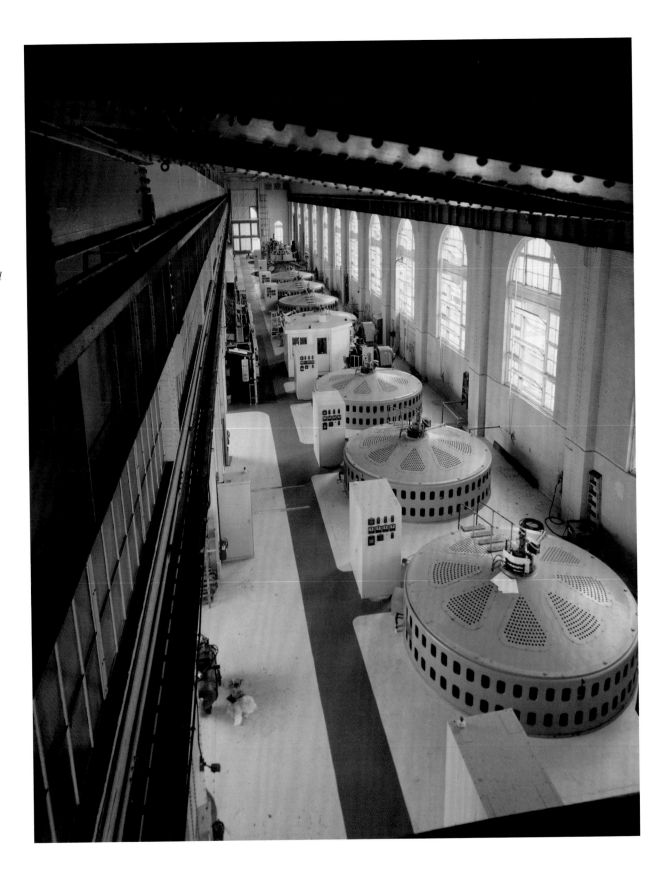

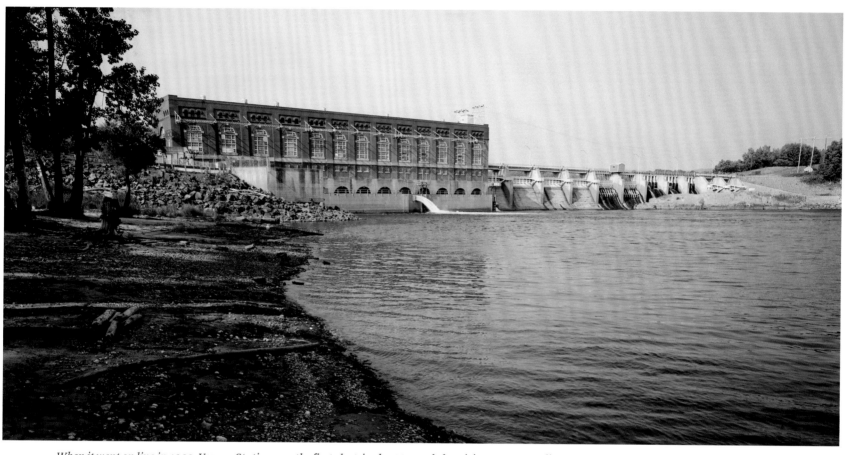

When it went on line in 1909, Vernon Station was the first electric plant to send electricity across state lines, providing power to southern Vermont and southwestern New Hampshire and to central Massachusetts towns such as Gardner and Fitchburg. The pool below the dam is a great fishing spot.

These bent trees on the floodplain at Northfield, Massachusetts, are testament to the river's power during spring freshet.

The Massachusetts border marks the river's transition from the Upper Valley to the Pioneer Valley area of Massachusetts and the Tobacco Valley of Connecticut.

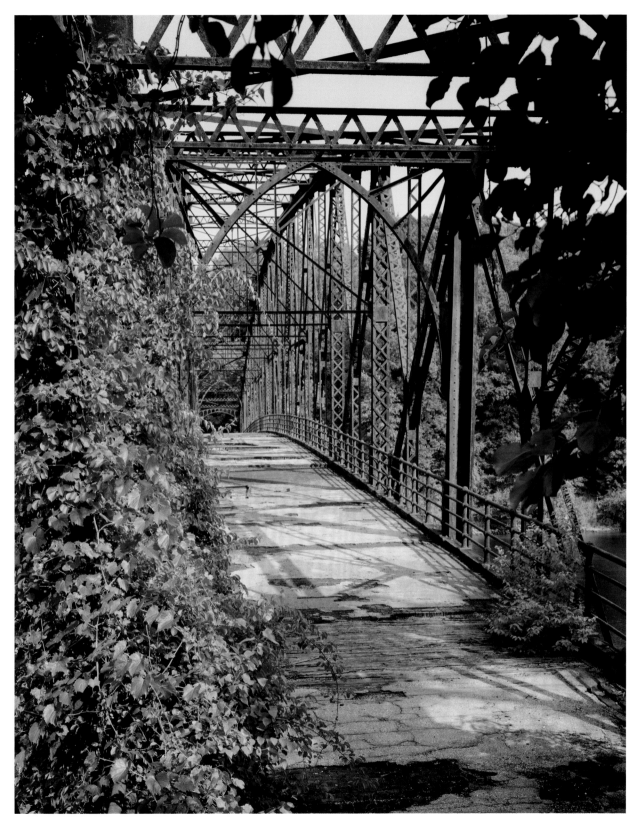

One of the most beautiful bridges on the Connecticut River, the Schell Bridge at Northfield, Massachusetts, was slated for demolition after two decades of neglect.

A Northfield citizens group sprung to its aid with a plan to rebuild it for pedestrian use and to connect it to a group of regional bike trails. Funds are being raised and the group is working to list the bridge in the National Register of Historic Places.

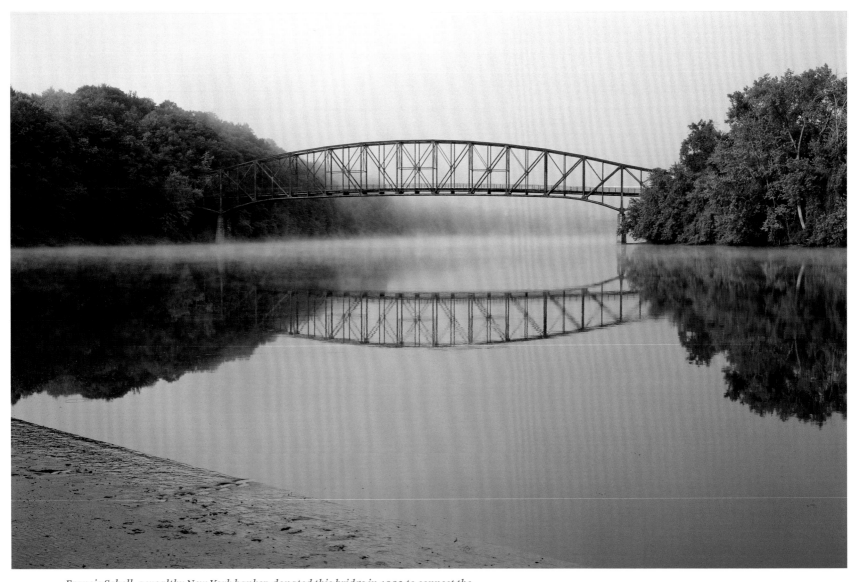

Francis Schell, a wealthy New York banker, donated this bridge in 1903 to connect the east and west sides of Northfield, Massachusetts. Although closed in 1985, the delicate frame of Schell's elegant 515-foot Pennsylvania truss bridge is still visible from the state boat launch at Pauchaug Brook, just off Route 63. On a still morning in early June the sunrise illuminates it from the north.

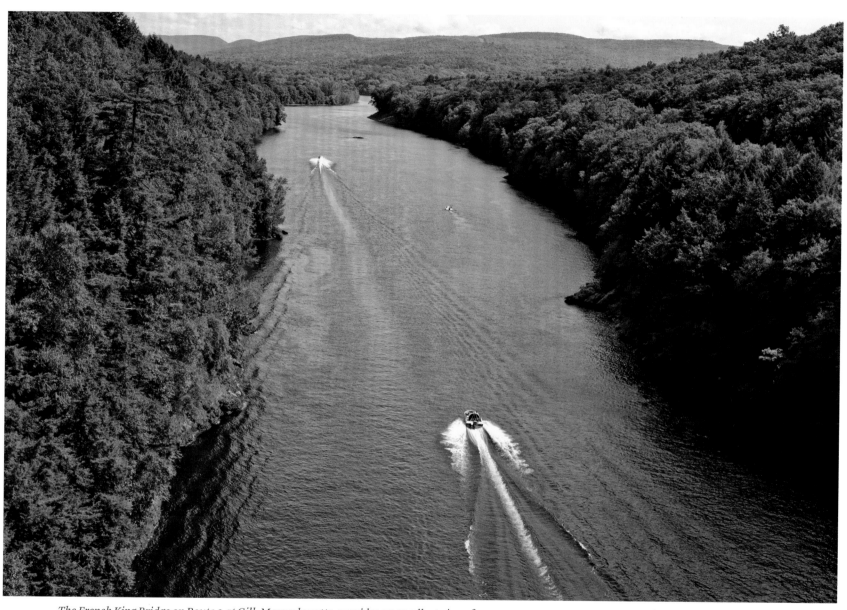

The French King Bridge on Route 2 at Gill, Massachusetts, provides an excellent view of the Connecticut River in a constrained gorge. This area is impounded behind Turners Falls Dam, allowing boating all the way to the base of Vernon Station in Vermont. The Northfield Mountain pumped storage project is just a mile upstream and can quickly affect river levels in this area. Fishing, skiing and canoeing are all popular. Watch out for French King Rock in the middle.

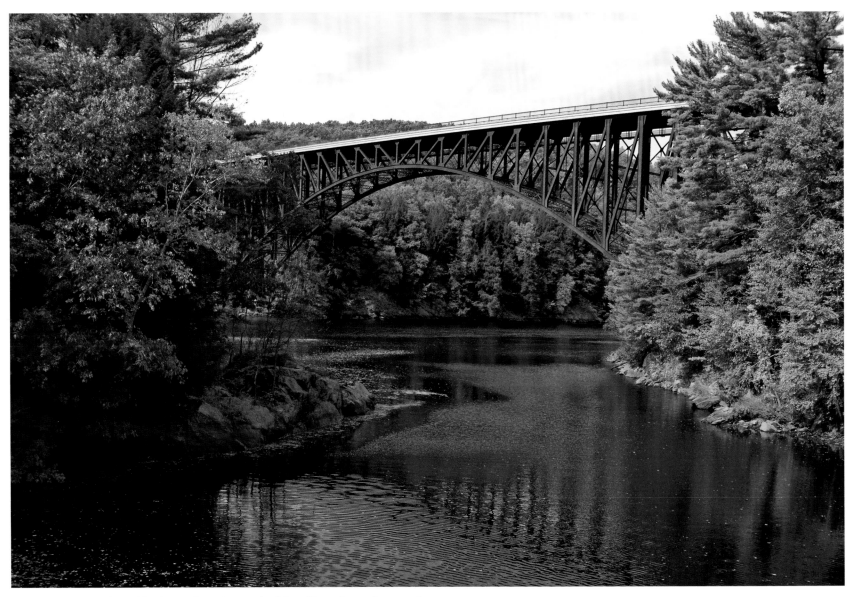

French King Bridge is seen from the mouth of the Millers River as it enters the Connecticut River. Here it takes a sharp bend west toward Barton Cove—home to a nest of bald eagles—and Turners Falls. The span was chosen as the most beautiful bridge in 1932 by the American Institute of Steel Construction.

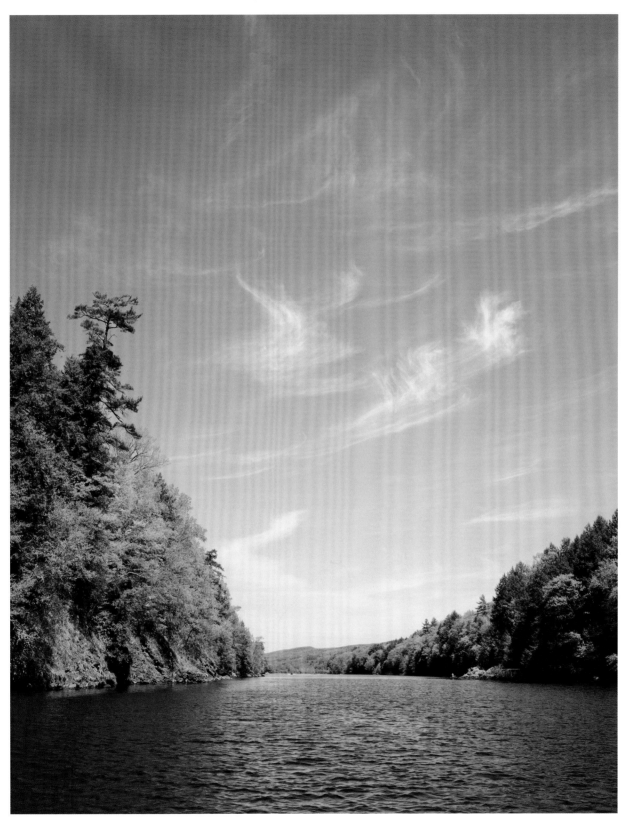

French King Gorge, near Gill, Massachusetts, lies along an ancient fault line that directs the river on its southern journey through the mountains of the area.

Much of the land in the gorge area is state owned or under various conservancy protections, preserving both the views and natural habitats.

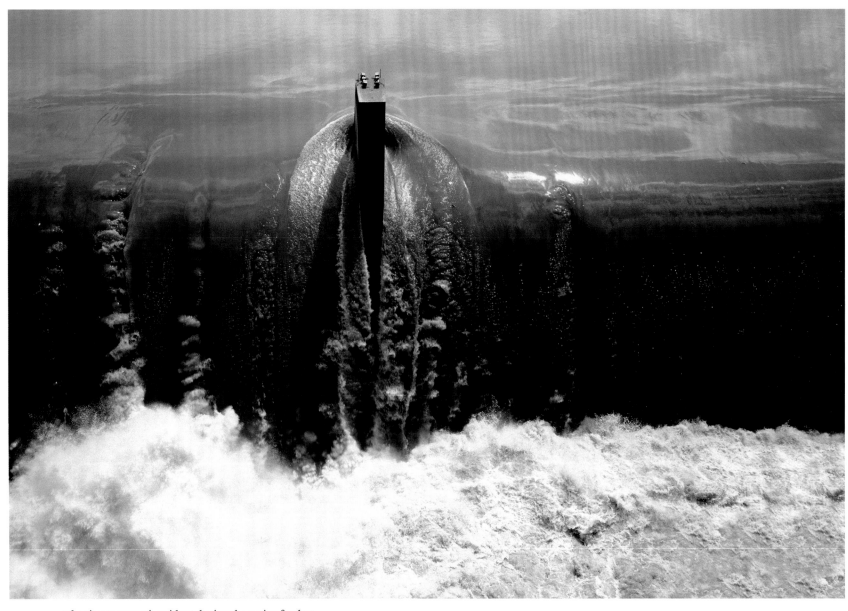

The river's power is evident during the spring freshet,
topping Turners Falls Dam, Turners Falls, Massachusetts.

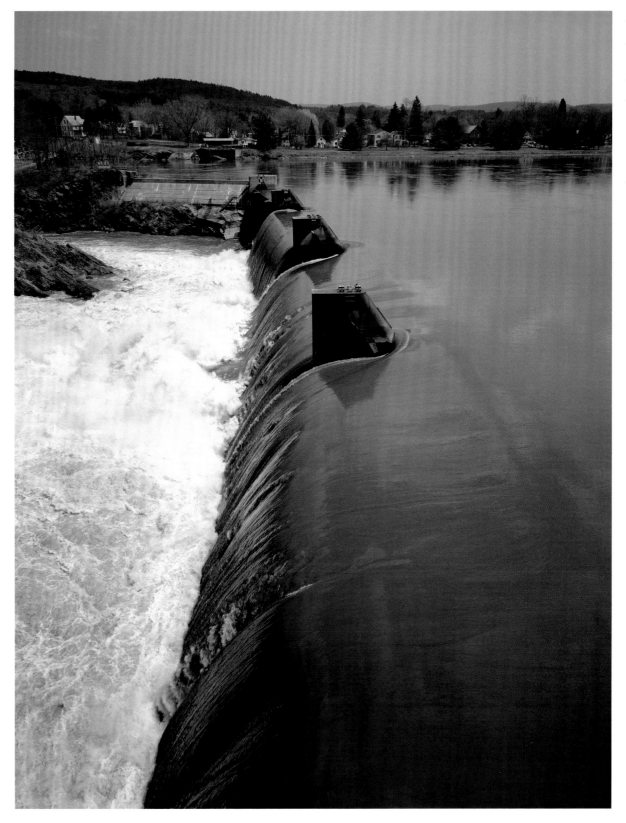

A wall of water plummets over the top of Turners Falls Dam, in northern Massachusetts, during the spring freshet. These high flows can't be contained and all the gates are fully opened to let the river pass.

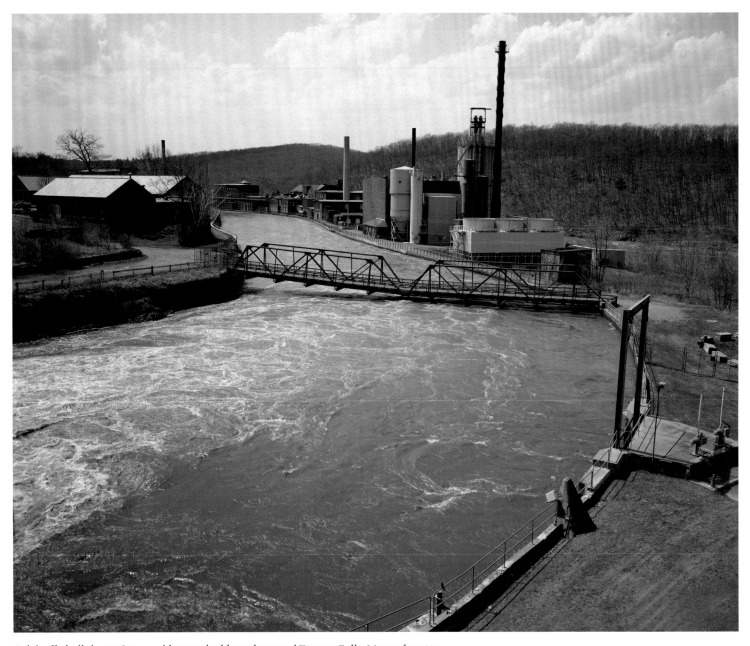

Originally built in 1798 to provide a navigable path around Turners Falls, Massachusetts, the canal was rebuilt for industrial use in 1869. The flow powered a row of paper mills and other manufacturers. Now the water continues to hydroelectric-generating stations on the west end of town before being released back into the main stem of the Connecticut River. A new bike path follows the eastern side of the canal across town.

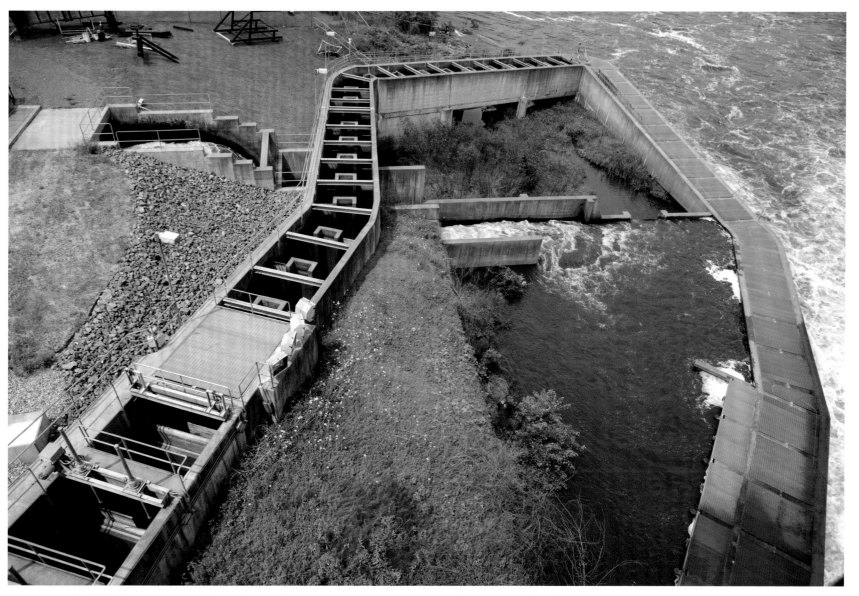

This fish ladder at Turners Falls Dam is one of many on the Connecticut River's main stem and tributaries used for restoration of Atlantic Salmon and other species. Operation is from mid-May to mid-June, during the salmon migration. Despite major efforts in salmon restoration, counts are quite low. American shad and sea lamprey are the major populations transiting the ladder.

*The Deerfield River joins the
Connecticut just south of Turners
Falls, flowing past pastoral historic
Deerfield, in central Massachusetts,
a preserved English settlement
prominent in the northward colonial
expansion.*

*Deerfield is most noted for a raid
on February 29, 1704, when the
Pocumtuck tribe and its French allies
attacked by surprise and killed or
captured about half the villagers in an
attempt to retake the area. Many of
the survivors were marched through
Vermont to Canada in harsh winter
conditions.*

*Contemporary exhibits display both
the English settlers' and the native
Pocumtucks' points of view and ask us
to consider "Who writes history?"*

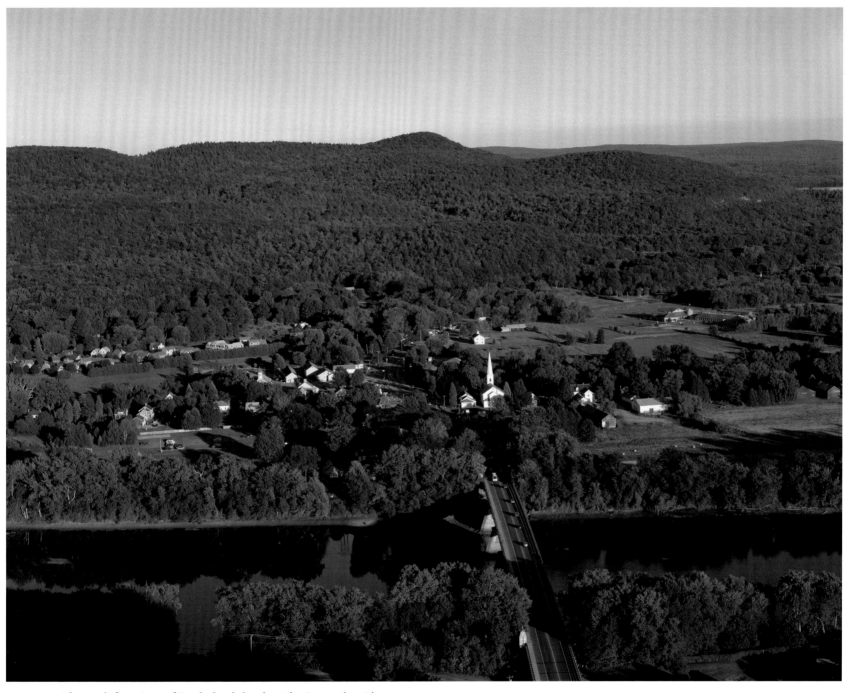

The scenic farm town of Sunderland sits along the Connecticut River
as seen from Mount Sugarloaf in central Massachusetts.

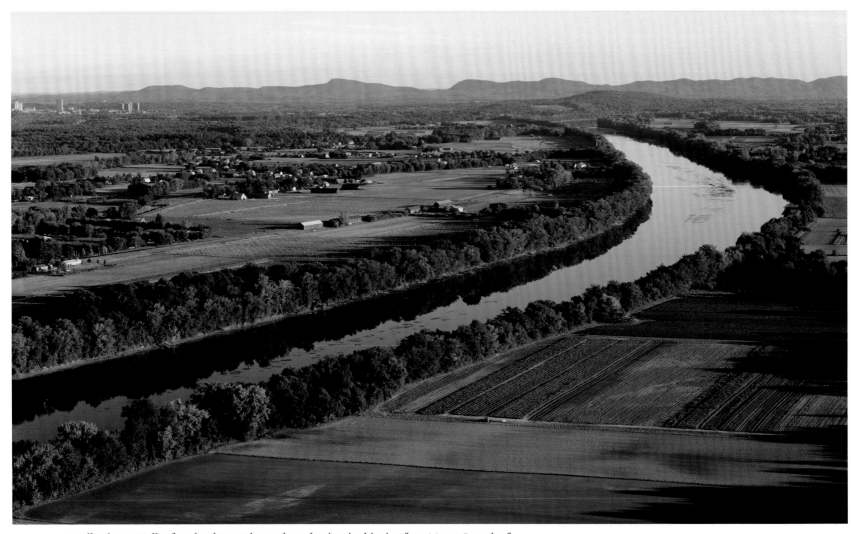

Fertile Pioneer Valley farmlands stretch out along the river in this view from Mount Sugarloaf State Reservation in South Deerfield, Massachusetts. Here and to the south, tobacco begins to be an important crop, growing beside corn, hay and vegetable fields. The Holyoke Range is in the distance, and the buildings of University of Massachusetts at Amherst, are on the far left.

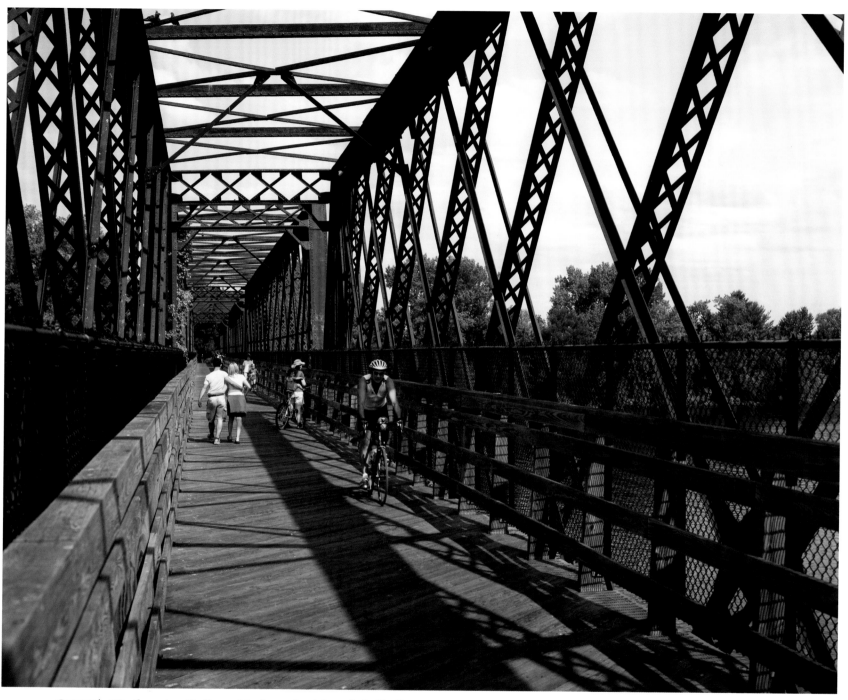

Connecting Northampton, Hadley and Amherst, the eight and a half mile Norwottuck Rail Trail
is an important part of Massachusetts' Connecticut River Greenway State Park, following the original
Boston and Maine rail line.

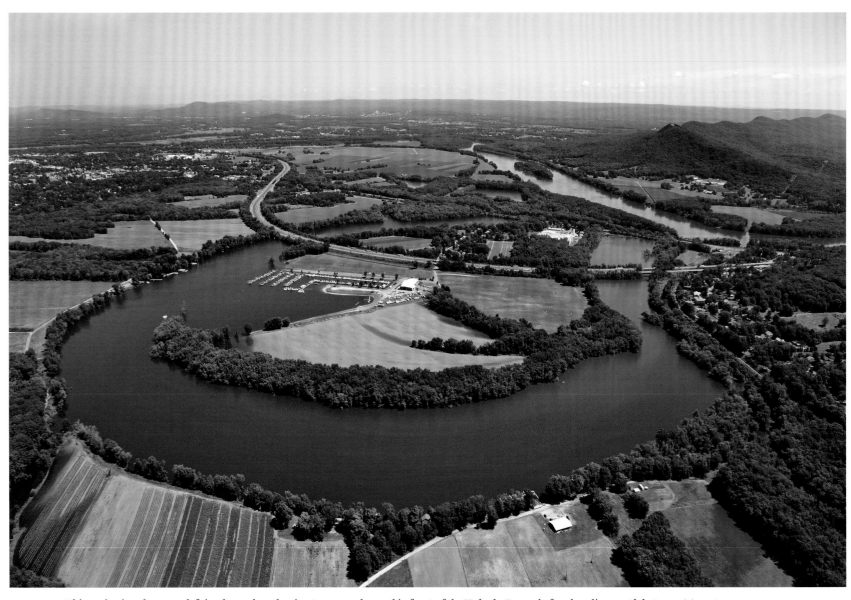

This majestic oxbow was left in place when the river's course changed in front of the Holyoke Range before heading south between Mount Holyoke and Mount Tom. At the top of Mount Holyoke, on the right, is the J. A. Skinner State Park, where Summit House provides great views of the Pioneer Valley to the north and the oxbow to the west. This landscape was immortalized in an 1836 painting by Thomas Cole, View from Mount Holyoke, Northampton, Massachusetts, after a Thunderstorm (The Oxbow). *The shape of the mountain range produces strong updrafts, making the area a significant habitat for many varieties of hawks and also peregrine falcons.*

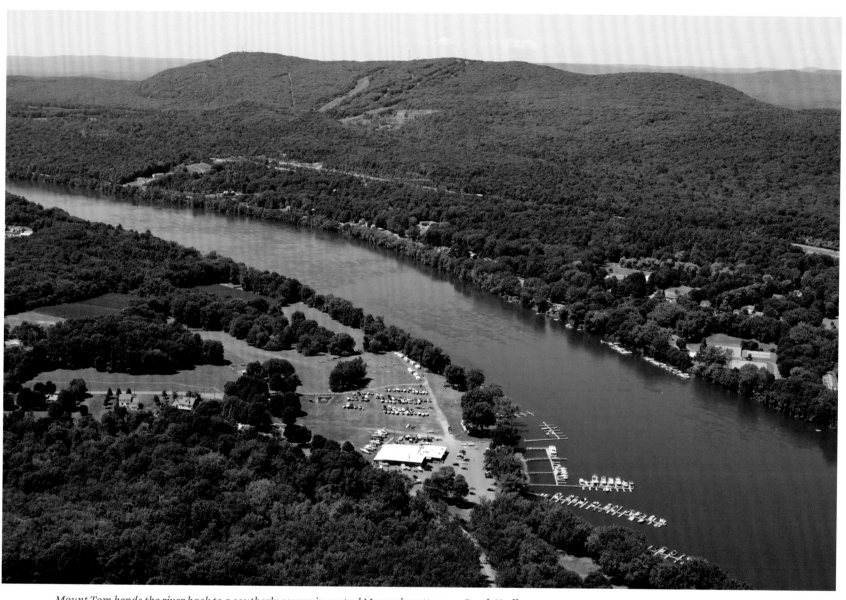

Mount Tom bends the river back to a southerly course in central Massachusetts, near South Hadley.
The northeastern end is a 2,000-acre state park with twenty miles of hiking trails and great views from
the summit. Hawks are often seen along the ridge. The western shore has an eight-acre site containing
134 dinosaur footprints preserved in sandstone. They were first studied by Professor Edward Hitchcock
of Amherst College.

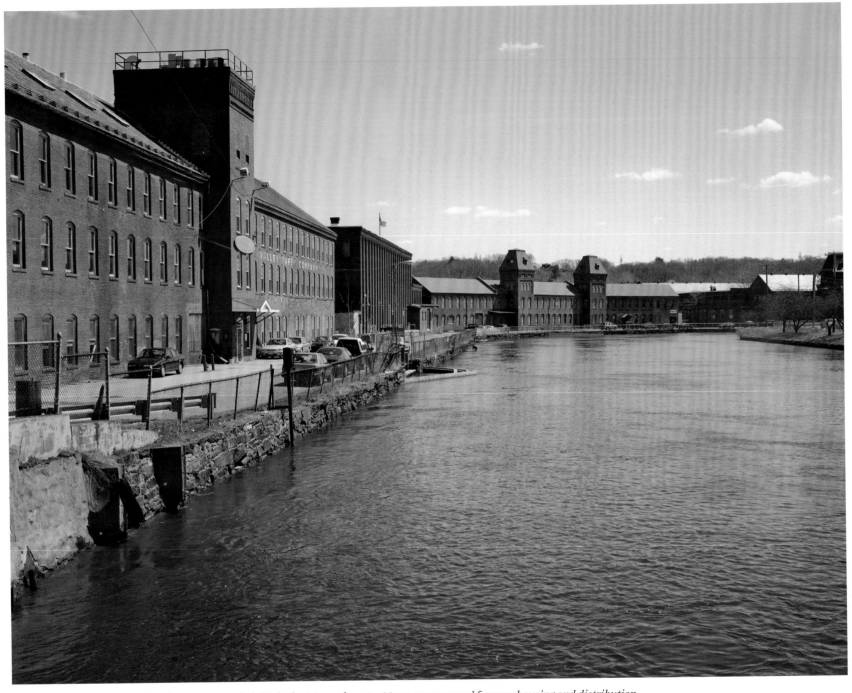

Industrial buildings line power canals in Holyoke, Massachusetts. Many are now used for warehousing and distribution, others are being converted to postindustrial uses as the city works to rebuild itself. In some cases, the buildings' water power structures were modernized with generators that continue producing electricity. Canal walkways are in the process of being designed and built for the area, offering new shopping and restaurant dining opportunities to visitors.

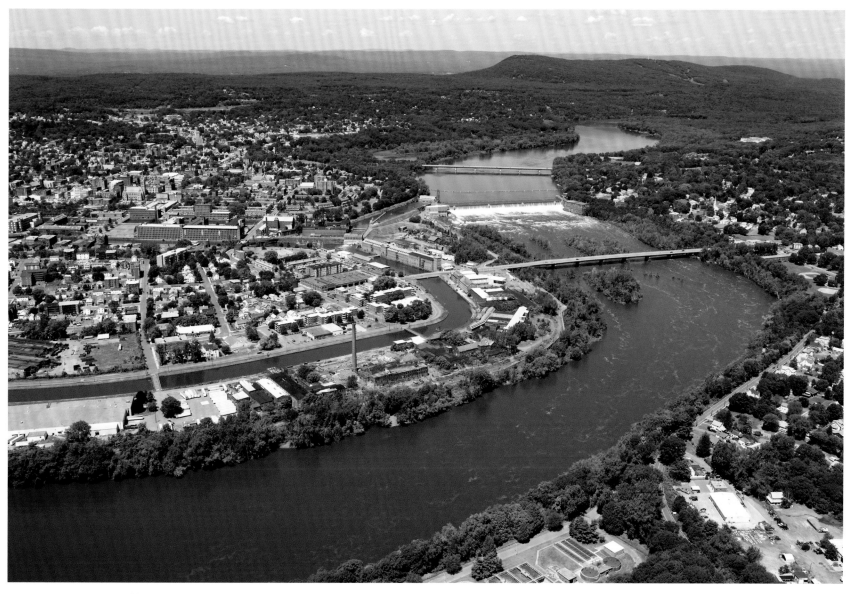

Powered by a fifty-seven-foot water drop within two miles, Holyoke, Massachusetts, was designed from the ground up as an industrial city. Four miles of canals were hand dug in preparation for water power. The first dam failed famously in 1847 after about five hours of operation. It was replaced within a year by a wooden dam that held until 1900 when the current 1,019-foot granite Holyoke Dam was installed. In the second half of the nineteenth century, in addition to its many textile factories, Holyoke became famous as the Paper City of the World, boasting twenty-five active paper mills along the canals.

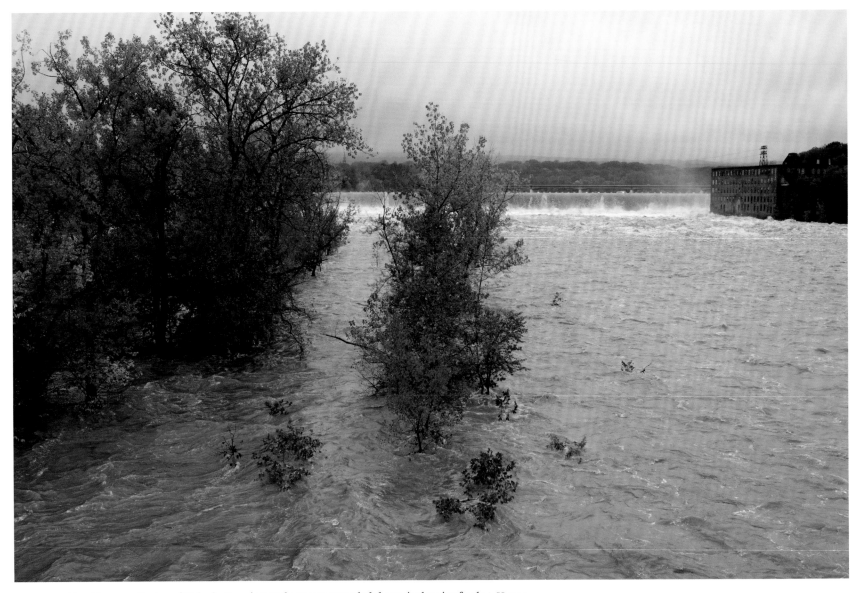

Flooding over the top of Holyoke Dam in October 2005 exceeded the typical spring freshet. Heavy rains upstream can cause high water levels quickly. In spring, during calmer water, it's a popular spot for shad fishing.

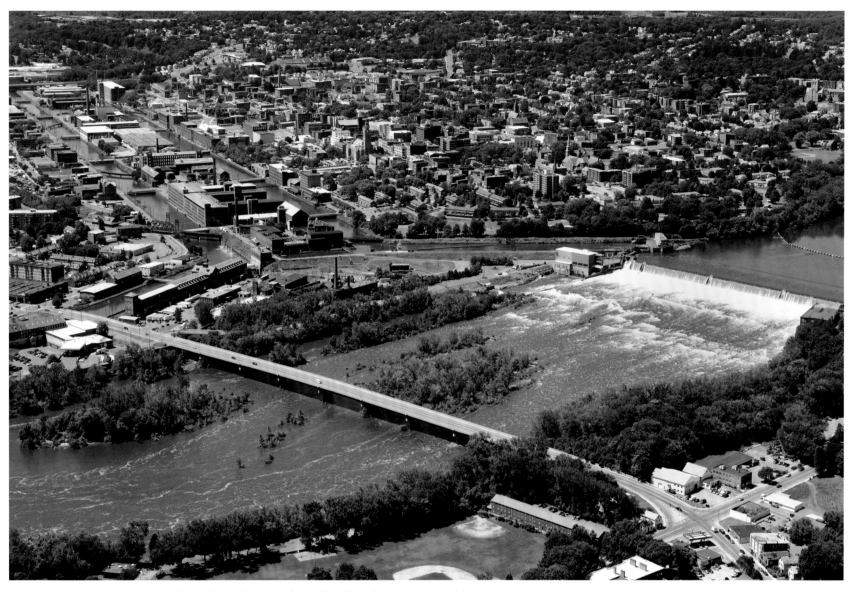

Central Holyoke's granite dam holds back the river's flow, diverting it to a two-turbine 43.8- megawatt municipal hydroelectric plant. Beyond the power plant, a channel feeds the industrial canal system. The dam has two fish lifts, which are used most often by American shad and sea lamprey. Atlantic salmon are caught for hatcheries or tagged with radio beacons and released upstream.

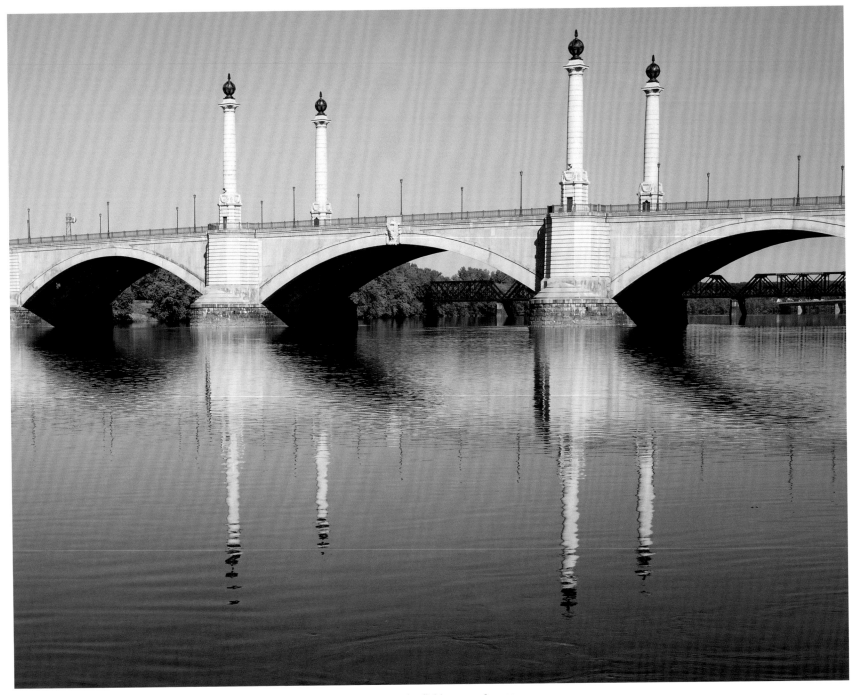

The magnificent Memorial Bridge provides a gateway to downtown Springfield, Massachusetts. It was dedicated in 1922 to "those who had died as pioneers, and soldiers in the Revolutionary, Civil and Foreign Wars." Its seven arches, totaling 1,515 feet, span the Connecticut River.

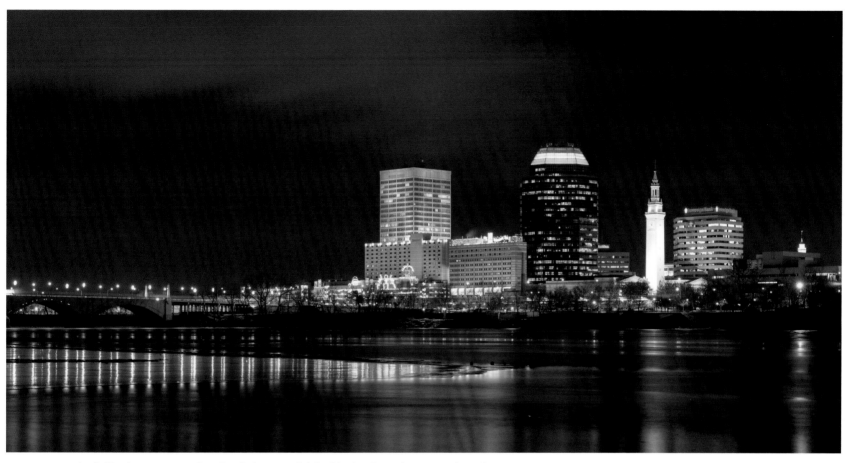

Springfield's downtown catches the Christmas spirit in this view from the Connecticut River.

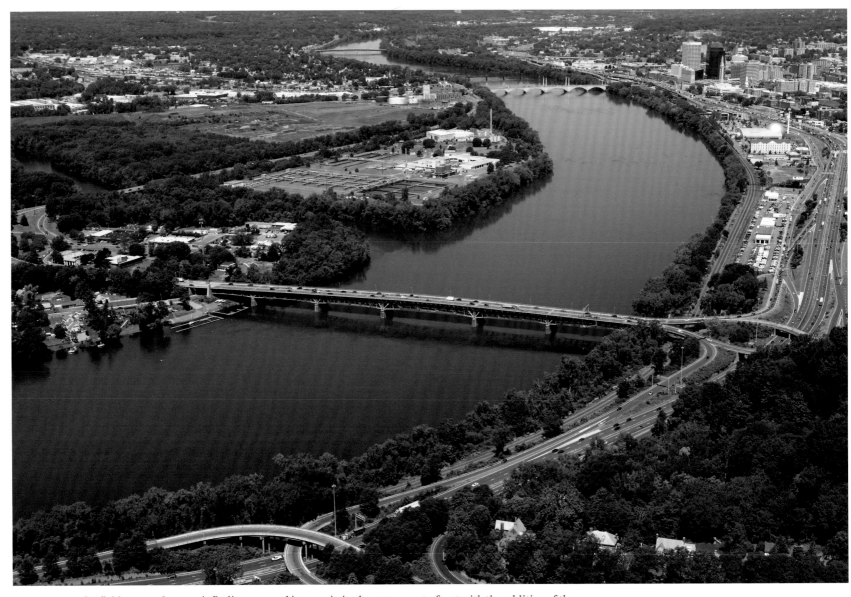

*Springfield, Massachusetts, is finding renewed interest in its downtown waterfront with the addition of the
Connecticut River Walk and Bikeway, Riverfront Park and destinations like the Basketball Hall of Fame. Springfield,
Holyoke and Chicopee, however, struggle with antiquated wastewater systems that spill a billion gallons of sewage-
laden water into the Connecticut Watershed each year in violation of Federal Environmental Protection Agency clean
water standards.*

The Connecticut River floodplain at Longmeadow, Massachusetts, is full of swamps, ponds and marshes, making it a prime area for migrating birds. Best known is the Fannie Stebbins Memorial Wildlife Refuge, offering hiking access to the shoreline where egrets, ducks and hawks are often found.

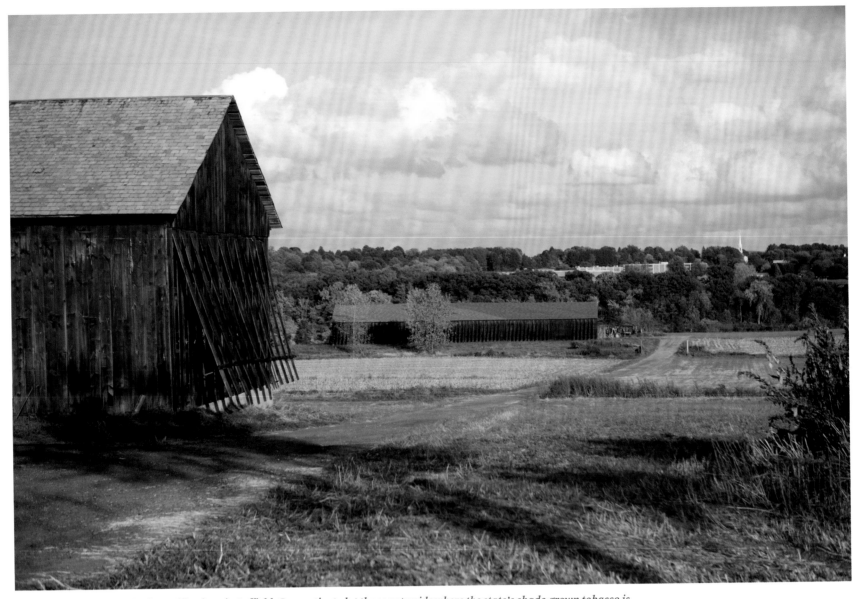

Tobacco-drying barns like these in Suffield, Connecticut, dot the countryside where the state's shade-grown tobacco is produced. Prized for its flavor, this "Cuban" style tobacco was hybridized to grow in Connecticut. It is used as the outer wrapper for over half of the premium handmade cigars produced in the United States. The tobacco-growing tradition dates back to the Native Americans in the Connecticut River Valley. Development pressure is increasing on the farms that remain.

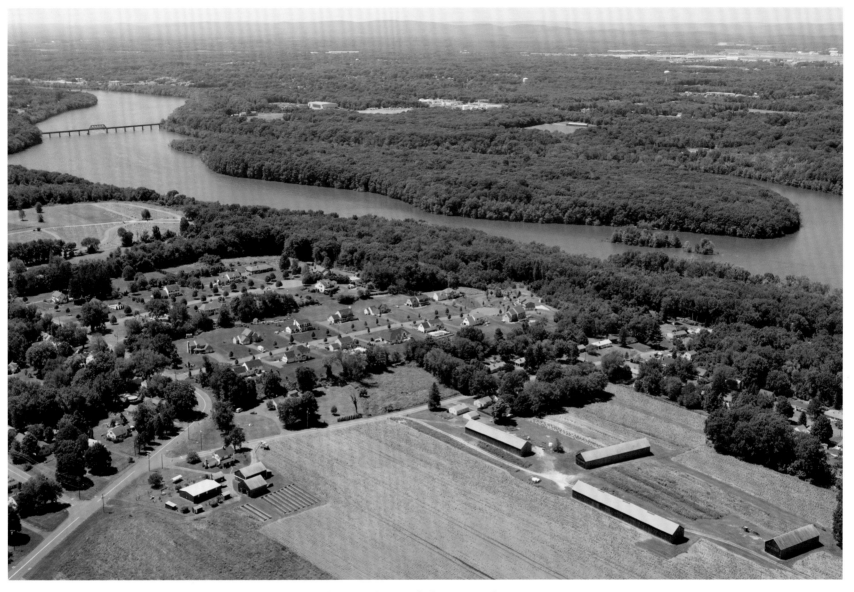

Development competes for farmland in the area near Kings Island, East Windsor, Connecticut.

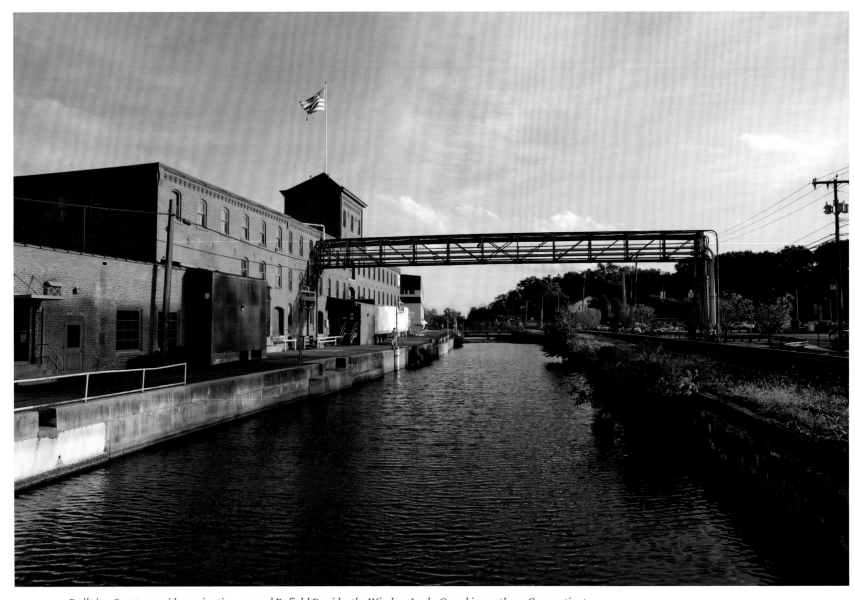

Built in 1829 to provide navigation around Enfield Rapids, the Windsor Locks Canal in northern Connecticut parallels the river's shoreline for over five miles. The canal continued in use until 1976. Enfield Rapids is the southernmost navigation barrier on the Connecticut River. The Windsor Locks Canal along with those at Holyoke, Turners Falls and others farther upstream, once supported river traffic as far north as White River Junction, Vermont. A hike and bike trail now follows the length of the canal.

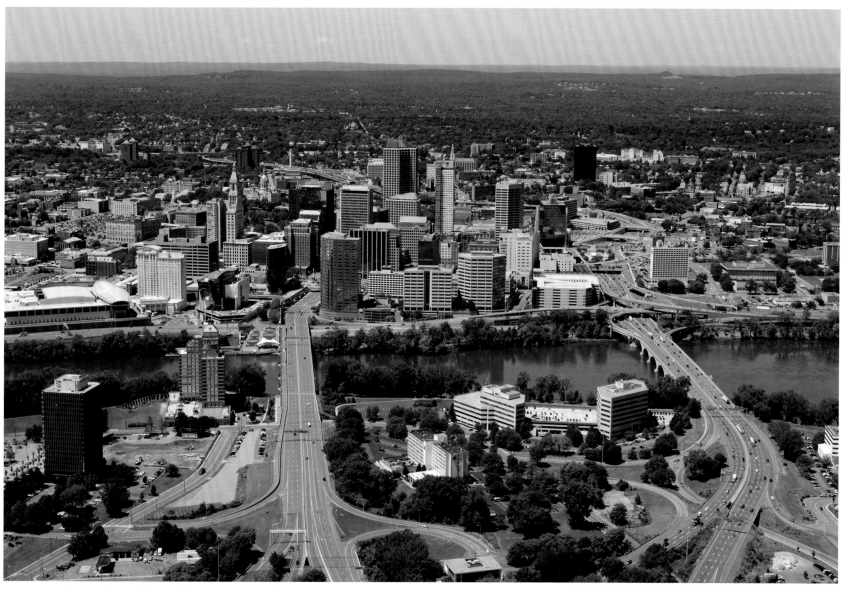

The Founder's Bridge and the century-old Bulkeley Bridge, on the right, offer parallel entrances to downtown Hartford, Connecticut. The downstream side of the Founder's Bridge has a wide pedestrian walkway connecting directly to the heart of downtown. At the foot of the bridge is a large amphitheater for public performances, the centerpiece of Riverfront Recapture's broad initiative to reconnect Hartford to its waterfront.

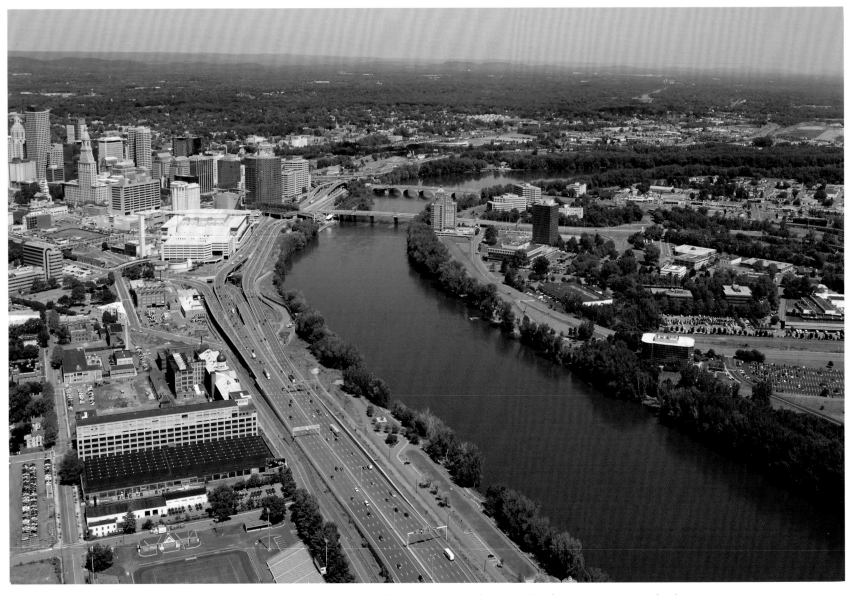

While roads, and ultimately Interstate 91, cut off Hartford, Connecticut, from its waterfront, the Riverfront Recapture organization leads the way in reconnecting people with the river. Newly landscaped parks line both sides of the river. A 350-seat amphitheater and public park are on the western shore. Great River Park, a boat launch and parking fill the eastern shore. The walkway across Founder's Bridge connects the two shores with features that include lookouts and sculptures. Designated a National Historic Landmark, the Colt Firearms plant (left foreground), with its blue onion dome presented by a Russian czar, is now being redeveloped as a center for commerce, retail and residences.

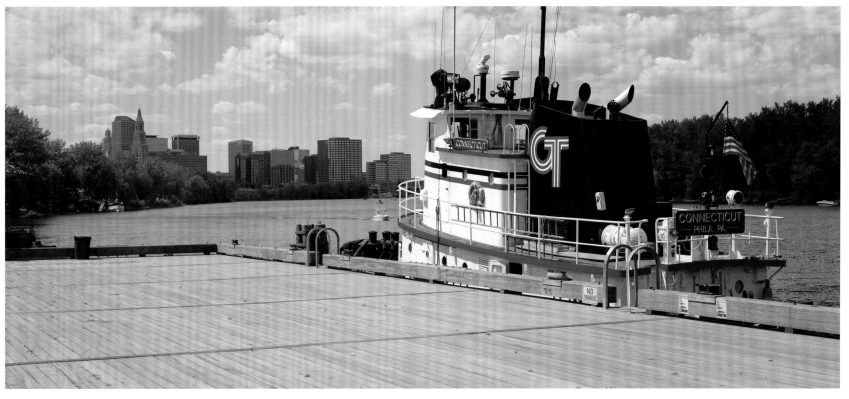

Hartford, Connecticut, was a riverfront city, with reliable steamship service to New York until 1931. The river
is dredged where needed to provide a minimum depth of ten feet from Old Saybrook up to Hartford's Bulkeley Bridge.
Shoals and sandbars are common, so a good chart, local knowledge and buoys are all important in navigating the river.
This type of tug transports barges on the river as far upstream as Hartford.

Boats are out in mass, rafted together in preparation for the Hartford Riverfest fireworks celebration. One of Riverfront Recapture's signature events, Riverfest brings large crowds downtown to the riverfront, which is becoming a place for enjoyment, recreation and community pride.

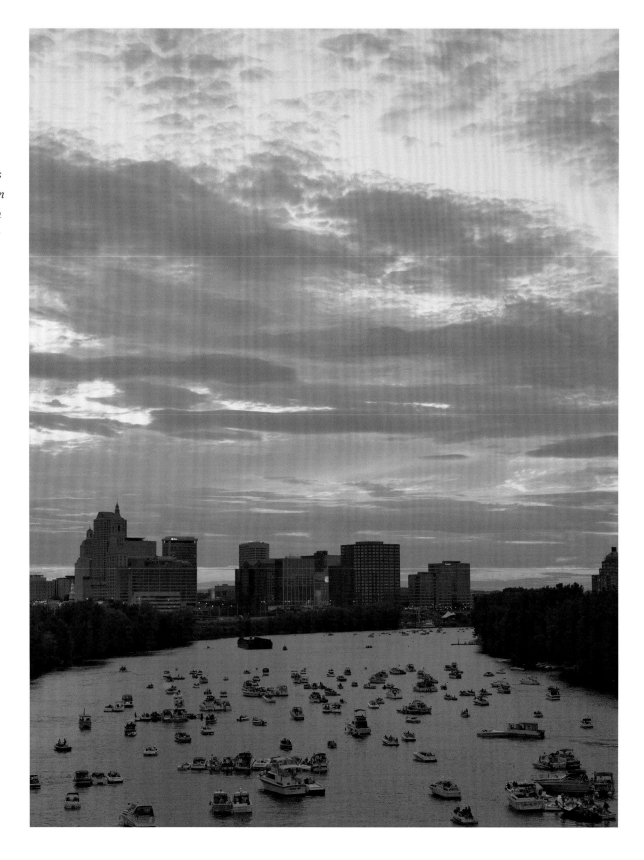

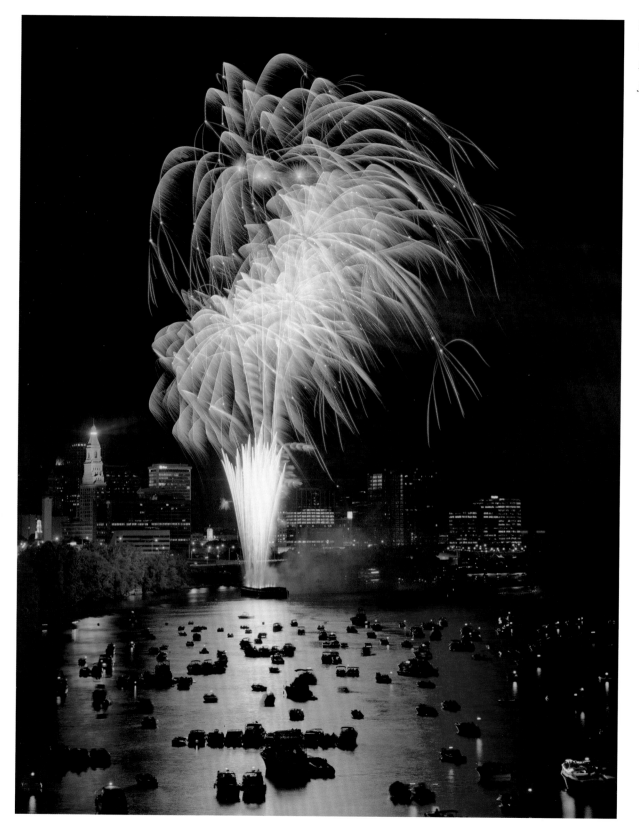

Hartford celebrates the Connecticut River with Riverfest fireworks.

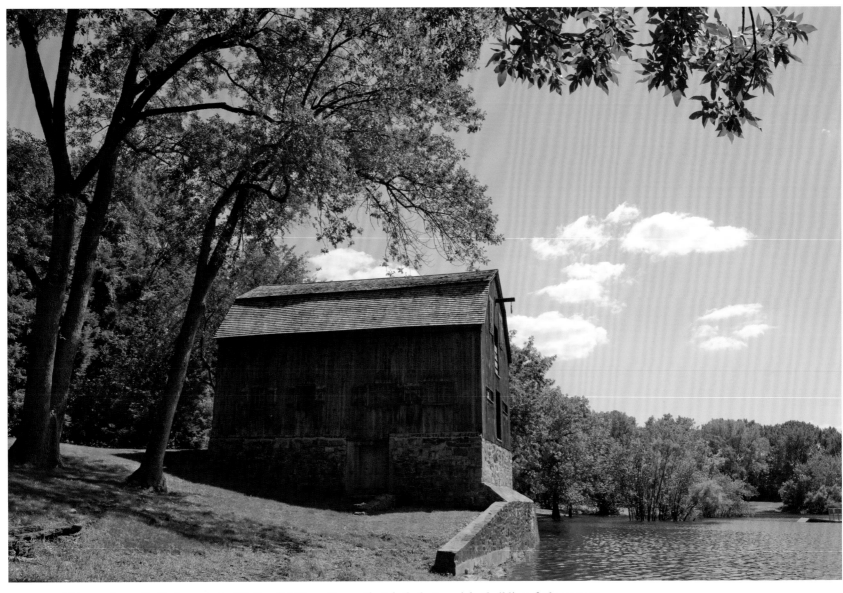

This warehouse (built circa 1790) at Wethersfield Cove, Connecticut, is the last surviving building of what was an active shipping port. The port began with a land grant for six warehouses in 1691. Even with the river's shift to the east, Wethersfield remained an active port into the 1830s. This image, at a time of high water, gives a sense that river boats could approach; however, after the warehouse was moved to a safe foundation, about fifty feet of beach usually separates the warehouse and waterfront.

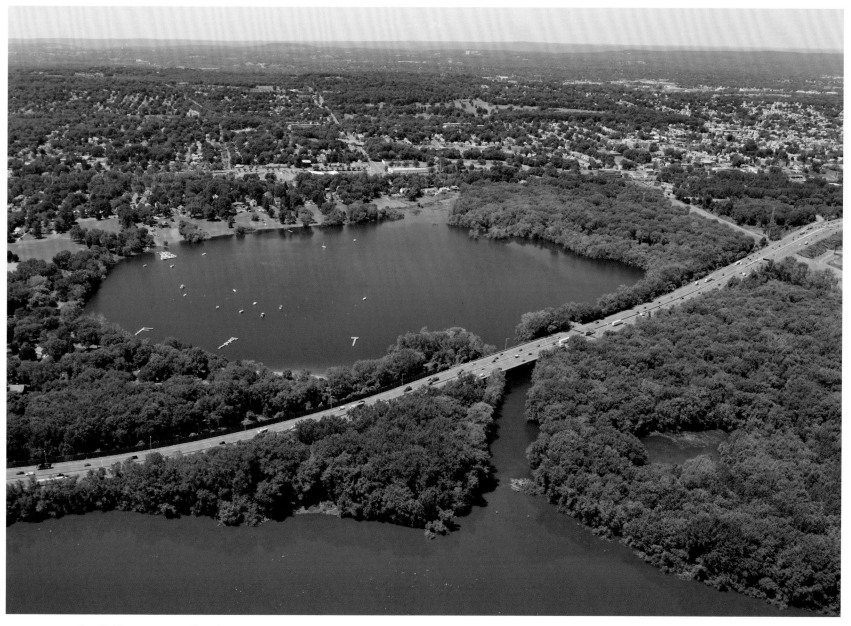

Wethersfield Cove, Connecticut, is now home for boaters and fishermen. Before a flood in 1692, however, the Connecticut River took a big meander around the southern and western edges of the cove before turning back to the north. That flood began to straighten the channel, eventually isolating the cove. A dredged entrance remains under Interstate 91, keeping the connection with the main stem of the Connecticut River.

Wethersfield Cove is a prime fishing spot along the Connecticut River. Northern pike,
black crappie, hickory shad and striped bass are frequently caught here.

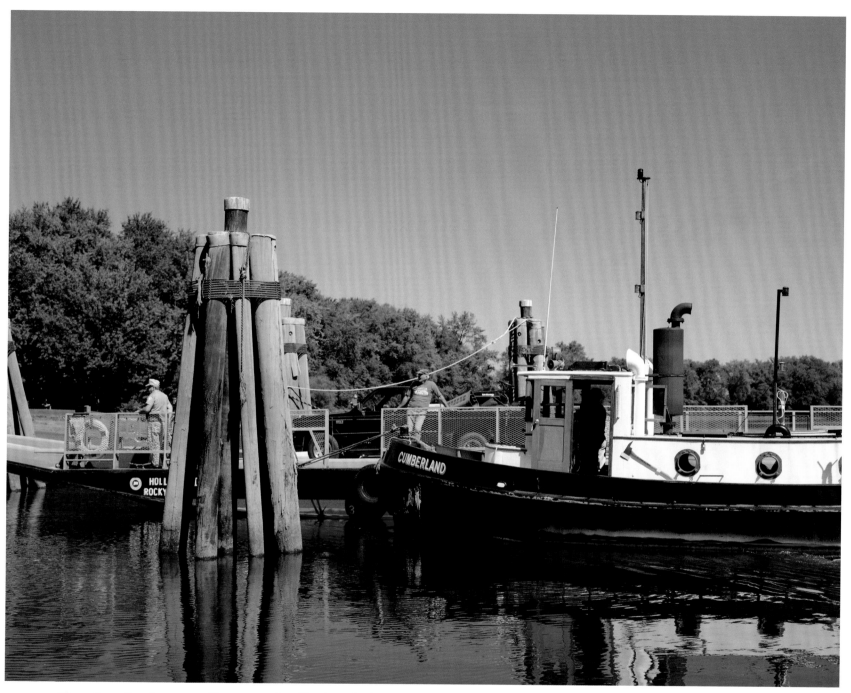

Since 1655, a ferry has operated between Rocky Hill and South Glastonbury, Connecticut. As the nation's oldest continuously operated ferry, it has gone through many versions, first being pushed by long poles, then powered by a horse on a treadmill and in 1876, by a steam-powered ferry. Today's ferry is a small tug towing a three-car barge across the river. Service runs May through October and is now operated by the State of Connecticut.

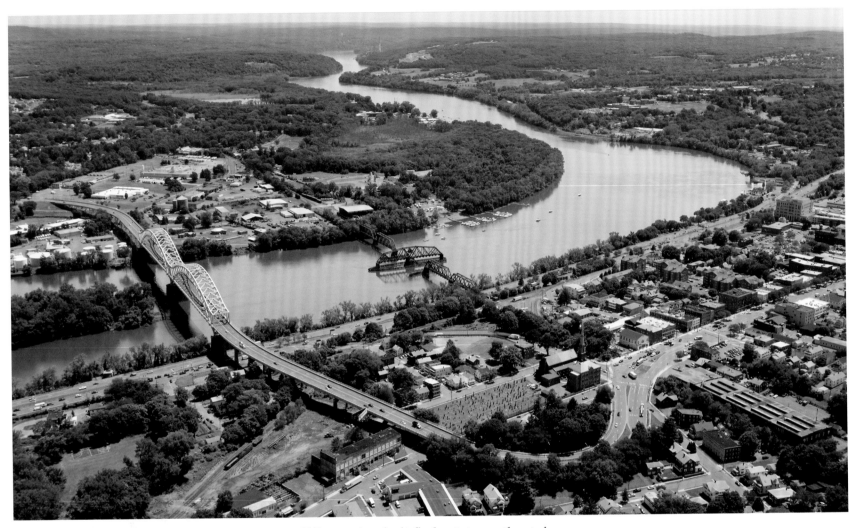

The Connecticut River takes a hard left turn at Middletown, changing its final route to a southeasterly direction as it cuts through the Bolton Ridge. Boaters will find Bodkin Rock located on the north shore of the ridge, an example of a hard granite called pegmatite that channels the river's course. This easterly running ridge is a result of a continental collision some 300 million years ago. The double arch Arrigoni Bridge and the turnstile railroad bridge connect Middletown with Portland, Connecticut.

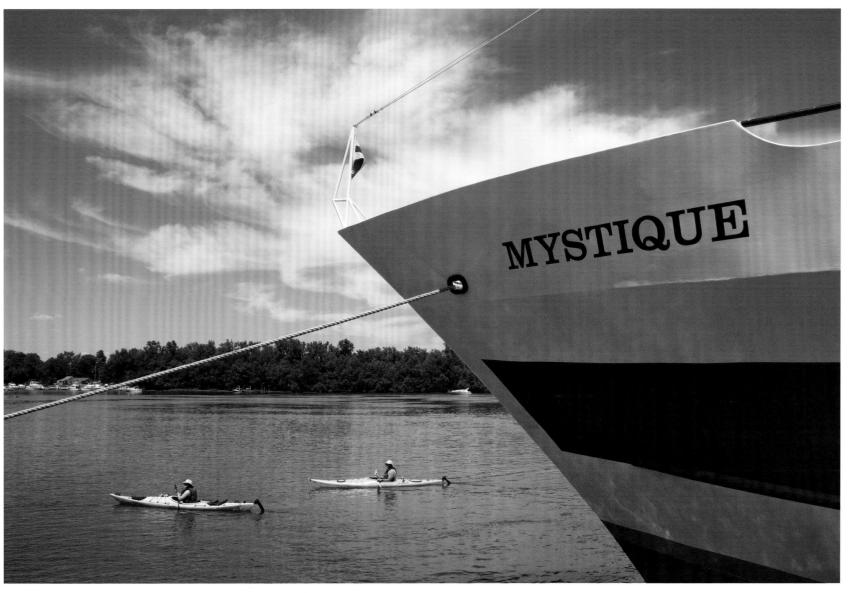

The waterfront at Middletown provides a contrast in scale between two ways of exploring the Connecticut River.

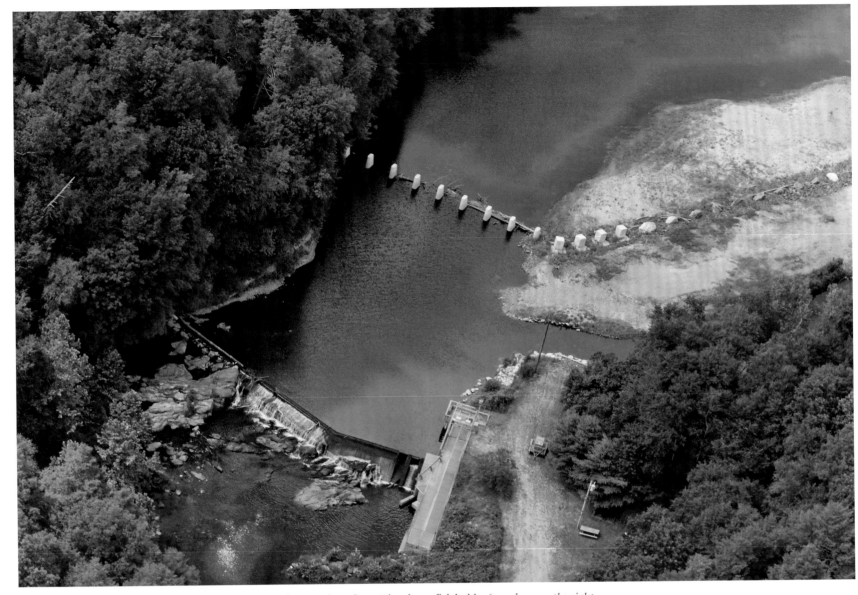

The Leesville Dam at East Haddam, Connecticut, on the Salmon River has a fish ladder (seen here on the right bank of the river) which is monitored as part of the Atlantic Salmon Restoration Program. The line of barriers above the dam is designed to break up ice in the winter. Much of the Salmon River above the dam is protected by the Wopowog Wildlife Management Area and the nearly 6,000-acre Salmon River State Forest. The river's cold water produces excellent trout fishing.

A great blue heron skims across the Connecticut River at Haddam Meadows State Park. In colonial times, this 154-acre floodplain was used as a common pasture for the village of Haddam, Connecticut, after the summer crops were harvested. It now provides trails, a picnicking area and large boat ramp with dock for river access.

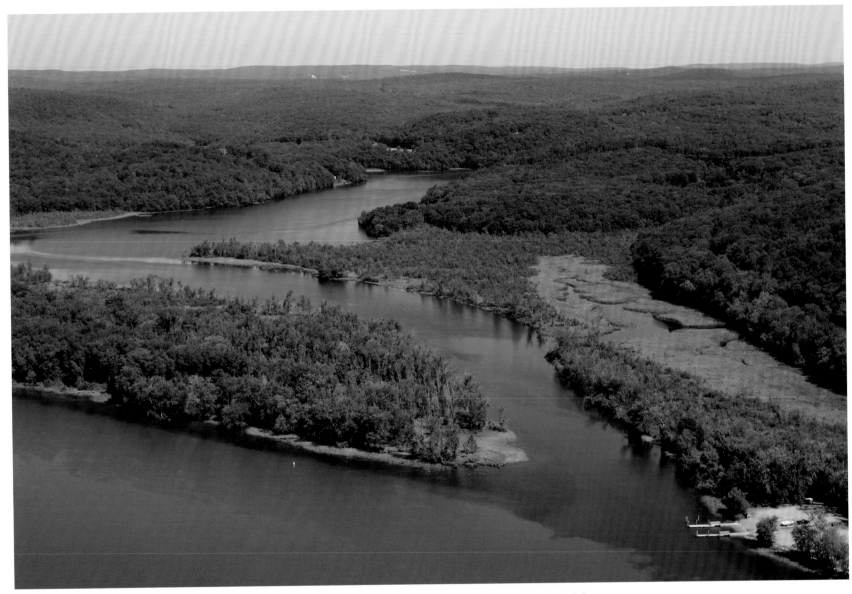

The Salmon River opens into Salmon Cove before it joins the Connecticut River. This freshwater tidal marsh is a favorite area for canoeing and kayaking. Nine species of freshwater mussels call the cove home, in part because of the clean water of the Salmon River and the minimal human impact on the marsh. In winter, it is bald eagle territory. The Brainard Homestead State Park, at the mouth of the cove, provides river access with boat ramp, docks and parking in East Haddam, Connecticut.

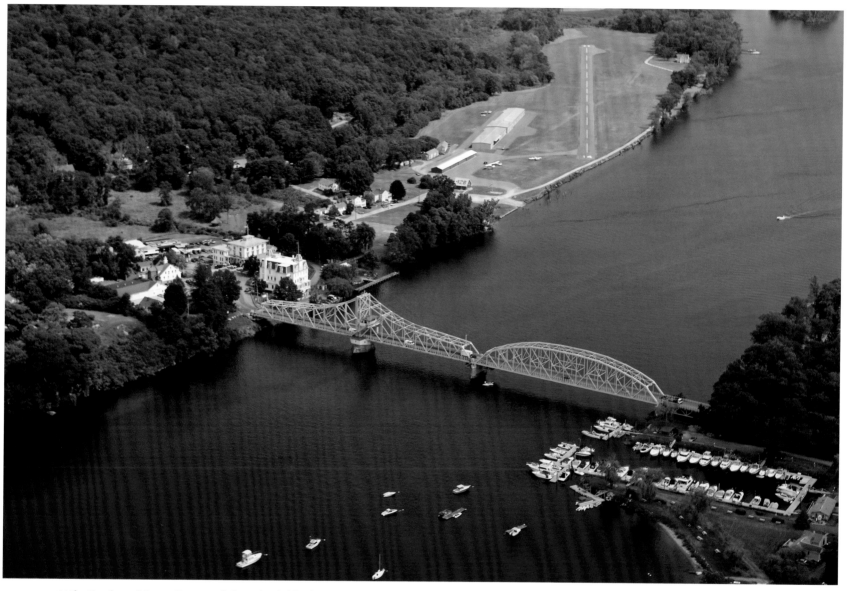

At the Goodspeed Opera House and the swing bridge in East Haddam, Connecticut, the river begins its movement to the Tidewater region. It has been running in a tight channel since breaking through the mountain ridges at Rocky Hill and Middletown. It will soon pass the Seven Sisters Ridge and Gillette Castle and begin to broaden, forming a series of ecologically important ponds, coves and estuaries.

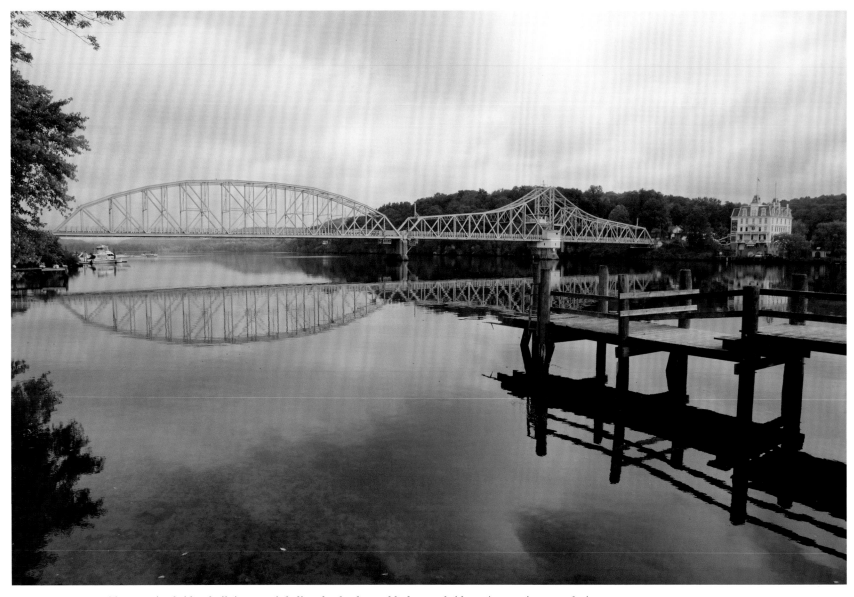

East Haddam's swing bridge, built in 1913, is believed to be the world's longest bridge using a swing truss design. Rebuilt in 1999, it carries over 11,000 cars daily and allows boats to pass by swinging the 461-foot turnstile section parallel to the river. It leads directly to the Goodspeed Opera House, built in 1876 and restored by 1963, which now is a center for musical performances in the area and a favorite landmark along the Connecticut River.

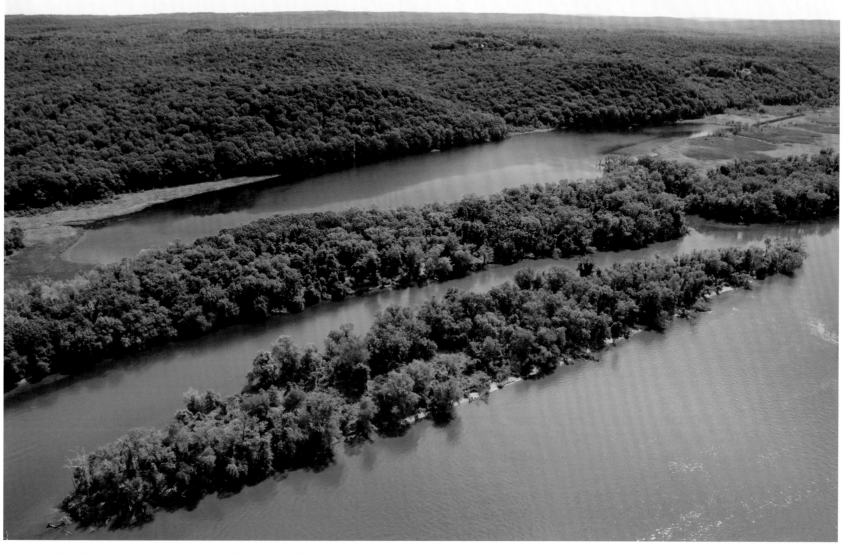

The Nature Conservancy preserves Chapman Pond, a premier freshwater tidal pond on the river's eastern shore in East Haddam, Connecticut. Known for wild rice marshes and bass fishing, it is a popular destination for canoeists and kayakers. The rice is well adapted to the tidal conditions and provides an important food supply for migrating ducks, rail, blackbirds and other species. This photograph was taken during a summer flood which turned the main stem of the Connecticut brown. It is interesting to note how little mixing of the waters occurs as the Connecticut flows by. Rich Island is in the foreground.

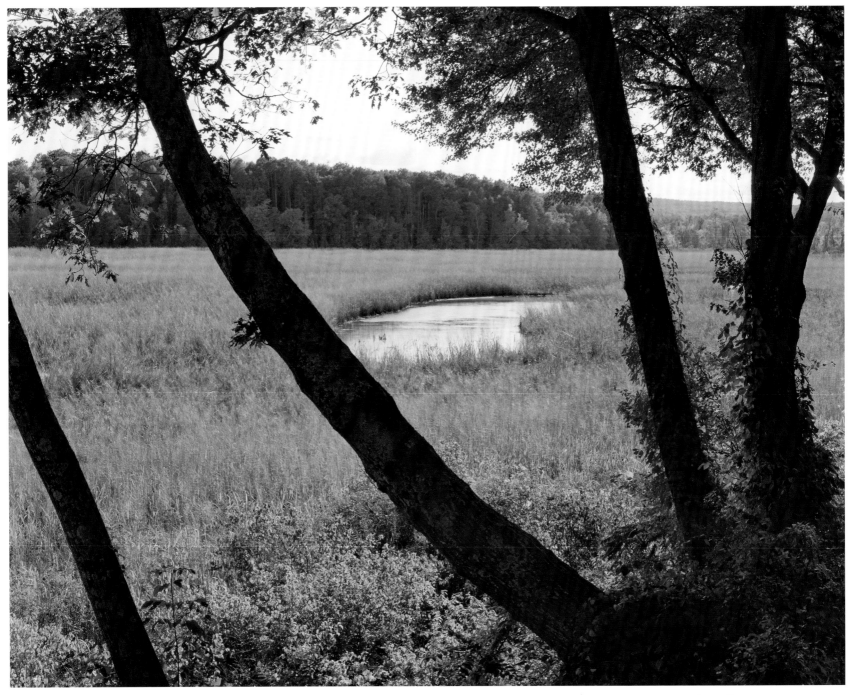

Whalebone Cove in the Hadlyme section of Lyme, Connecticut, is a freshwater tidal marsh well known for wild rice that can grow ten feet tall. It is an important part of the fall bird migration route, supporting wood ducks, black ducks, blackbirds and other species. Warblers and vireos call the cove home, while the surrounding trees provide roosting sites for blue herons and snowy egrets.

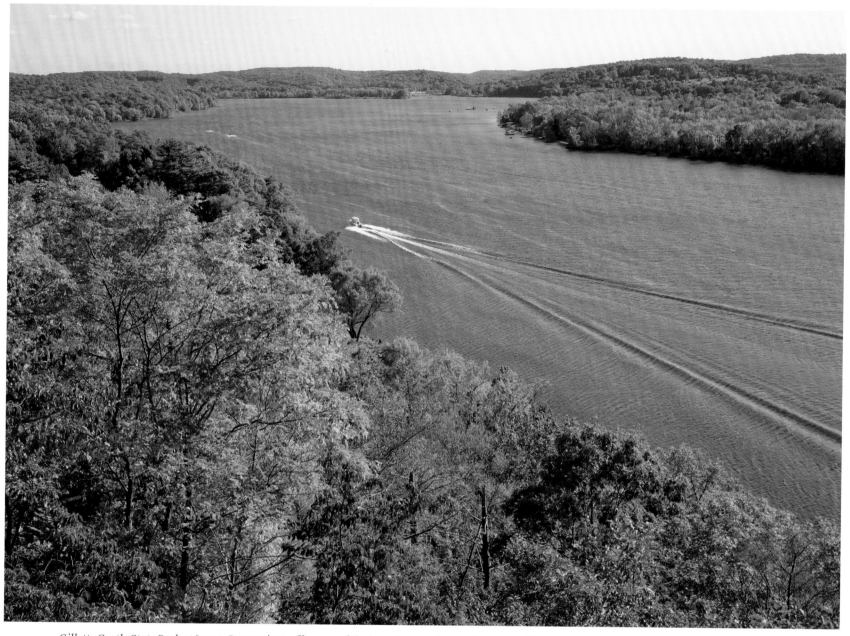

Gillette Castle State Park at Lyme, Connecticut, offers one of the best views on the southern part of the Connecticut River as it follows a bend toward Chester and Deep River, Connecticut. Gillette Castle was built between 1914 and 1919 by New York actor William Gillette on the southernmost hill in a ridge called the Seven Sisters.

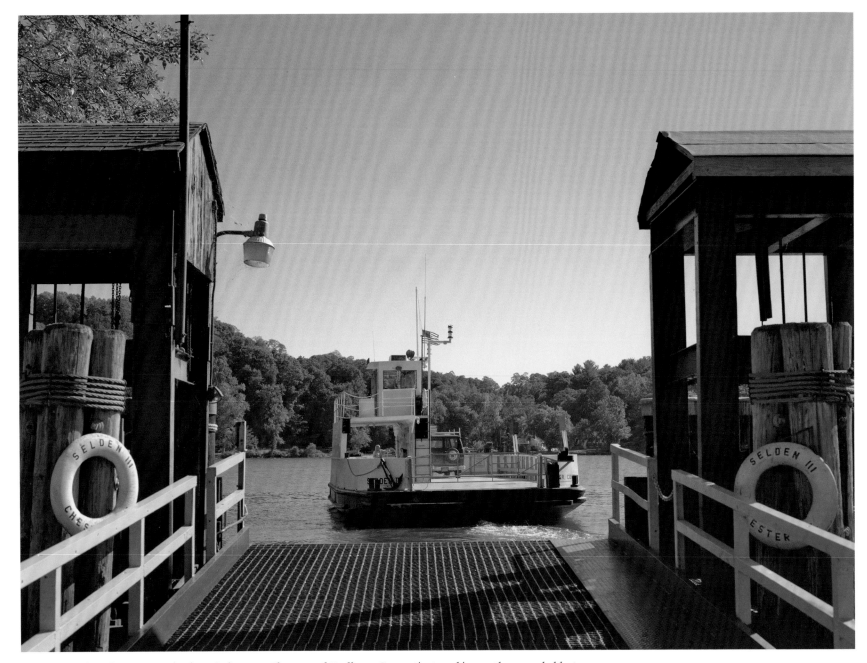

A ferry began operating in 1769 between Chester and Hadlyme, Connecticut, and is now the second oldest continuously operated ferry in the United States. Long poles were used to push the first version of the ferry, which was used extensively during the Revolutionary War. The ferry was replaced by a steam-powered barge in 1879 and remained in private hands until the State of Connecticut began operation in 1917. The current barge was built in 1949 and handles eight or nine cars per trip.

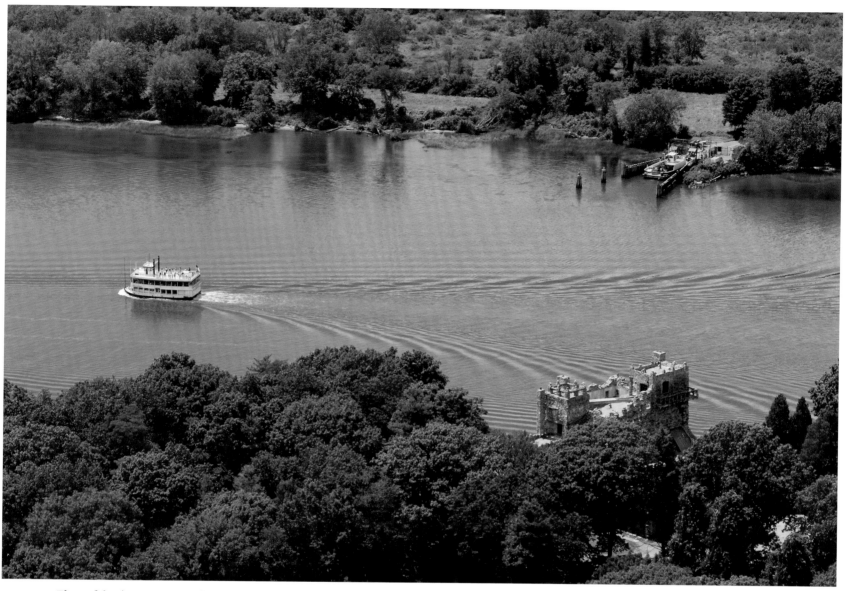

Three of the river's most popular attractions are visible in this Lyme, Connecticut, scene: Gillette Castle, the Chester-Hadlyme Ferry, and the Becky Thatcher cruise boat. The cruise boat connects to the Connecticut Valley Railroad's Essex Steam Train at Deep River, providing a "land and sea" view of the Connecticut River. The castle's woodwork and stonework are testament to Gillette's great imagination.

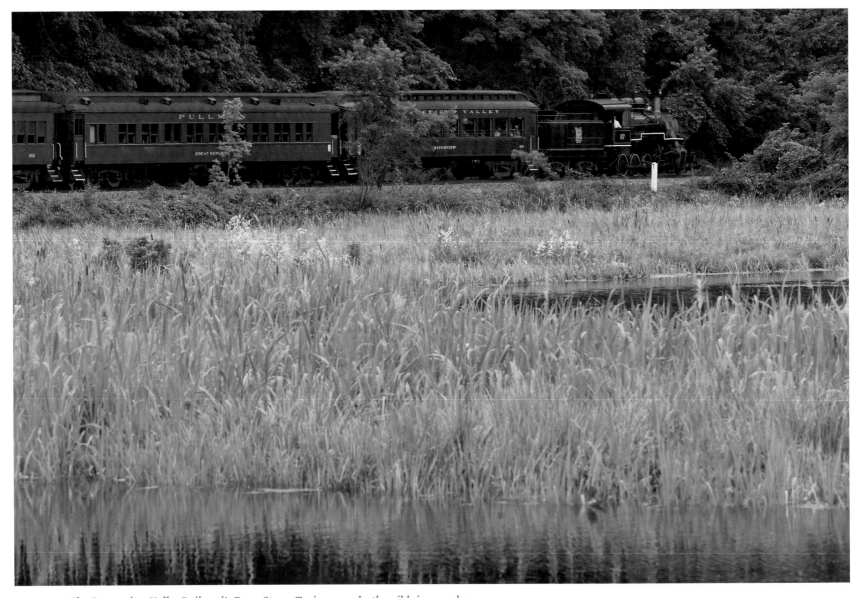

The Connecticut Valley Railroad's Essex Steam Train passes by the wild rice marshes at Pratt Cove, Deep River. The popular attraction travels from Essex to Deep River, Connecticut, where it connects to the Becky Thatcher cruise boat.

Wild rice and purple-flowered pickerelweed crowd the edge of the creek in Pratt Cove at Deep River, Connecticut. The Deep River Land Trust and the Nature Conservancy have both protected and studied the tidal freshwater marshes that surround Pratt Creek. The diversity of the plant life in the marshes includes cattail, tape grass, sedges, rushes, jewelweed and tearthumb. Mallards and black ducks are visitors during the fall migration.

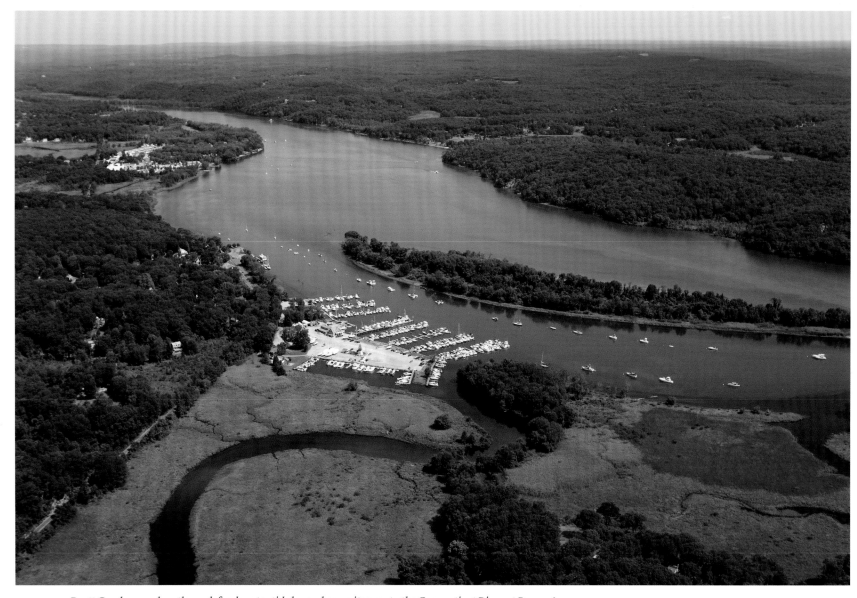

Pratt Creek meanders through freshwater tidal marshes on its way to the Connecticut River at Brewer's Marina. On the opposite shore is Selden Neck State Park. Four campsites, accessible only by water, are spread along the western shore and provide quiet sites for boaters on this southern part of the river.

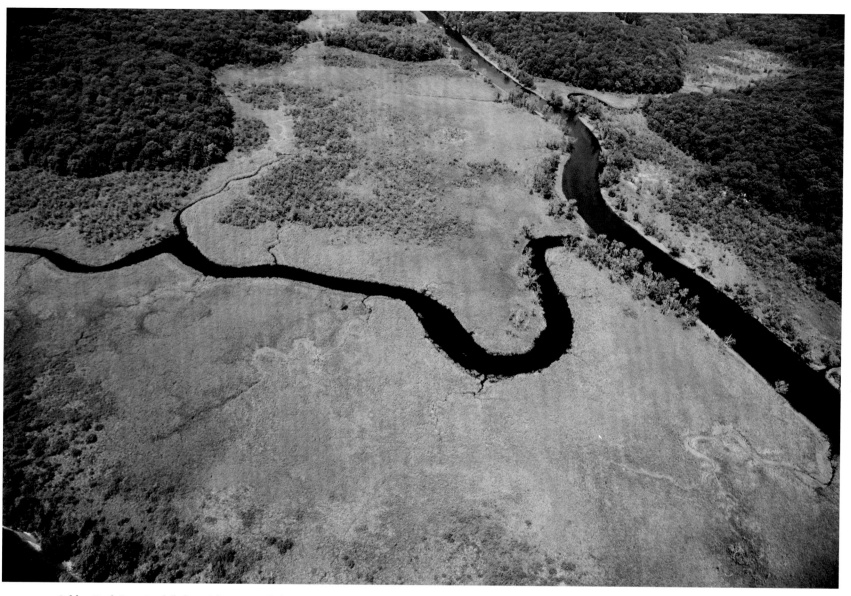

Selden Neck State Park (left and foreground) *is separated from the Lyme, Connecticut, mainland by* *Selden Creek* (right), *a popular canoe trek along the eastern shore known for great bird watching. Ospreys, great egrets, great blue herons, kingfishers and hawks are common, as are warblers, tanagers and orioles. The diversity of plant life is impressive and the channel is also home to painted and snapping turtles.*

This private dock at the end of Ely's Ferry Road in Lyme reminds us of the early days of riverboat travel.

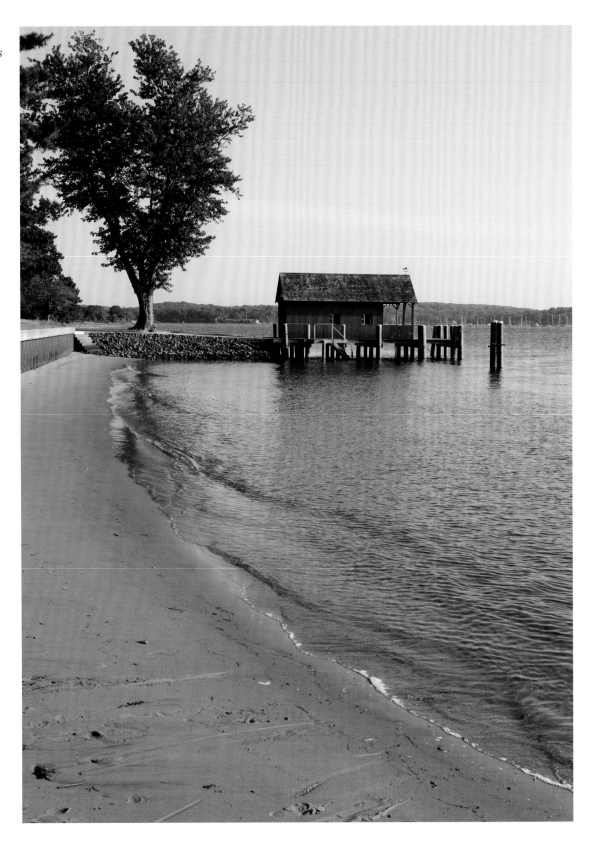

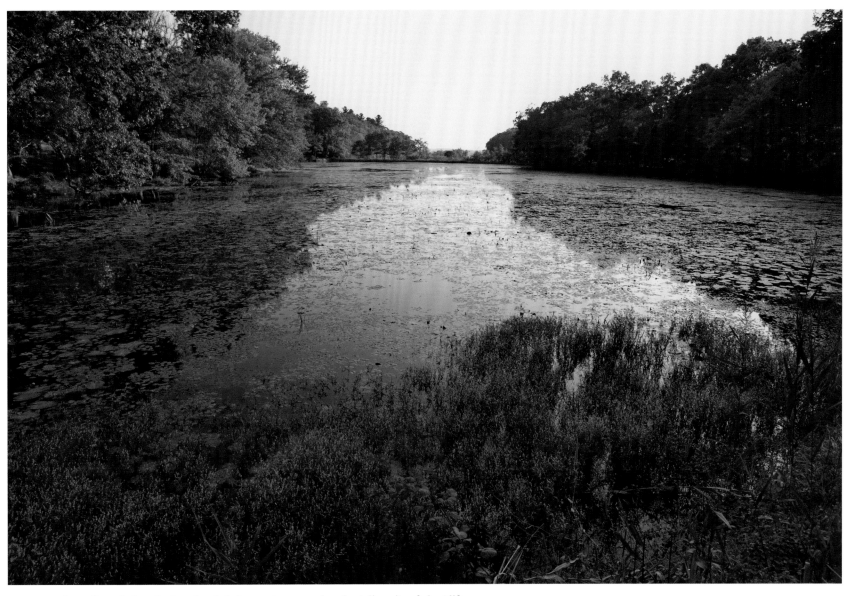

A small pond along Joshua Creek, in Lyme, shows an abundant diversity of plant life.

The granite face of Joshua Rock provides a landmark along the Lyme shore, just north of the mouth of the Eightmile River. It marks the western end of the Mohegan Range, a rare east-west ridge that extends to Rhode Island. Joshua Rock is named for Chief Joshua, a great Mohegan chief, who, it was said, sat at the summit and observed his tribe fishing below on the Connecticut River.

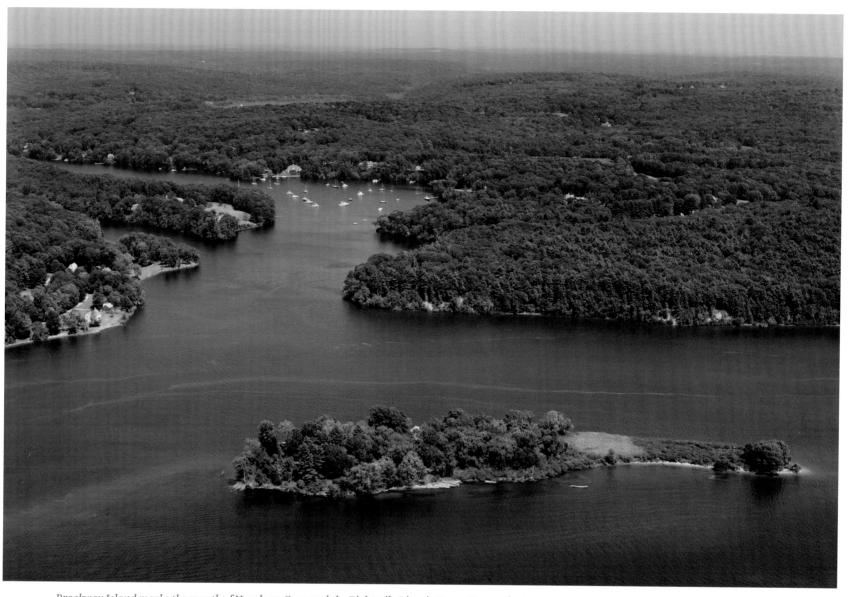

Brockway Island marks the mouth of Hamburg Cove and the Eightmile River in Lyme, Connecticut.
The river was named in colonial times for being eight miles upstream from the mouth of the Connecticut.
The Eightmile River was designated a Wild and Scenic River in 2008 in recognition of its important and
contiguous areas of habitat, rare and diverse wildlife, pristine water and unimpeded flow.

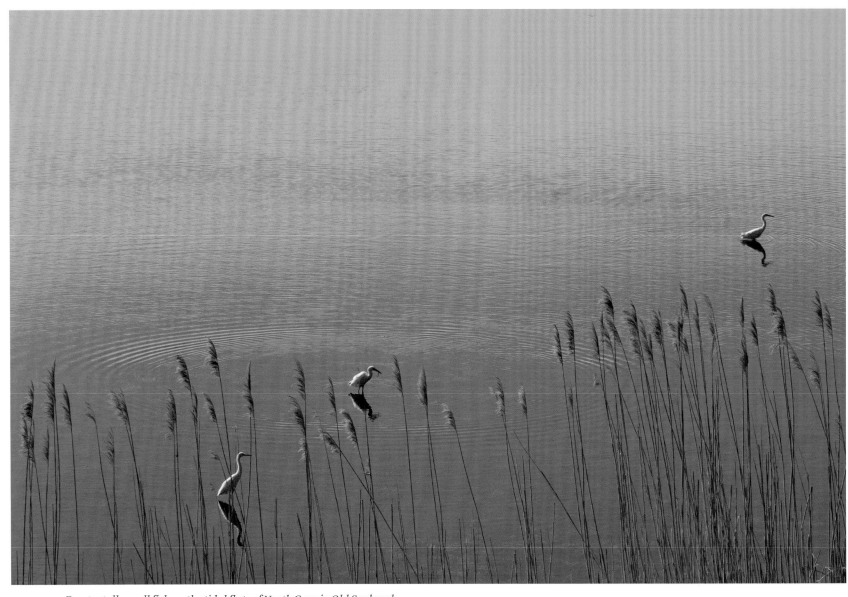

Egrets stalk small fish on the tidal flats of North Cove in Old Saybrook,
just beyond a line of invasive phragmites *on the shoreline.*

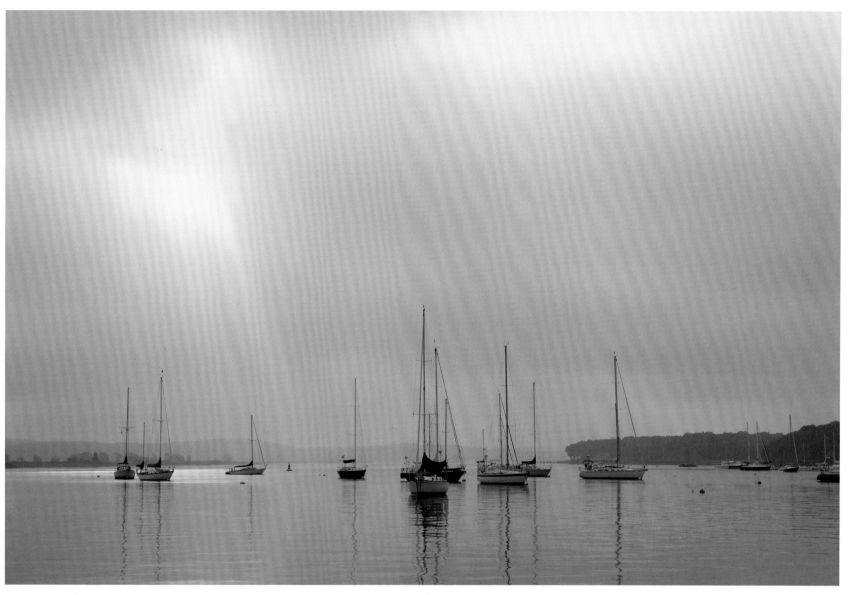

Sailboats ride at anchor on a quiet morning in Essex Harbor, Essex, Connecticut.

Native hibiscus (also known as rose mallow), narrow leaf cattail, and wild rice (upper right) are examples of the diversity of plant life near Lord Cove in Lyme, Connecticut.

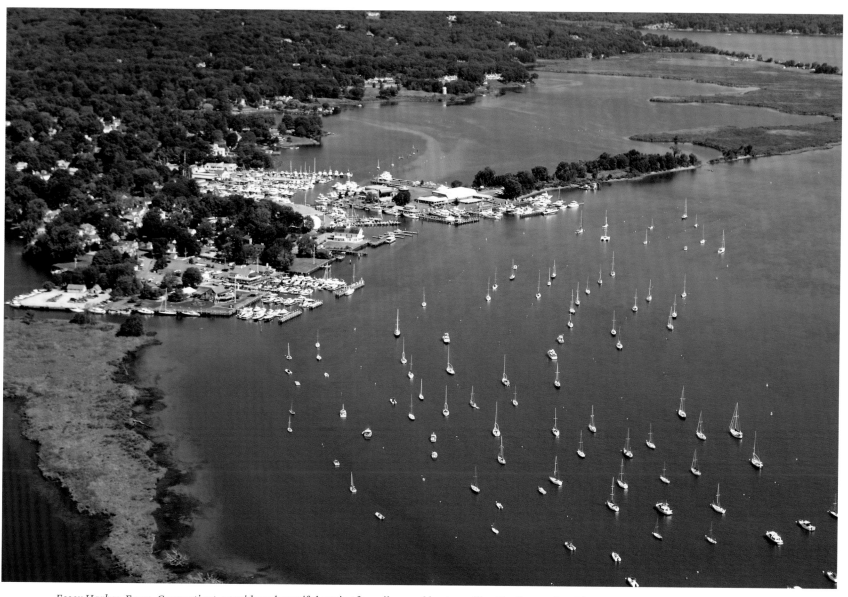

Essex Harbor, Essex, Connecticut, provides a beautiful setting for sailors and boaters alike. The Connecticut River Museum takes center stage at Steamboat Dock, offering visitors a wide-ranging history of the Connecticut River. Boat building began here in 1731 and became an important contribution to the Revolutionary War, with Essex's 300-ton Oliver Cromwell *capturing nine British ships. During the War of 1812, the British attacked Essex, sinking twenty-eight American ships.*

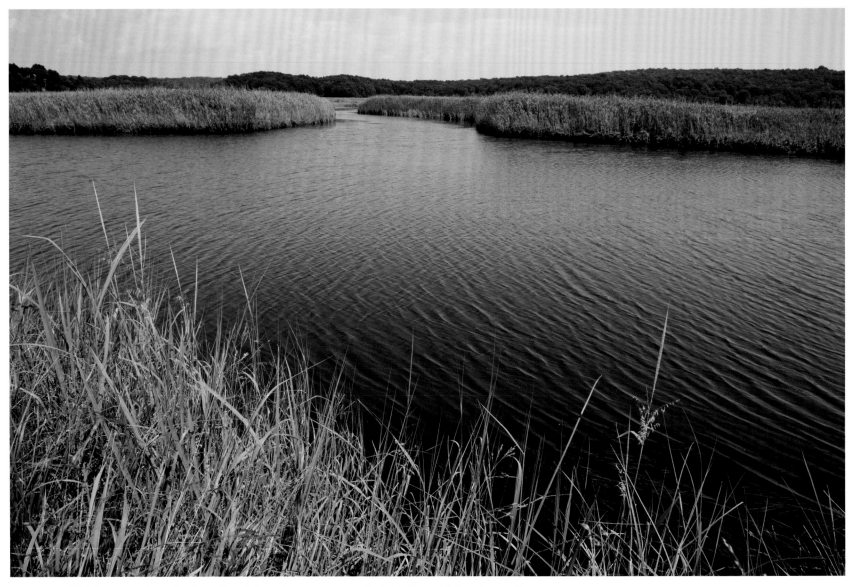

Wild rice grows along the shore of Lord Cove at the entrance to Coult's Hole. Wild rice, phragmites, *narrow leaf cattails and many grasses and sedges fill the marshes surrounding the cove. This immense cove complex in Lyme, Connecticut, is one of the major wildlife habitats in the Tidewater area. It is a key duck migration—and hunting—area for mallards, black ducks and teal.*

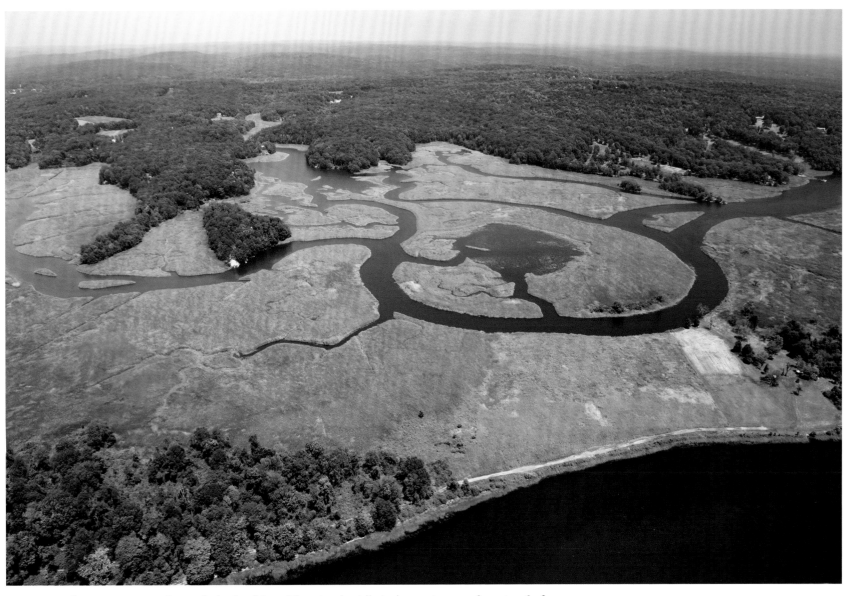

Bring your compass when exploring Lord Cove. The extensive tributaries create a complex network of channels heading in every direction in this rich habitat. Among the mammals thriving in the marsh are mink, muskrat and raccoon. Wild rice competes with phragmites, *cattails and many sedges and grasses. Wildflowers include milkweed and native hibiscus.*

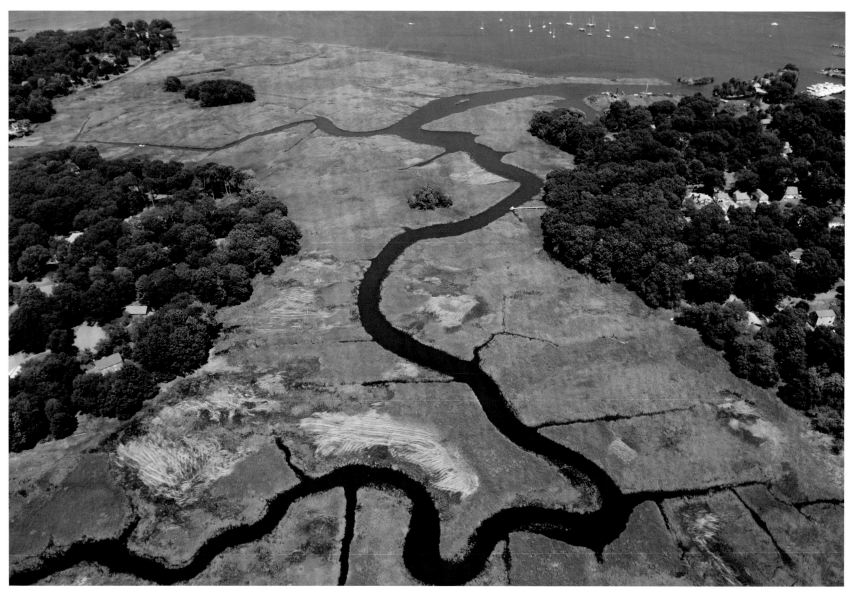

Brown areas show the work of marsh restoration at Ayers Point, on the north shore of Old Saybrook, Connecticut. In these areas where invasive phragmites *are removed, native plants will be encouraged to take their place.*

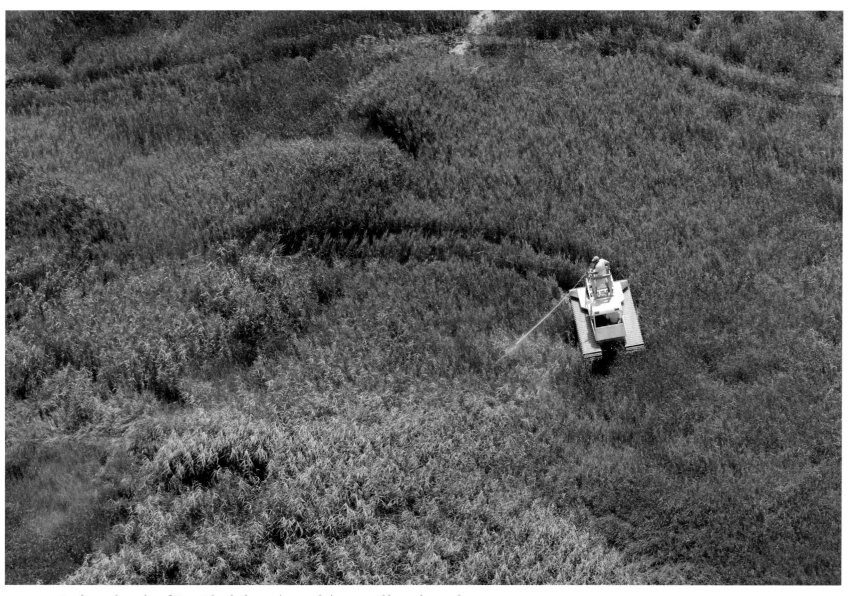

On the north portion of Great Island, phragmites *are being sprayed by workers under the supervision of the Connecticut Department of Environmental Protection. Hoping to stem the advance of this invasive species, workers will replace them with native grasses and sedges that support native habitats.*

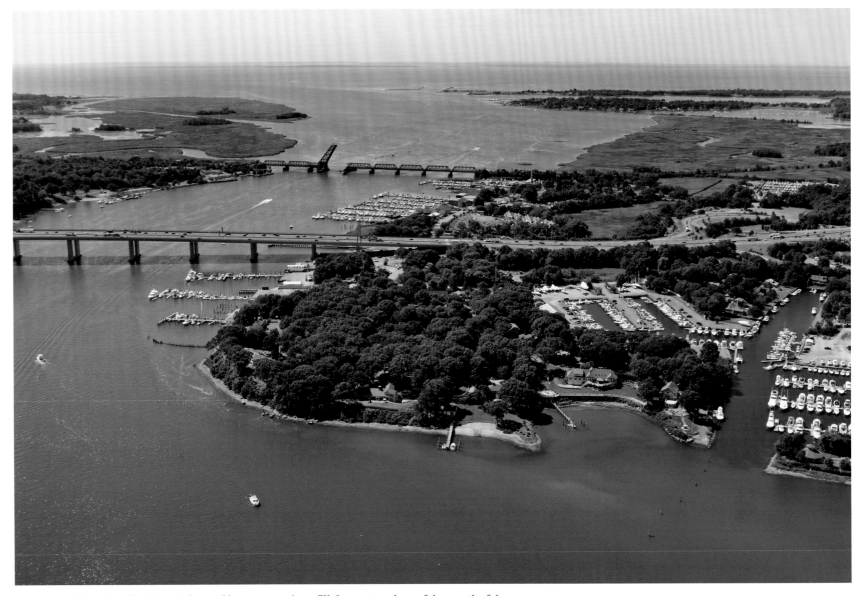

Old Saybrook at Ferry Point, and its many marinas, fill the western shore of the mouth of the Connecticut River. Interstate 95 crosses on the Baldwin Bridge, while Amtrak and the Shore Line East commuter rails cross on the river's southernmost bridge. In the distance on the right is Ragged Rock Creek, North and South Coves and the Borough of Fenwick. On the eastern shore is Great Island, in Old Lyme, Connecticut.

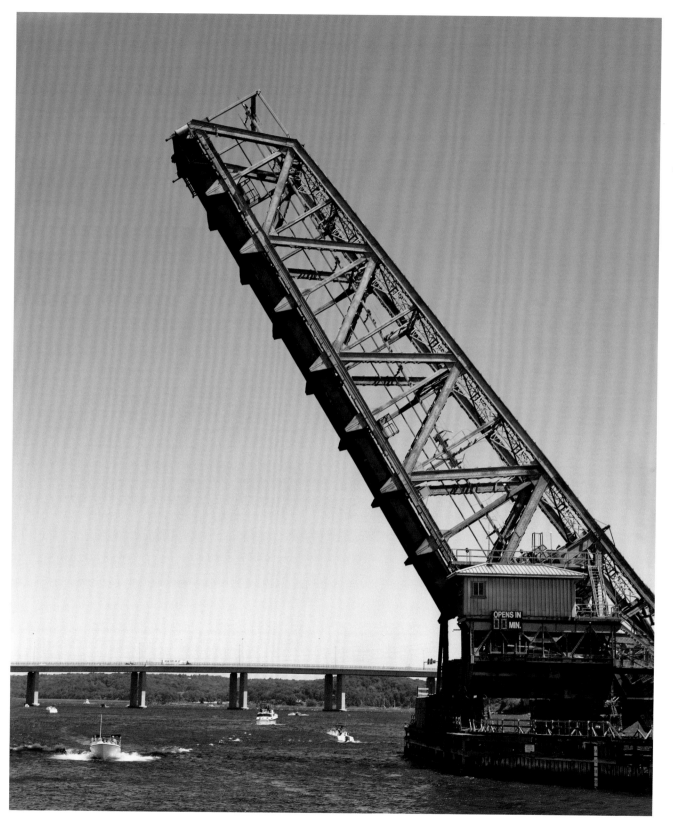

The Amtrak drawbridge at mile 3.4 from the mouth of the river was completed in 1907, spanning from Old Saybrook to Old Lyme.

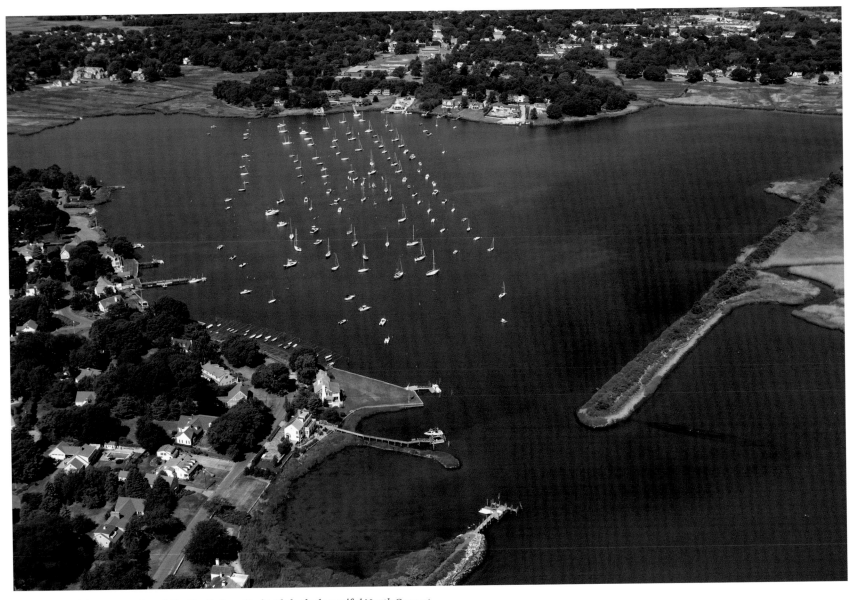

With Town Dock and the North Cove Yacht Club, the beautiful North Cove at Old Saybrook, Connecticut, is a popular anchorage. Egrets, cormorants and blue herons work these marshes during low tide.

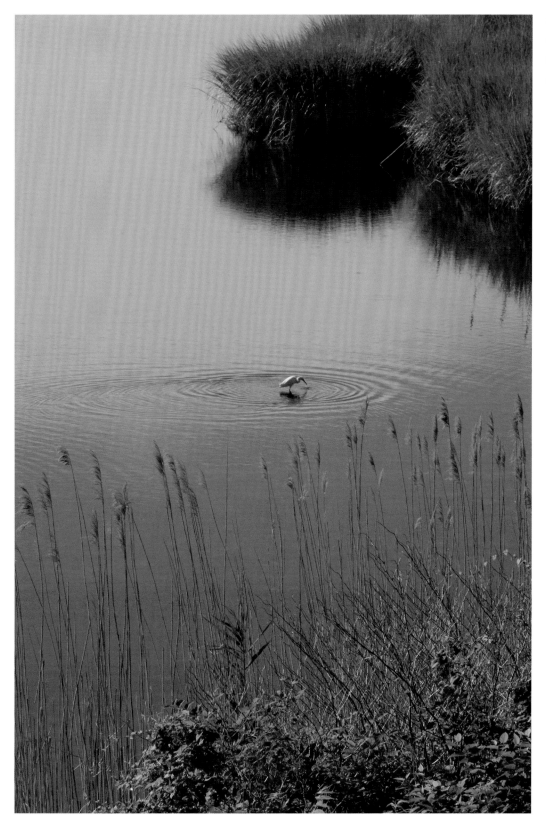

An egret fishes the shallows in North Cove at Old Saybrook, Connecticut.

The boardwalk at the Connecticut Department of Environmental Protection Marine Headquarters at the base of the Amtrak Bridge in Old Lyme is a popular fishing site and also provides views of the marshes at Great Island. October is good for bluefish.

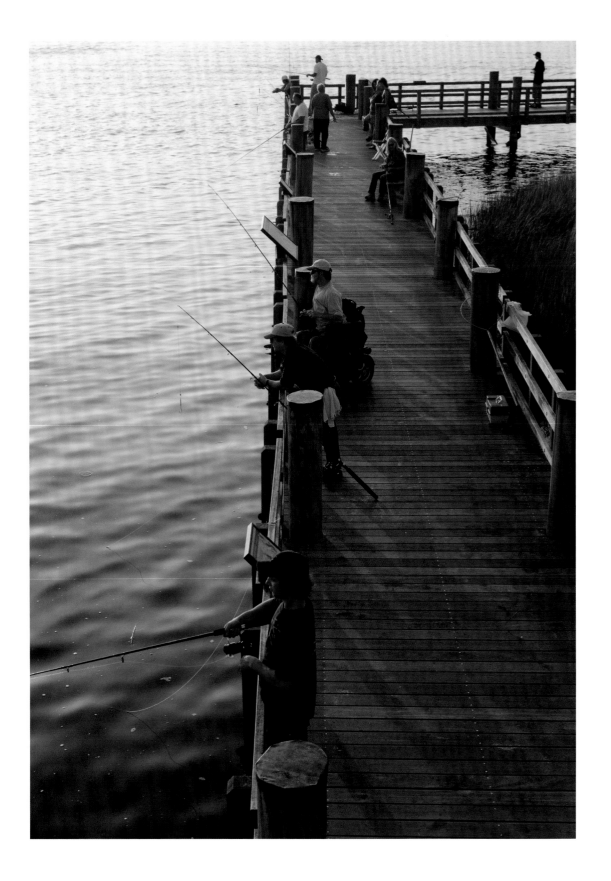

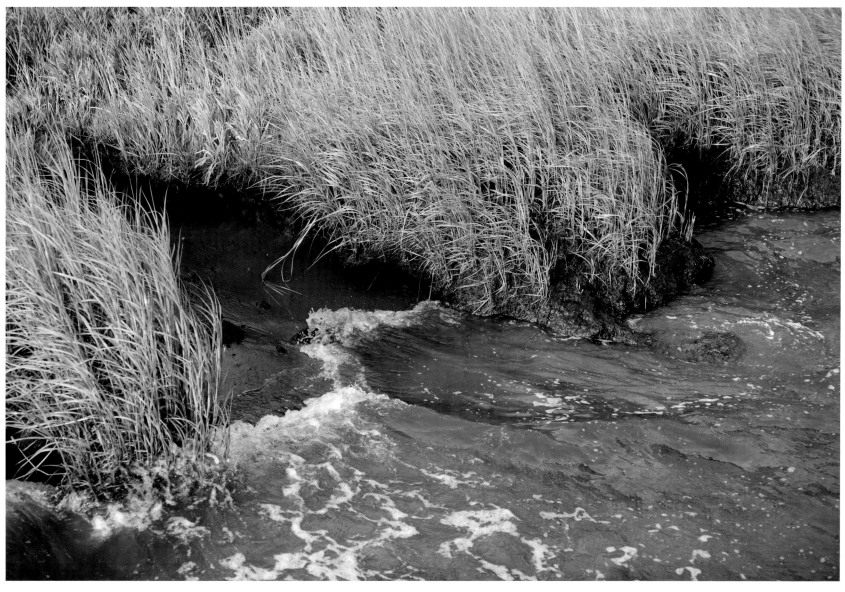

Saltwater washes in with the tide at these marshes in Old Lyme, Connecticut.

Saltwater grasses grow on peat that has built up over many years.

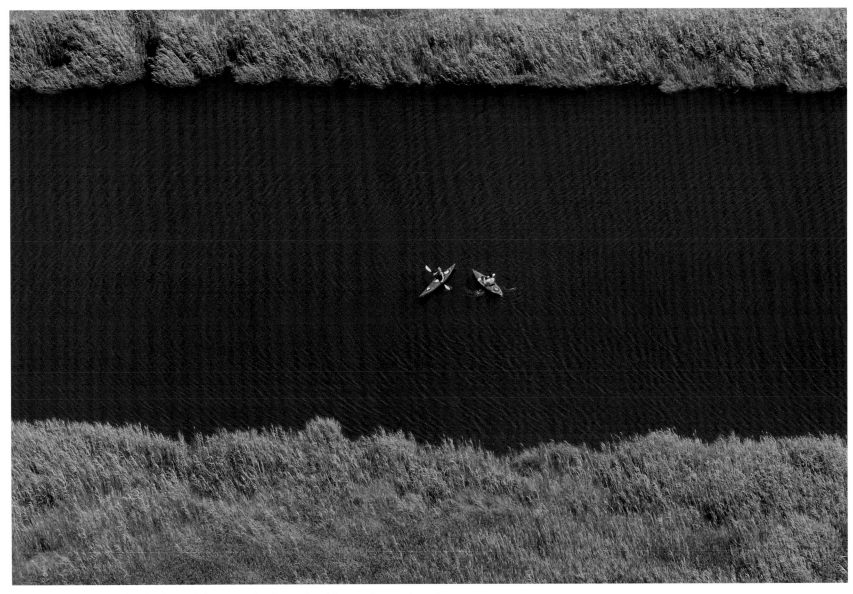

Kayakers enjoy the channels in Great Island near the Old Lyme, Connecticut, shore.

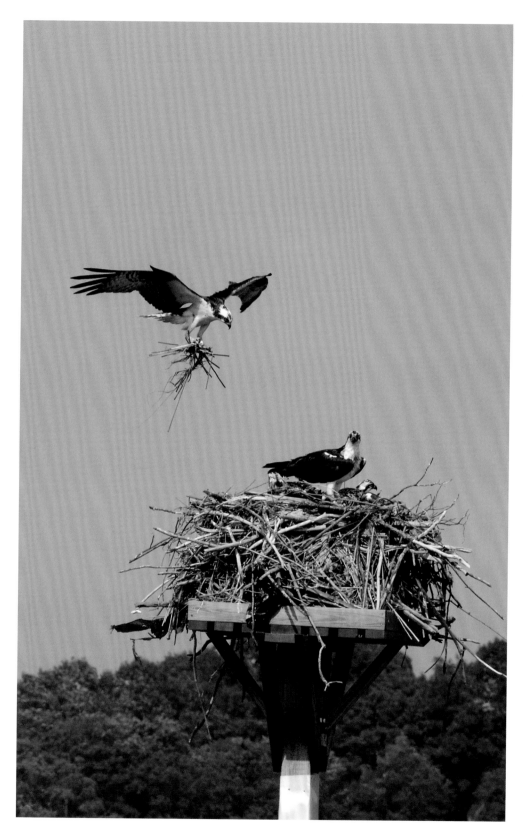

An osprey brings additional material to its nest near the mouth of the Connecticut River. The success at restoring the osprey population is a testament to enormous efforts by the state and conservation volunteers after the banning of DDT.

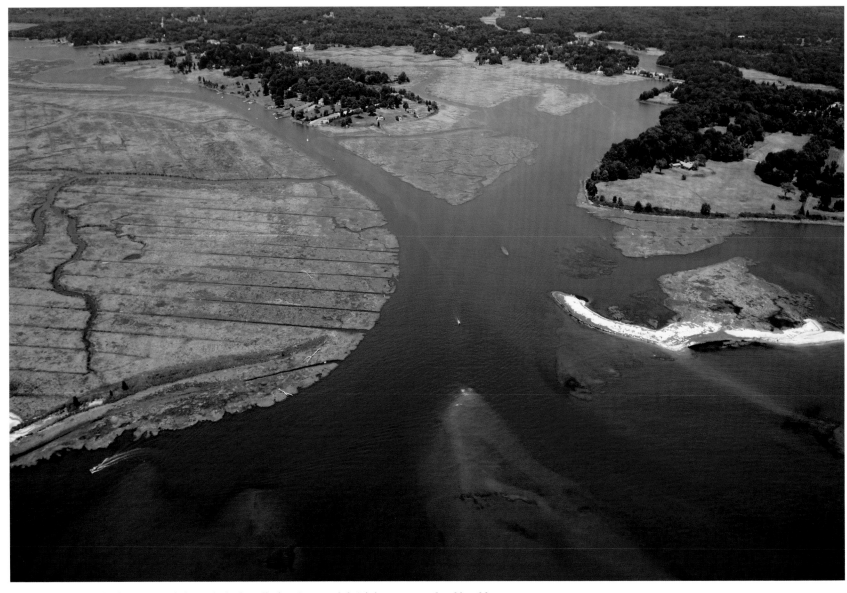

The Back River (upper left) *and Black Hall River* (upper right) *join at Great Island in Old Lyme, Connecticut, as they enter Long Island Sound. The sandy arm of Griswold Point swung way out and protected the entire end of Great Island as recently as 2002. Since then, major winter storms have washed away much of Griswold Point, providing an example of the continual shifting sands and bars along the river's mouth. The parallel ditches on Great Island were dug in the 1930s to control mosquitoes. They are now recognized as disruptive to the marsh habitat and are being allowed to fill in.*

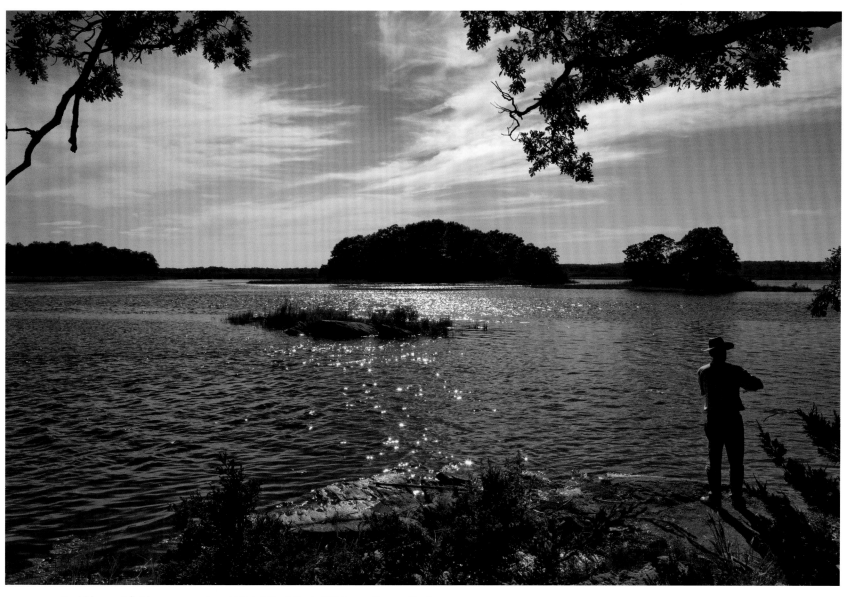

Crabbing and fishing are popular at Watch Rock Park, Old Lyme, Connecticut, a preserve
along the shore behind Great Island. Clumps of exposed bedrock within Great Island provide
a foundation for clusters of trees that sustain pockets of woodland habitat.

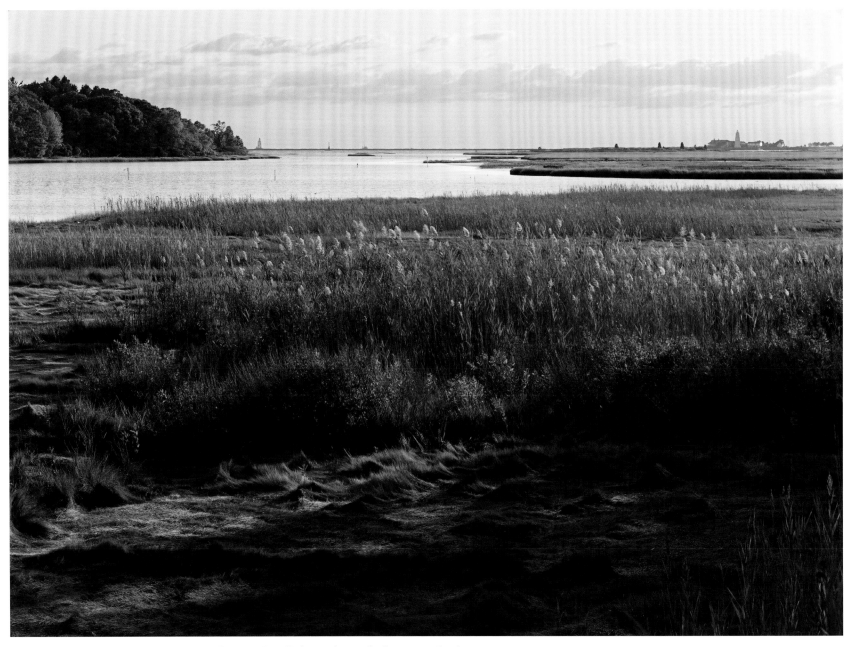

Brackish marshes line the edge of the Black Hall River as it empties into Long Island Sound. The lighthouses of Saybrook Jetty and Lynde Point on the horizon mark the mouth of the Connecticut River.

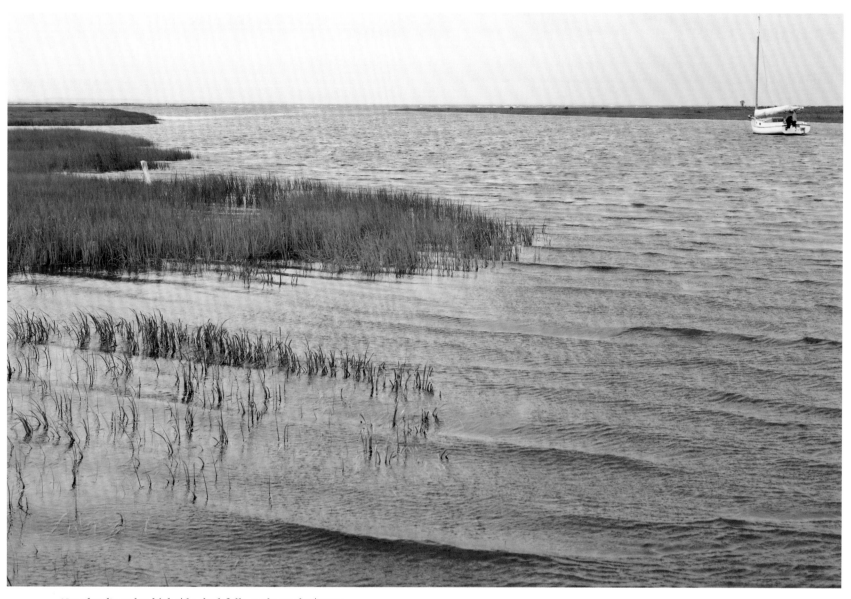

*Near land's end at high tide, dusk falls on the Back River as
saltwater flows into the spartina grass marshes.*

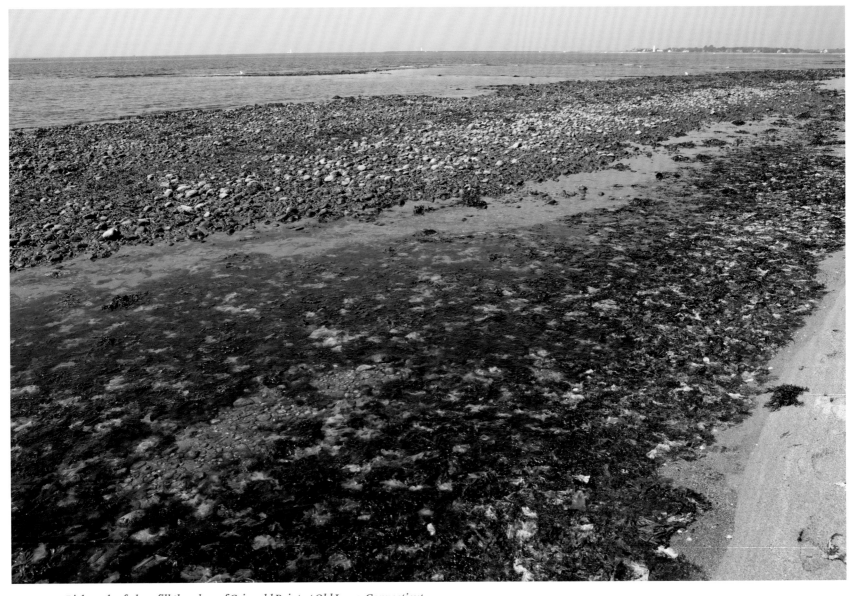

Rich pools of algae fill the edges of Griswold Point at Old Lyme, Connecticut.
Their active photosynthesis provides the organic mix at the base of the food chain
as well as important habitat for crustaceans, insects and small shellfish.

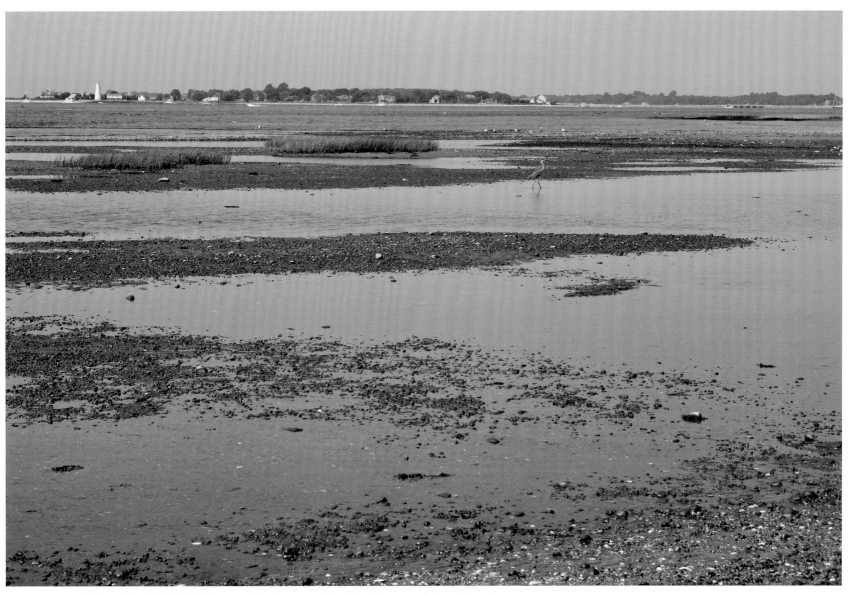

Low tide at Griswold Point finds a great blue heron working the shallow pools. Any fish and crabs trapped here are a quick prey for herons, egrets and terns who flock to these tidal flats. This site is also a protected habitat for the endangered piping plovers that nest nearby.

The harbor entrance at Old Saybrook, Connecticut, is marked by the sixty-five-foot Lynde Point Light, built in 1838. The station is now automated and operated by the U.S. Coast Guard.

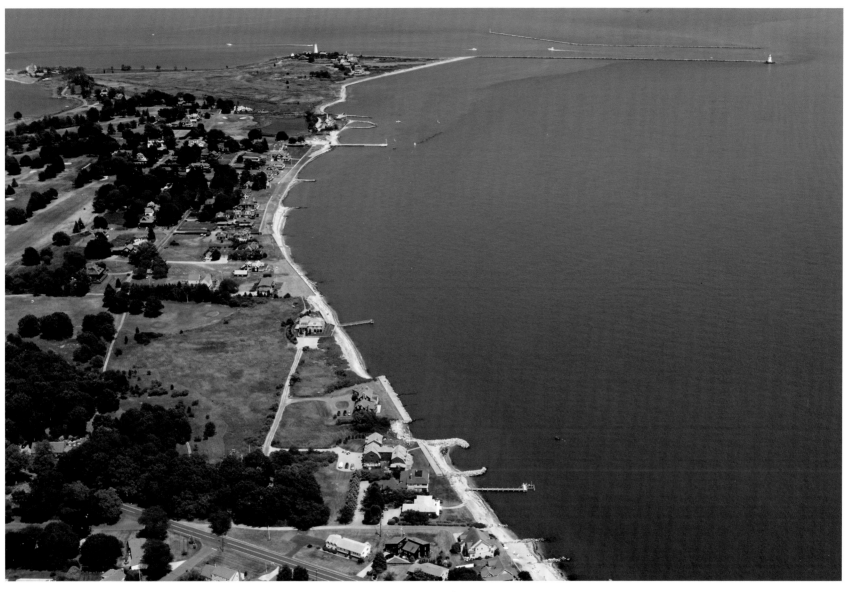

The Saybrook Outer Bar Channel heads into Long Island Sound, past exclusive residences in Fenwick, Connecticut. Dredged to twenty feet, the channel provides the only safe passage into the Connecticut River. Its small size and the surrounding sandy shallows have prevented the river from becoming an industrial port. This "blessing in disguise" has helped protect the ecologically important estuaries of the lower river from development.

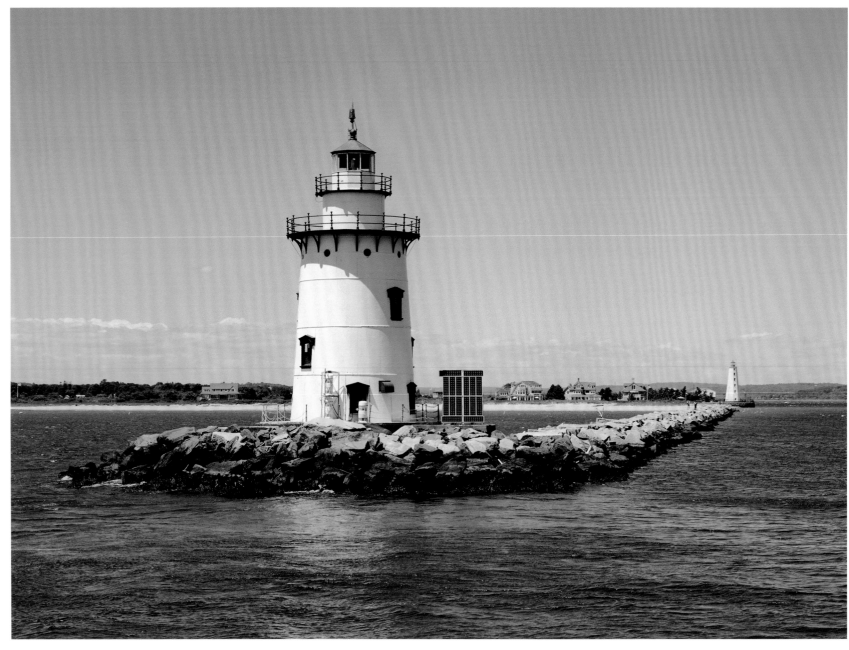

An icon of the State of Connecticut, this lighthouse on Saybrook Jetty marks both the very end of the Connecticut River and the entrance to her many prized harbors. This cast-iron lighthouse began operating in 1886, replacing a buoy at the river's mouth, and has been automated since 1959. Its image has been featured on Connecticut license plates with the motto "Preserve The Sound."

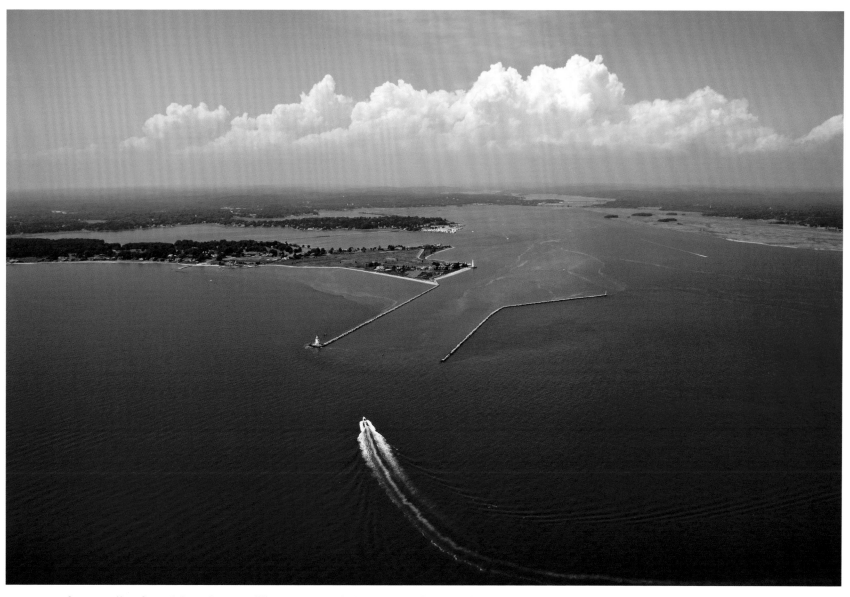

After 410 miles of travel through a 7.2-million-acre watershed and a 2,600-foot elevation drop, the Connecticut River flows into Long Island Sound, bringing 70 percent of its fresh water. The majestic river now supports 2.3 million people and hundreds of other species in an immense ecological and recreational resource covering major parts of New Hampshire, Vermont, Massachusetts and Connecticut.

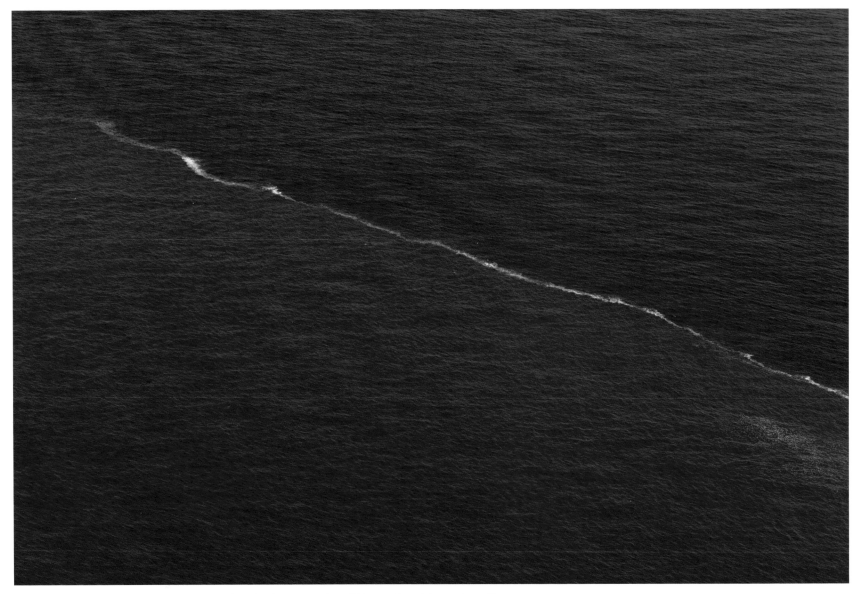

The last echo of the Connecticut River, fresh water pushes offshore at low tide creating a line of rich contrast with the saltwater of Long Island Sound. Water that began in the mists above the Fourth Connecticut Lake returns to the sea, completing yet another cycle of nature.

Afterword This Is a Place Worth Defending

When Al Braden asked me to write an essay for this book, I was honored and a bit daunted by the responsibility of trying to capture in words what he does so eloquently in his photographs. As you have seen in these pages, the Connecticut River is beautiful and diverse. Al's stunning images show why this region brings out such passionate advocacy from those who live here. It powers our homes and provides refuge to people and rare species. It is a place for us to laugh with our children and share with them the joys of discovery. More difficult to see are the threats to the Connecticut River's health and the impact they have on our communities—and what we can do about them. This is a place worth defending, worth the necessary time, effort and resources that will keep its waters clean and its fish and wildlife healthy.

The Connecticut River starts as a mere trickle at the northern tip of New Hampshire, a stone's throw from the Canadian border. Moose, heron and the rare pine marten drink from these headwaters. Loons call across the Connecticut Lakes. It is a rugged area, known for its beauty and for the solace that can be found in its large stands of spruce fir forests.

The river flows 410 miles, draining more than 11,000 square miles. On its southward journey, the Connecticut passes under covered bridges and flows by swallows' nests, steepled churches and Native American petroglyphs. As it is joined by other streams and rivers, its bed expands and its flow increases. Sometimes meandering, other times rushing headlong downstream, the Connecticut River flows past a diverse landscape of rich farmlands, rural communities and urban centers.

As it flows to Long Island Sound, the lower Connecticut's network of freshwater, brackish, and saltwater marshes contains wetlands of international importance. The undisturbed marshes are havens for the shortnose sturgeon, piping plover and other rare species, offering food-rich nurseries and pathways for migratory fish and birds.

Al Braden's images remind us of the river's ability to provide us with power, transportation and food. It is famous for its log drives and the innovative precision manufacturing that took place along its banks. It was the nation's first large river developed for transportation. Recently, its ecological value has begun to receive wider acclaim. In 1997, the Connecticut River Watershed Council donated Third Island in Deerfield, Massachusetts, to formally establish the Silvio O. Conte National Fish and Wildlife Refuge. It is the only refuge designated to protect the flora and fauna of an entire watershed and one of just a handful that has fisheries protection as a key mandate. The Connecticut is also one of only fourteen rivers in the United States designated an American Heritage River by an American president, an acknowledgment that its rich heritage, ecological importance and natural diversity have national significance.

ISSUES CONFRONTING
THE CONNECTICUT RIVER BASIN

For those who live here, the New England landscape is woven through our daily lives, becoming part of our identity. But pollution and development pressure are slowly taking their toll on that identity. Our formerly compact villages are sprawling into the countryside and our fertile agricultural lands are being subdivided and paved over. Premier cold-water streams, a haven for fish and anglers, are being polluted and diverted, creating more pressure on the land and water, threatening the health of these vital natural resources. *It doesn't have to be this way.*

The issues facing the Connecticut River basin—pollution from urban sewer overflows and hot water discharges, and habitat loss and fragmentation, to name a few—present serious threats to our natural heritage. Given what is at stake, these issues demand that we work side by side to find solutions that work for our communities today and provide future generations with natural rivers, grasslands and forests.

ISSUE 1: COMBINED SEWER OVERFLOWS

The biggest threat to the health of the Connecticut River is failing sewage collection and treatment systems. The Connecticut River basin contains some of the oldest sanitary systems in the country. The combined sewer systems in the three Massachusetts cities of Springfield, Chicopee and Holyoke alone dump an average of one billion gallons of sewage-laden water every year into the Connecticut and Chicopee Rivers. These discharges come from "combined sewer overflows," or CSOs. They are triggered by as little as one tenth of an inch of rain, which can overwhelm aging systems.

This pollution means that in many urbanized areas, when it rains, the Connecticut River is not meeting water quality standards that ensure safe fishing and swimming.

Though progress has been made eliminating CSOs, it has been exceedingly slow. While our nineteenth-century systems continue to deteriorate, construction costs continue to mount. The longer these conditions linger, the worse the problems become as already stressed sanitary systems try to cope with ever-greater volumes of input and runoff. *It doesn't have to be this way.*

Solutions to Combined Sewer Overflows

With persistence and hard work it is possible to stop sewage overflows into the Connecticut. Our first priority is to alert the public when bacteria levels make the river unsafe. That requires increasing the amount of water quality testing that is taking place in CSO communities and issuing alerts when bacteria counts exceed recommended levels for recreational use. Signs that identify discharge pipes should be visible from land and water, making it clear to the general public that untreated or partially treated sewage may be discharged there.

We also need a long-term strategy to control and eliminate sewage from the Connecticut. In fact, communities that have sewage overflows are supposed to develop long-term plans to do just that. Appallingly, several communities have been allowed to operate for two decades or more without a plan. The U.S. Environmental Protection Agency and state departments of environmental protection should send the clear message that municipalities operating without long-term control plans, and those that exceed their permit levels, will be held accountable for violations of the Federal Clean Water Act.

Solutions must also include ensuring that adequate financial resources are available for fixing combined sewer overflows. In the Hartford, Connecticut, region, where an additional one billion gallons of sewage overflows into the Connecticut and local streams, residents recently passed a bond referendum to replace and add stormwater pipes and increase sewage storage capacity. The bond's passage made

these communities eligible for Clean Water Funding, a combination grant and loan program administered by the state. State and federal funding, through grants and low-interest loans, is a vital component to ensuring that a comprehensive fix is feasible.

ISSUE 2: POLLUTION FROM THERMAL DISCHARGES

The clean, crisp waters that flow from the upper Connecticut Lakes and in many streams throughout the basin have long supported a vibrant cold-water fishery. The region has drawn anglers in search of brook, rainbow and brown trout. Regrettably, thermal pollution—the discharge of hot water from industries and power plants—increases the temperature of our rivers, making them particularly inhospitable to species that need colder water.

Thermal discharges are all the more important to control in the face of climate change, which is predicted to reduce the range of cold-water and cool-water fish by an average of 50 percent nationwide.

Power plants, industries, dams and runoff from paved surfaces all contribute to heating the Connecticut and its tributaries. A significant source of thermal pollution occurs at the Vermont Yankee Nuclear Power Plant at Vernon. Since the early 1990s, when Vermont Yankee runoff began increasing the temperature of the river, the American shad population near the plant has declined by a shocking 99 percent.

Vermont Yankee can discharge up to 543 million gallons per day at a temperature that can reach 105 degrees. The resulting thermal influence has been detected up to 50 miles downstream at the Holyoke Dam. *It doesn't have to be this way.*

Solutions to Thermal Pollution

The Connecticut River basin can once again be a haven for cold-water fish and the anglers that pursue them. Studies mapping the thermal load of the Connecticut River are vital to helping us understand the cumulative impact these discharges have on our river. In-stream temperature monitoring should be a requirement for all thermal discharge permits. Best available technologies should be used to reduce the volume and temperature of cooling water. For example, Vermont Yankee, arguably one of the largest sources of thermal pollution in the basin, has cooling towers designed to reduce water temperature before discharging it into the Connecticut River. The nuclear plant often bypasses these cooling towers to shave costs, putting our aquatic resources at risk. Dry cooling technology could be an alternative, which is more protective of water quality. It uses radiator-type coils to disperse heat, resulting in no thermal discharge, reduces water usage by up to 98 percent and allows power plants to be located away from major water bodies.

ISSUE 3: HABITAT LOSS, ALTERATION AND FRAGMENTATION

Rivers and riparian zones are considered among the most dynamic and diverse habitats in the world. They are vital pathways for the movement of many species of fish, plants, birds and mammals. Habitat alteration, fragmentation, and loss threaten the ecological integrity of the Connecticut River basin. Dams are a source of significant negative impacts. There are at least 1,000 dams in the Connecticut River basin (some estimates put the total at double that number). Dams impair a river's health by cutting off migratory paths for fish and other aquatic species. They isolate species and populations. Because dams alter natural river flows, they can reduce small-scale, beneficial flooding, separating a river from its floodplain. Ponding behind dams can also alter river habitat by increasing river temperatures, decreasing the amount of available oxygen, concentrating pollutants, and burying vital river-bottom habitat under sediment.

Inappropriate development throughout the Connecti-

cut River basin also threatens to alter our New England landscape by destroying vital wildlife habitat and farmlands. Stormwater pollution increases with these land-use changes. Increased development stresses local services including sewer and wastewater treatment plants. Filling wetlands, building in floodplains and cutting vegetation along rivers also destroy vital habitat and increase the risk of large-scale flooding. These changes adversely affect the character of our communities, diminishing their diversity and the natural beauty of our lands and waters. *It doesn't have to be this way.*

Solutions to Habitat Loss, Alteration and Fragmentation

We are fortunate to live in a region where working farms, open space, marshlands and diverse forests are still a part of our lives. Preserving the integrity of these vital habitats is not only within reach, but something each of us can directly contribute to. Individual decisions might include choosing an existing home with a modest footprint over new development, minimizing the amount of pavement around our home, planting native vegetation and buying locally grown foods.

Many of the dams that exist in our watershed are "deadbeat dams" that no longer serve their intended purpose. Removing them will restore and reconnect riverine habitats. Dams deemed necessary for flood control, hydropower or other reasons should be managed in ways that protect the health of the river and species. Over the next ten years, six Connecticut River hydropower dam licenses will come up for renewal. These licenses are valid for thirty to fifty years. License renewal time gives us a rare opportunity to have a positive, long-term impact by advocating for management practices that balance our need for power with conservation of natural resources.

AN INDIVIDUAL PERSPECTIVE

While writing this essay trying to describe both the incredible progress we've achieved and the threats that still exist, I decided to go for a bicycle ride to clear my head. I hadn't set out to ride to the Connecticut River, about ten miles from my home, but that is where I ended up. I rode past people sitting and laughing together in the yard, a father and two boys fishing in a local pond, balloons tied to a mailbox signaling the day as important and a woman pulling tomatoes off a plant nearly as tall as she was.

A few miles into my ride I connected up with a rail trail, the Norwottuck, which means "in the mist of the river." I rode alongside a protected wetland where painted turtles sunned themselves on a fallen log. Here, a couple weeks ago, I'd watched a great egret move deliberately through the water in pursuit of a meal. Today, wild grapes were ripe for the picking, their sweet scent luring me to stop more than once as I made my way toward the Connecticut River.

The path was full of people enjoying the cool afternoon—walkers deep in conversation, families on bicycles and on foot and a scout troop with binoculars and pouches full of natural treasures hanging from their necks. At one point, the path serves as a boundary between fields of pumpkins and corn and grazing cows on one side, and strip malls and construction on the other. At the river, the path crosses a 1,400-foot trestle bridge that spans the Connecticut, joining Hadley to Northampton.

I stopped to look down at the kayakers and motorboaters, the dock used by the university rowing team and large Elwell Island.

Something one of my daughters said to me not long after I became director of the Watershed Council came to mind. She was seven, and, upon catching sight of the Connecticut River, exclaimed, "Mom, there's the river you work for." Her observation was on target but as I rested from my ride,

I realized that what the organization has done particularly well over the years is to work on behalf of this incredible basin *and* the people who live here. We advocate for the river, and the child fishing, the woman in her garden, the turtle on the log, and the friends gathered in celebration. As one of the oldest watershed organizations in the United States, we have been pioneers in the understanding that we are connected—to each other and to this river—and that to consider either in isolation diminishes us all.

For centuries, countless residents and travelers have found inspiration and renewal in this river valley. This book is an incredible tribute to the Connecticut River and the people who care about this region.

After experiencing the Connecticut through Al Braden's breathtaking images I hope you'll be as inspired as I am to explore and preserve our home river. On the following pages are a few of the many worthy organizations that can help you do just that.

As my daughter would say, we can all work for the river.

CHELSEA REIFF GWYTHER
Executive Director
Connecticut River Watershed Council

Selected Resource Organizations

The following organizations have been especially helpful to me in exploring the river while writing and photographing for this book, but this list is neither complete nor exhaustive. An Internet search will find many other local and regional groups also working for the Connecticut River and its tributaries.

Connecticut River Greenway State Park, 136 Damon Rd., Northampton, MA 01060, www.mass.gov/dcr/parks/central/crgw.htm

Connecticut River Joint Commissions, 154 Main St., Charlestown, NH 03603, www.crjc.org

Connecticut River Museum, 67 Main St., Essex, CT 06426, www.ctrivermuseum.org

Connecticut River Scenic Byway, PO Box 1182, Charlestown, NH 03603, www.ctrivertravel.net

Connecticut River Watershed Council, 15 Bank Row, Greenfield, MA 01301, www.ctriver.org

Connecticut Science Center, 50 Columbus Boulevard, Suite 500, Hartford, CT 06106, www.ctsciencecenter.org

Great Falls Discovery Center, 2 Avenue A, Turners Falls, MA 01376, www.greatfallsma.org

Montshire Museum of Science, One Montshire Rd., Norwich, VT 05055, www.montshire.org

The Nature Conservancy, 4245 North Fairfax Dr., Suite 100, Arlington, VA 22203, www.nature.org

Riverfront Recapture, 50 Columbus Boulevard, 1st Floor, Hartford, CT 06106, www.riverfront.org

Silvio O. Conte National Fish and Wildlife Refuge, 103 East Plum Tree Rd., Sunderland, MA 01375, www.fws.gov/r5soc

The Trust for Public Land (Connecticut River Program), 1 Short St., Suite 9, Northampton, MA 01060, www.tpl.org/ctriver

Locations of the Images

Note: The following list is organized by page number.

1. Fourth Connecticut Lake, Pittsburg, NH, *May 29, 1999*
2. Start of the Connecticut River, Pittsburg, NH, *July 24, 2004*
3. Connecticut River above Second Connecticut Lake, Pittsburg, NH, *September 9, 2001*
4. Dan Braden at Moose Bog, Deer Mountain Campground, Pittsburg, NH, *September 9, 2001*
5. Moose Falls Dam, Deer Mountain Campground, Pittsburg, NH, *September 9, 2001*
6. Morning mist on Scott Stream, Pittsburg, NH, *July 24, 2001*
7. Shoreline of Second Connecticut Lake, Pittsburg, NH, *July, 24, 2001*
8. Outflow of dam at First Connecticut Lake, Pittsburg, NH, *October 7, 2000*
9. Free-flowing section of Connecticut River, Pittsburg, NH, *July 24, 2004*
10. Pittsburg-Clarksville Bridge, Pittsburg, NH, *October 7, 2000*
11. Indian Stream, Pittsburg, NH, *September 9, 2001*
12. Connecticut River after confluence with Indian Stream, Pittsburg, NH, *October 7, 2000*
13. Mt. Orne covered bridge, Lunenburg, VT, *May, 28, 1999*
14. Passumpsic River joins Connecticut River, East Barnet, VT, *July 4, 2003*
15. Comerford Dam, Monroe, NH, *July 29, 2008*
16. Connecticut River Valley at Monroe, NH, *July 29, 2008*
17. Connecticut River between Fairlee, VT, and Orford, NH, *July 29, 2008*
18. Dan Braden on rope swing, Hanover, NH, *September 4, 1999*
19. Wilder Station, Wilder, VT, *October 2, 1999*
20. Sumner Falls, Hartland, VT, *July 29, 2008*
21. Cornish-Windsor Bridge from Cornish, NH, *June 1, 2002*
22. Christmas tree farm along the Connecticut River near Ascutney, VT, *October 14, 2000*
23. River bank near Charlestown, NH, *July 21, 2001*
24. Cannon fire along the Connecticut River, Fort at No. 4, Charlestown, NH, *June 1, 2002*
25. Fort at No. 4, Charlestown, NH, *June 1, 2002*
26. Bank swallow nests along the Connecticut River, Charlestown, NH, *July, 21, 2001*
27. Floodplain farmland south of Charlestown, NH, *October 1, 2001*
28. Back cove, North Walpole, NH, *August 1, 2001*
29. Back cove, North Walpole, NH, *August 20, 1998*
30. Stone arch bridge, Bellows Falls, VT, *April 13, 2001*
31. Bellows Falls, VT, from Table Rock on Fall Mountain, NH, *May 23, 2002*
32. Dam on Connecticut River at Bellows Falls, VT, *April 27, 1999*
33. Bellows Falls Station, VT, *April 27, 1999*
34. Roller gate open at Bellows Falls Dam, VT, *April 13, 2001*
35. Pulling the flash boards on the Bellows Falls Dam, VT, *April 24, 2001*
36. Vilas Bridge at high water, Bellows Falls, VT, *April 14, 2001*
37. Vilas Bridge and natural channel in low water, Bellows Falls, VT, *September 10, 1998*
38. Spring ice breakup at Westminster, VT, and Walpole, NH, *March 17, 2001*

Selected Bibliography

Benson, Robert. *The Connecticut River* (Boston: Bulfinch Press, Little, Brown and Company, 1989). A beautiful source-to-sea photo essay.

Connecticut River Watershed Council. *The Complete Boating Guide to the Connecticut River, Third Edition* (Guilford, CT: Falcon Guide, The Globe Pequot Press, 2007). The complete guidebook to the river.

Dina, James. *Voyage of the Ant* (Harrisburg, PA: Stackpole Books, 1989). An exciting canoe voyage up river in a homemade birch bark canoe, using only seventeenth-century technology.

Ewald, Richard, and Adair Mulligan. *Proud to Live Here* (Charlestown, NH: Connecticut River Joint Commissions, 2003). An indispensable and wide-ranging resource on the Vermont–New Hampshire section of the Connecticut River.

Grove, Bill. *Log Drives on the Connecticut River* (Littleton, NH: Bondcliff Books, 2003). A comprehensive history of the log drives.

Maloney, Thomas, et al. *Tidewaters of the Connecticut River* (Old Saybrook, CT: River's End Press, 2001). A detailed guide to the estuaries and coves of the lower Connecticut River.

Nedeau, Ethan. *Freshwater Mussels and the Connecticut River Watershed* (Greenfield, MA: Connecticut River Watershed Council, 2008). The definitive guide to freshwater mussels in the watershed and a fresh view of the watershed from a unique perspective.

Stekl, William and Evan Hill. *The Connecticut River* (Middletown, CT: Wesleyan University Press, 1972). I was introduced to this complete upstream tour of the river after completing my book. It presents a fascinating "before" contrast to the same themes over three decades earlier and outlined the urgency of conservation.

Tougias, Michael. *River Days* (Boston, MA: Appalachian Mountain Club Books, 2001). An interesting personal story of a source-to-sea voyage undertaken, to the extent possible, by canoe and kayak.

Wetherell, W. D. *This American River* (Lebanon, NH: University Press of New England, 2002). An anthology of five centuries of writing about the Connecticut River.

Wikoff, Jerold. *The Upper Valley* (Chelsea, VT: Chelsea Green Publishing Company, 1985). A collection of essays on many facets of Upper Valley history, originally published as a weekly column in the West Lebanon, NH, *Valley News*.